100 POSTERS

that changed the world

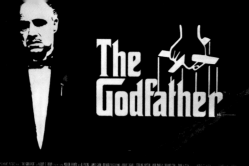

The Godfather

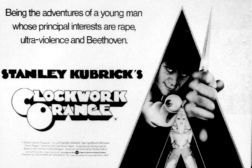

Being the adventures of a young man whose principal interests are rape, ultra-violence and Beethoven.

STANLEY KUBRICK'S
CLOCKWORK ORANGE

Stephen Baldwin Gabriel Byrne Chazz Palminteri
Kevin Pollak Pete Postlethwaite Kevin Spacey

the Usual Suspects

FIVE CRIMINALS. ONE LINE UP.
NO COINCIDENCE.

THE MOST ELECTRIFYING AND EXCITING MOVIE EXPERIENCE YOU WILL SURVIVE THIS YEAR!

the silence of the lambs
from the terrifying best seller

THE GRAND BUDAPEST HOTEL

AUDREY TAUTOU MATHIEU KASSOVITZ

Amélie

A film by JEAN-PIERRE JEUNET

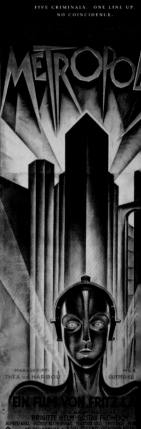

METROPOLIS

EIN FILM VON FRITZ

#1 BEGBIE #2 DIANE #3 SICK BOY #4 SPUD #5 RENTON

Trainspotting

From the makers of
Shallow Grave

WILLIAM PETER BLATTY'S

THE EXORCIST

Directed by WILLIAM FRIEDKIN

A STEVEN SPIELBERG FILM

JURASSIC PARK

An Adventure
65 Million Years In The Making.

He was the Lord of Ten Thousand Years,
the absolute monarch of China.
He was born to rule a world
of ancient tradition.
Nothing prepared him for our world of change.

THE LAST EMPEROR
A True Story

Something almost beyond comprehension is happening to a girl on this street, in this house...and a man has been sent for as a last resort. This man is The Exorcist.

ELLEN BURSTYN · MAX VON SYDOW · LEE J. COBB
KITTY WINN · JACK MacGOWRAN · JASON MILLER as Father Karras
LINDA BLAIR as Regan · Produced by WILLIAM PETER BLATTY
Executive Producer NOEL MARSHALL · Screenplay by WILLIAM PETER BLATTY based on his novel

FRANCIS FORD COPPOLA

Apocalypse Now

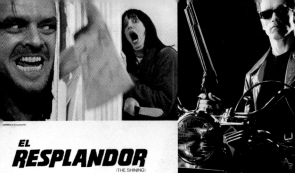

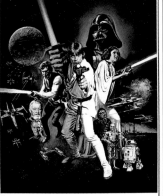
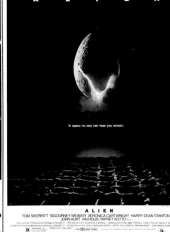

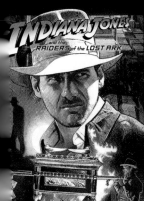
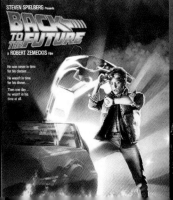
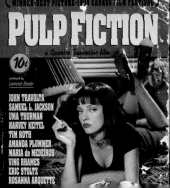

Pavilion
An imprint of HarperCollins*Publishers* Ltd
1 London Bridge Street
London SE1 9GF

www.harpercollins.co.uk

HarperCollins*Publishers*
Macken House,
39/40 Mayor Street Upper,
Dublin 1
D01 C9W8

10 9 8 7 6 5 4 3 2

First published in Great Britain by Pavilion,
an imprint of HarperCollins*Publishers* Ltd 2020

© 2020 Pavilion

Colin Salter asserts the moral right to be identified as the
author of this work.
A catalogue record for this book is available from the
British Library.

ISBN 978-1-911641-45-2
This book is produced from independently certified
FSC™ paper to ensure responsible forest management.

For more information visit: www.harpercollins.co.uk/
green

Printed and bound by GPS Group, Slovenia

Previous spread: A selection of the greatest movie posters of all time from
directors including Francis Ford Coppola, Steven Spielberg, Danny Boyle,
Wes Anderson, Quentin Tarantino, George Lucas, James Cameron, Stanley
Kubrick, Robert Zemeckis, and the Coen Brothers.

100 POSTERS

that changed the world

—

Colin Salter

PAVILION

Contents

OPPOSITE: Henry George Gawthorn designed a number of classic travel posters for the LNER in the 1920s and 1930s, including this one of the Forth Rail Bridge. Swann Auction Galleries in New York, who specialize in auctions of printed material, sold an original Clacton-on-Sea Gawthorn poster for $5,000 in 2014.

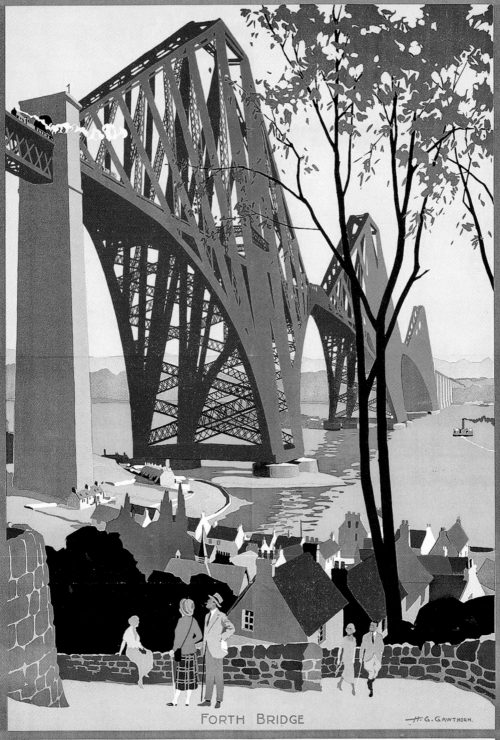

L·N·E·R

FORTH BRIDGE

H. G. GAWTHORN.

EAST COAST TO SCOTLAND

Introduction

We can't say definitively who hung the first poster, or when. Was it an ancient Roman entrepreneur announcing the attractions at the local amphitheatre? Or an ancient Greek democrat appealing for your vote? One thing is certain: they were trying to draw eyes to their message.

In a world with myriad media through which to attract attention, the poster has always had distinct advantages. It can be placed exactly where its intended audience will see it. Newspapers and television, for example, reach a public defined by the reputation of the publication or the programme which the TV channel is broadcasting – not necessarily the same demographic or even the same geographical area in which you want to sell your product. A poster for a touring circus, however, will only be put up in the town to which the Big Top is coming. A health campaign announcement can be displayed where it needs to be seen; so abstinence posters were placed outside bars, and anti-drug campaigns were promoted in senior schools and colleges. Posters can hit their intended targets.

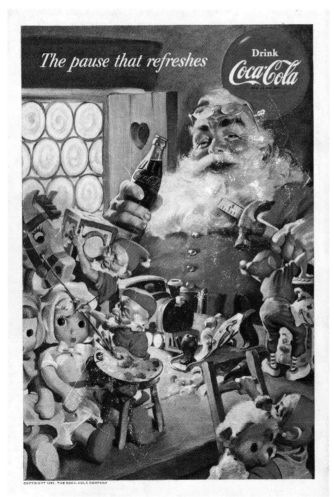

"LOOK AT ME!"
Every poster's principle message is "Look at me!" Until it has caught your eye, nothing else matters. Only once it has grabbed attention can it proceed to sell you whatever it is selling – ideas or goods, magazines or bicycles, a plea for morality or a temptation to sin. Communist poet, playwright and poster designer Vladimir Mayakovsky said that if a poster could not bring a running man to a halt it had not done its job.

Just as the invention of printing meant you didn't have to draw every poster by hand, so the arrival of lithography transformed the art and ushered in the

LEFT: Haddon Sundblom's jolly, rubescent Santa Claus in his traditional red robe enjoying, "The pause that refreshes" in the 1950s. Many believe it was Coca-Cola who gave Santa his red attire for its advertising campaigns, but a quick look at the cover of Puck *magazine from 1896 quickly dispels that myth.*

Golden Age of the Poster. From 1880 to 1940, poster designers were liberated by the new possibilities of full colour reproduction to create the most beautiful combinations of art and commerce.

The period coincided with the Art Nouveau and Art Deco movements when first the forms of nature and then those of engineering were applied to design on all fronts – architecture, household objects, even forms of transport. Posters reflected these cultural trends and in some cases, for example the world of French cabaret clubs, led them. Art Nouveau gave us sinuous curves, evocative of absinthe-induced dreams and spinning Parisian dancers. Art Deco gave us streamlining, and the travel posters of the 1920s and 1930s offered a world of unparalleled glamour and speed by trans-European train or transatlantic liner.

Posters have always sold ideas as well as the goods and services they advertise. Those early bicycle posters weren't only offering you an expensive contraption; buy a bicycle and you would be buying modernity – the future, as Paul Newman briefly believed in the film *Butch Cassidy and the Sundance Kid* before returning to his slower but more dependable horse. Bicycles were the latest craze as the real Cassidy launched his crime spree.

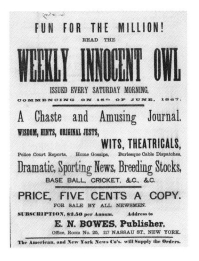

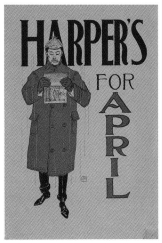

ABOVE: Posters regularly appeared to advertise American journals, such as the debut of the short-lived Weekly Innocent Owl *in 1867. However the market took a quantum leap forward when* Harpers *magazine used a colour poster by Edward Penfield to promote their edition for April 1893. The approach was quickly copied by rival publishers and the monthly promotional poster quickly became collectors' items.*

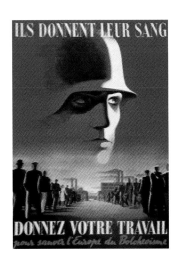

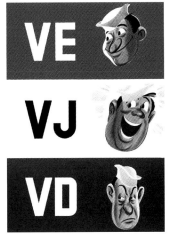

LEFT: Two very different poster messages from World War II. In Nazi-occupied France the German propagandists were keen to persuade the French population to work in armament factories both at home and in Germany. The poster reads: "They give their blood. Give your work."

After victories in Europe and Japan, and with millions of men celebrating the fact that they'd got through the war unscathed, the US Navy were keen that their returning sailors didn't bring home unwelcome souvenirs. The Army and Navy produced many different VD posters to combat the upsurge in cases.

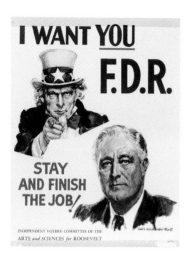

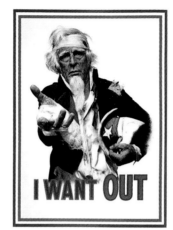

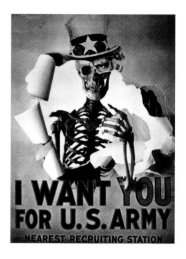

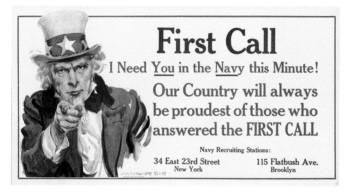

ABOVE: Uncle Sam had been a popular character in the US for over a century, but he was defined once and for all by James Montgomery Flagg's recruitment poster for World War I. Imitating the pose struck by Lord Kitchener in 1914, Flagg's portrait of Uncle Sam first appeared on the cover of Leslie's Illustrated Magazine *in 1916, asking what the US was doing to prepare for conflict. Like many classic posters it has been subverted to portray a whole range of different messages since, such as helping to re-elect Franklin D. Roosevelt, or to draw attention to the war in Vietnam.*

KEEP CALM AND CARRY ON

Sometimes, however, the idea is everything. Ideology comes to the fore in times of war; and if truth is the first casualty of war, propaganda is the first lie. George Washington's recruitment poster for the Continental Army promised the opportunity to travel across the country, but did not mention the high risk of death in the process. Propaganda posters are a vital weapon of war. Governments use them to justify the conflict to their citizens; to reassure them that the home side is winning; and to enlist the country's civilians in the war effort. You could do your bit by saving materials and growing your own food, even if you were too young or too old for military action.

The first job in war is to make your enemy the faceless villain of the piece. It's not always an easy thing to do. Before both World Wars, Britain and Germany had close ties and the countries were connected by many individual friendships. Adolf Hitler planned to put the abdicated King Edward VIII, who admired him, back on the British throne. After Pearl Harbor, the demonization of Japanese people was scaled down in Hawaii, where they made up a third of the population. Nevertheless soldiers must be taught to hate, and propaganda posters routinely depict the enemy as a monster ravaging

daughters and murdering your sons.

A second strand of posters is directed at maintaining morale back home. In the face of privations caused by food shortages and bombing raids, governments put a lot of effort into reassuring its people that life is normal. "Keep calm and carry on," as the most famous wartime propaganda poster never to have been used in wartime put it. Posters carry the message that nothing has been disrupted, minimizing setbacks and maximizing successes.

"I WANT YOU!"

The third job is to procure the resources to fight. War is an expensive business, it needs men, machines and materials to conduct. One of the odder wartime shortages, experienced in the United States during World War I, was the lack of binoculars, as all the lenses were supplied by Zeiss of Germany. Donations of binoculars and spyglasses were sought from the public in several poster appeals. The authorities didn't learn from the experience. When Germany declared war on the United States in December 1941, the posters had to be issued all over again.

What an army (and navy and airforce) really needs is people. Peacetime armies are rarely maintained at full strength. Britain's entry into World War I and America's into World War II, triggered an early rush of volunteers to fight for the cause. But it is a fact of war that men die and have to be replaced. Posters from the seventeenth

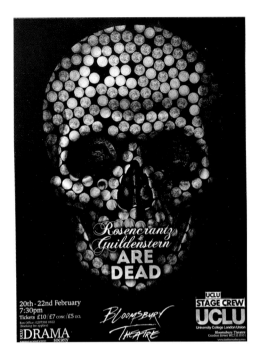

ABOVE: Some posters have familiar elements. For theatrical productions of Shakepeare's Hamlet, *the poster is most often based on the court jester Yorick's skull. Tom Stoppard's play takes two characters from* Hamlet, *Rosencrantz and Gildenstern, who spend most of the play tossing a coin, of which the outcome is always heads. So what better way to illustrate it than Yorick's skull made up from coins. All tails.*

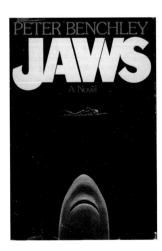

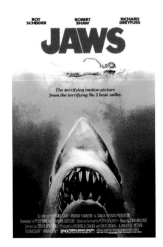

LEFT: Many of Steven Spielberg's films have memorable movie posters, none more so than Jaws. *But the idea of the menacing shark approaching the lone swimmer from below came from the cover of Peter Benchley's original book. For the movie, the shark got considerably more teeth.*

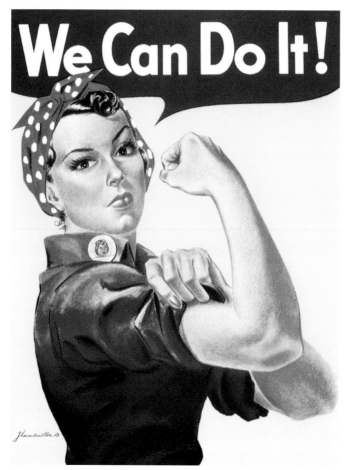

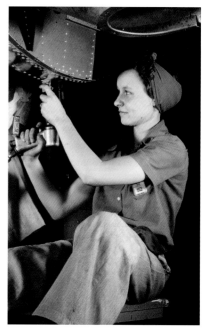

ABOVE: *Rosie the Riveter first appeared in a popular song from 1942: "All day long, rain or shine, she's part of the assembly line. She's making history, working for victory, Rosie, brrrr, the riveter." During World War II many American women worked on aircraft production lines, such as above right, at the Douglas Aircraft Company in Long Beach, California. Artist Howard J. Miller was commissioned by Westinghouse to create a series of posters for their factories and his 'We Can Do It' was displayed for a two-week period in 1943. Like the 'Keep Calm and Carry On' poster it was put into a drawer and forgotten for many years. When it re-emerged, it became known as Rosie the Riveter.*

century onward have always led the recruitment drive.

Most famous of all recruitment advertisements, perhaps the most famous poster of all, is the pointing finger of Britain's Lord Kitchener telling you – yes YOU! – that he "wants you" to join the army. The poster inspired Uncle Sam's similar appeal, and hundreds of parodies. Kitchener is a controversial military figure, responsible for some very brutal campaigns. Princess Elizabeth Bibesco, daughter of Britain's wartime Prime Minister Herbert Asquith, summed Kitchener up thus: "if Kitchener was not a great man, he was, at least, a great poster."

After World War II the world was a very different place, although ideological conflicts continued in the Cold War and in battles for hearts and minds within countries like Vietnam and China. After the privations of war, materialism acquired new followers seeking a brave new world where prosperity and peace ruled and which one might travel far and wide in the name of friendship.

The transition from paintings and drawings to photography in advertising happened gradually in the

two decades after World War II. Airlines, for example, were still using graphic illustrations at the dawn of the 1960s, perhaps because the reality of some of their less developed destinations was not well served by photography. David Klein's 1960s posters for TWA, recently repurposed for an online travel company, still evoke the exotic excitement of travel as Howard Hughes' new fleet of Boeing 707s came into service.

With photography came new ways of presenting and enhancing reality. Some of the most effective photographic poster campaigns have used the camera to shock the viewer. Issue-based posters about animal welfare for example, or the results of drug abuse, speeding or drink-driving, pull no punches. We still instinctively believe that the camera cannot lie, even in the Photoshop age. Posters of every period have at the very least exaggerated or distorted images for the purpose of convincing us. At best they have done so with style and artistry in the spirit of their age. Long may they continue to persuade us to LOOK!

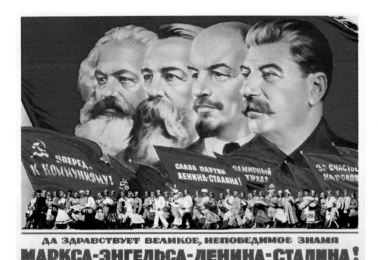

LEFT: *Mao Zedong took his ideological lead from Soviet communism. He also used their graphics. Many posters of Mao emulate the Cult of Stalin from the 1930s, 40s and 50s, including the famous painting by A. Kossov (1953) featuring the founders of communism, titled* Long Live the Great Invincible Banner of Marx, Engels, Lenin, Stalin. *After the death of Stalin in 1953 Mao forged his own poster identity appearing in deified form, with the rays of a golden sun emanating from behind his portrait.*

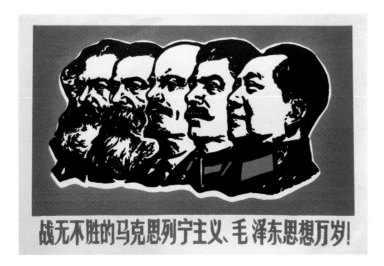

Early Wanted Posters

(1651–1881)

Thanks to countless Western movies with lantern-jawed cowboys riding into the sunset, Wanted posters may seem like romantic relics of nineteenth-century America. However, their roots go back much further than the Wild West of the States to the wilder shires of seventeenth-century England.

Though the form of these particular public notices has evolved over the years, their purpose remains the same as that of all public notices: to assert the authority of the law and the power of whoever wields it. It is the lawmakers who decide what is against the law and who is, therefore, an outlaw.

One of the most famous Wanted posters dates to 1651. It calls for the apprehension of Charles II of England and was issued four days after the Battle of Worcester where the King's forces had been defeated by Cromwell's New Model Army. Charles fled the battlefield and, famously, hid from Cromwell's Roundheads by hiding in an oak tree in Boscobel Wood. He escaped to France before returning to England and retaking the throne in the Restoration of 1660.

Billed as "a proclamation" and issued "by the Parliament", the Wanted poster underlines that it was the victorious Parliamentarians that had lawful authority and not the "malicious and dangerous traitor" Charles Stuart. The notice stresses that Parliament has control of the country, but is careful to acknowledge a higher power: it notes that the battle went the way of the Puritans "by the blessing of God". Parliament is ruling by God's grace; much as the monarchy ruled by divine right.

Unlike most later Wanted posters, the £1,000 reward for the King's capture is not prominent. Although it was an immense sum of money in the seventeenth century, it is not mentioned until the end of the proclamation. The inference is that the apprehension of Charles is

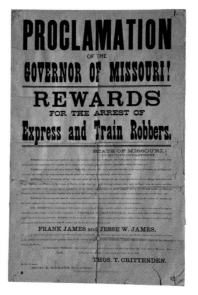

the patriotic duty of not only civil and military officers but also all other "good people of this nation". By contrast, anyone deliberately shielding Charles was aiding and abetting their "traitorous and wicked practices and designs". Wanted posters can be propaganda for the ruling classes.

The 1881 Wanted poster for Jesse James also has elements of public relations spin and reputation management. Frank and Jesse James, along with their outlaw gang, were admired in some quarters as folk heroes, almost Robin Hood figures. Thomas T. Crittenden, Governor of Missouri, was determined to alter perception of that image. The poster authorized by Crittenden lists the crimes, including murder, committed by their gang. Rather than heroes, the James brothers are presented as killers and thieves.

Other factors came into play but the Wanted posters helped bring about the demise of the brothers. Jesse was shot from behind in April 1882 by Robert Ford, one of his own gang members, who promptly laid claim to the reward money. Five months later, Frank turned himself in to Governor Crittenden.

OPPOSITE: Charles II's Wanted poster served two purposes. Not only did it incentivize anyone who might have information of the whereabouts of the monarch, it was also a stark warning to his supporters that any alliance with him would not be tolerated.

~~**By the Parliament.**~~

A PROCLAMATION
FOR THE

Diſcovery and Apprehending of *CHARLS STUART*, and other Traytors his Adherents and Abettors.

Whereas CHARLS STUART Son to the late Tyrant, with divers of the Engliſh and Scotiſh Nation, have lately in a Trayterous and Hoſtile maner with an Army invaded this Nation, which by the Bleſſing of God upon the Forces of this Commonwealth have been defeated, and many of the chief Actors therein ſlain and taken priſoners; but the ſaid Charls Stuart is eſcaped: For the ſpeedy Apprehending of ſuch a Malicious and Dangerous Traytor to the Peace of this Commonwealth, The Parliament doth ſtraightly Charge and Command all Officers, as well Civil as Military, and all other the good People of this Nation, That they make diligent Search and Enquiry for the ſaid Charls Stuart, and his Abettors and Adherents in this Invaſion, and uſe their beſt Endeavors for the Diſcovery and Arreſting the Bodies of them and every of them; and being apprehended, to bring or cauſe to be brought forthwith and without delay, in ſafe Cuſtody before the Parliament or Councel of State, to be proceeded with and ordered as Juſtice ſhall require; And if any perſon ſhall knowingly Conceal the ſaid Charls Stuart, or any his Abettors or Adherents, or ſhall not Reveal the Places of their Abode or Being, if it be in their power ſo to do, The Parliament doth Declare, That they will hold them as partakers and Abettors of their Trayterous and Wicked Practices and Deſigns: And the Parliament doth further Publiſh and Declare, That whoſoever ſhall apprehend the perſon of the ſaid Charls Stuart, and ſhall bring or cauſe him to be brought to the Parliament or Councel of State, ſhall have given and beſtowed on him or them as a Reward for ſuch Service, the ſum of One thouſand pounds; And all Officers, Civil and Military, are required to be aiding and aſſiſting unto ſuch perſon and perſons therein. Given at Weſtminſter this Tenth day of September, One thouſand ſix hundred fifty one.

Early Recruitment Posters

(1776–1795)

In feudal times armies were recruited not from the willing ranks of the peasants but on the orders of their overlords. In times of greater free will, military forces have to rely on conscription or on volunteers. Early recruitment posters reveal the temptations used to lure civilians into service.

Men like to fight for all sorts of reasons. Some are just plain belligerent. Most will fight for ready money. Some fight for the ideals of a cause, either to defend an institution or to destroy it in favour of a new one. When General George Washington was recruiting a revolutionary army in 1776 his poster led with an impassioned appeal "for the defence of the liberties and independence of the United States". At war with France in 1814, the British Navy sought volunteers among "all who have good Hearts, who love their King, their Country and Religion, who hate the French and damn the Pope." This, the poster was saying, was a patriotic war, an idealistic conflict, a them-and-us situation. Little has changed in governments' portrayal of wars before or since.

Ideals, however, don't put food on the table. In the small print at the bottom of Washington's poster lies the nitty-gritty of the deal. The "encouragement to enlist" included generous pay, a bonus just for signing up, food, clothing and the "opportunity of spending a few happy years in viewing the different parts of this beautiful continent" – an early example of the "join the army and see the world" approach, which blurs the fundamental reason that armies exist: not to travel but to fight.

The glamour of a uniform has always held a certain attraction. Washington's poster and many since have included images of soldiers in exciting positions. The regiment of Royal-Piemont illustrated theirs with a proud cavalry officer in 1789, the year of the French Revolution. Perhaps the minimal offer of inducements – none for recruits but a bounty for those who procured them – was the reason for the Royalists' rapid defeat and the triumph of the peasantry that year.

Volunteers may join in a red haze of patriotic fervour but in the cold light of day there have to be reasons for staying. Alexander the Great retained his army by offering a share of the spoils as he advanced ever further

eastwards, away from his soldiers' homes in Greece. Potential British Marine recruits to fight in the 1812 war with the US were promised a similar share in the profits from any American ship captured. Most countries disavow such state-sponsored piracy today and instead inducements include the opportunity to learn new skills to use after you have left the service.

The bond between men who have grown up in the same village may prove useful in time of war; friends may be more daring together than as individuals. Posters were placed where they would catch the attention of such groups of men, very often the local inn where bravado flowed like beer and caution evaporated like whisky. Washington's poster was put up in towns in advance of a visit by a recruiting party which assured each volunteer that he would return "with his pockets full of money and his head covered with laurels." But when battles resulted in losses on the scale of Gettysburg or the engagements of World War I, entire generations of small communities might be wiped out.

OPPOSITE TOP: A Royal Navy recruitment poster circa 1795.
OPPOSITE BOTTOM: A recruitment poster for George Washington's Continental Army. Captain Alexander Grayson, in his 1811 memoir, described the difficulties he had in recruiting soldiers to fight as it was mainly the wealthy elite who objected to the intervention of the British crown while the men he tried to recruit in taverns just wanted the beer money.

VOLUNTEERS.

G. R. III.

God Save the King.

LET us, who are Englishmen, protect and defend our good KING and COUNTRY against the Attempts of all *Republicans* and *Levellers*, and against the Designs of our NATURAL ENEMIES, who intend in this Year to invade OLD ENGLAND, *our happy Country*, to murder our gracious KING as they have done their own; to make WHORES of our *Wives* and *Daughters*; to rob us of our Property, and teach us nothing but the *damn'd Art of murdering one another*.

ROYAL TARS
Of OLD ENGLAND,

If you love your COUNTRY, and your LIBERTY, now is the Time to shew your Love.

R E P A I R,

All who have good Hearts, who love their KING, their COUNTRY, and RELIGION, who hate the FRENCH, and damn the POPE,

T O

Lieut. W. J. Stephens,

At his Rendezvous, SHOREHAM,

Where they will be allowed to Enter for any SHIP of WAR,

AND THE FOLLOWING

BOUNTIES will be given by his MAJESTY.
in Addition to Two Months Advance.

To Able Seamen, - - - *Five Pounds.*
To Ordinary Seamen, - - - *Two Pounds Ten Shillings.*
To Landmen, - - - *Thirty Shillings.*

Conduct-Money paid to go by Land, and their Chests and Bedding sent Carriage free.
Those Men who have served as PETTY-OFFICERS, and those who are otherwise qualified, will be recommended accordingly.

LEWES: PRINTED BY W. AND A. LEE.

TO ALL BRAVE, HEALTHY, ABLE BODIED, AND WELL DISPOSED YOUNG MEN,

IN THIS NEIGHBOURHOOD, WHO HAVE ANY INCLINATION TO JOIN THE TROOPS, NOW RAISING UNDER

GENERAL WASHINGTON.

FOR THE DEFENCE OF THE

LIBERTIES AND INDEPENDENCE
OF THE UNITED STATES,

Against the hostile designs of foreign enemies,

TAKE NOTICE,

GOD SAVE THE UNITED STATES.

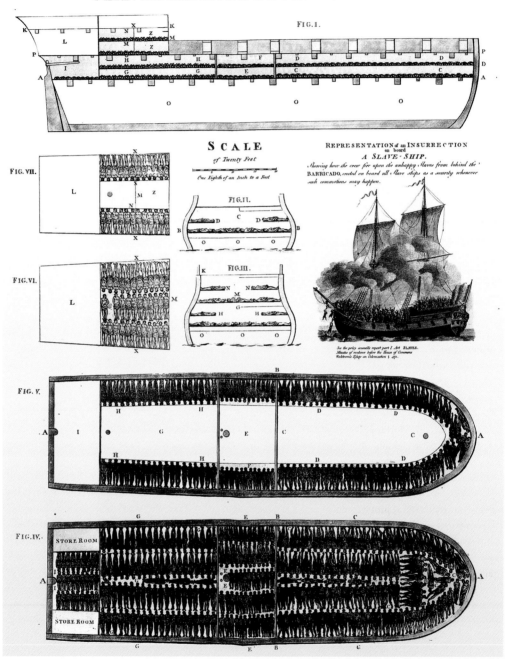

ABOVE: The Brookes *slave ship drawing was a propaganda coup for the Society for*
Effecting the Abolition of the Slave Trade.

Anti-Slavery Campaigns

(1788–1865)

The abolition of slavery in the Western World was a struggle long fought for. In America only a civil war could end a practice many of the nation's founders firmly supported. In Britain the governing powers were just as complicit, but a poster helped sway public opinion.

I t's a little-known fact that in 1315 the King of France outlawed slavery in France. Unfortunately it remained legal elsewhere in his Empire and those of other imperial powers for another five hundred years. The growing sense that slavery was immoral reached a tipping point in the later eighteenth century. Quakers in America and Britain raised their voices in objection and were joined by other non-conformist denominations.

At that time Africans were routinely sold into slavery by other Africans or simply kidnapped by white slave traders and shipped to the New World. There they were auctioned off like cattle and sold on in the same way. Posters survive which announce such sales. In Britain a very different poster appeared in 1788. It was designed to shock, and as such constitutes one of the earliest examples of a poster used as propaganda.

The poster carried the now famous diagram of the slave ship *Brookes*, packed to the gunwales with 478 slaves in appallingly cramped conditions. The *Brookes* routinely sailed from its base in Liverpool to the Atlantic coast of North Africa to pick up slaves to trade in North America. The ship was licensed to carry 454 "passengers", but was known to have carried more than 700 on occasion. Each was given a space six feet long and one foot four inches wide, with little headroom because of the practice of adding extra mezzanine levels between the ship's original decks.

The *Brookes* poster was designed by Plymouth members of the Society for Effecting the Abolition of

the Slave Trade, formed a year earlier in a printshop in London. It was widely distributed and played a significant role in raising awareness of the issue. Within three years the abolitionist William Wilberforce was sufficiently encouraged to promote a parliamentary bill making the slave trade illegal. It failed, but Wilberforce and his colleagues persisted and in February 1807 Britain at last outlawed the North Atlantic slave trade.

The United States followed suit a month later. But supporters of slavery in both countries were quick to take advantage of the fact that, although importing slaves was now illegal, owning slaves was not. In Britain it took a further Act of Parliament in 1833 to ban slavery itself. In the US the practice continued, sadly, for many more years. In the cotton-growing southern states, slavery was formally legalized in 1850, and the slave population actually increased as the children of slaves were themselves enslaved and traded between owners. It took a civil war to bring about the final emancipation of American slaves in 1865.

France, meanwhile, had abolished slavery in 1794 in the wake of the French Revolution, but reinstated it under Napoleon as a way of controlling its colonies. It wasn't until 1905 that France finally outlawed it in its West African possessions.

The Great Wave off Kanagawa

(1829)

It wasn't the first wave to be depicted in the medium of Japanese woodblock art. It wasn't even the first wave engraved by Katsushika Hokusai. But the sophisticated simplicity of *The Great Wave off Kanagawa* marks it out as the work of a master at the height of his powers.

A striking print of three fishing boats dwarfed by the wave about to engulf them, with Mount Fuji sitting impassively in the background, it's effortlessly iconic, its dynamic composition enhanced by elegant, minimalist line-work and a limited colour palette.

Still the most familiar Japanese artwork to Westerners, it grew out of the tradition of ukiyo-e, which translates as "pictures of the floating world". A genre stretching back centuries, ukiyo-e came into its own in the Edo period (1603–1868), when the innovation of woodblock printing made it possible for a growing merchant class to own commercial prints.

Hokusai (1760–1849) was its greatest exponent. Known to his parents as Tokitar, he adopted many names, but Hokusai, meaning "The North Studio", was the one that stuck. After the death of his master, Shuns, and his expulsion from the Katsukawa school, he began to develop his own style, and changed the subject matter of his pictures. Traditionally, ukiyo-e had been dominated by courtesans and kabuki actors, but Hokusai gave prominence to landscapes, populating them with images of common people going about their lives.

Between 1829 and 1833, he produced his magnum opus, "Thirty-Six Views of Mount Fuji", of which *The Great Wave off Kanagawa* is a part, and became an ukiyo-e superstar, writing art manuals, collaborating on illustrated books and (legend has it) creating a painting of the Buddhist priest Daruma that was 600 feet long.

With the passing of the Edo period, Japan opened up to the world again after 200 years of isolation. Japanese art was exhibited at the 1867 World Fair in Paris, and prints began to make their way to Europe, often as packaging in crates of porcelain. The Impressionists, seeking to free themselves from the strictures of academic painting, were enthralled by the Japanese approach to line, colour and perspective. Manet, Whistler, Degas, Van Gogh, Renoir, Gauguin, Toulouse-Lautrec – all strove to achieve the effects they had seen in Japanese art, along with designers and architects like Charles Rennie Mackintosh, Louis Comfort Tiffany and Frank Lloyd Wright. The trend was given a name, *Japonaiserie*, and above it towered Hokusai's indomitable wave.

That early Japanese influence became part of the palette of Western art, so deeply assimilated now that its influence is hardly noticeable. But the process repeated itself more than 100 years later with the explosion of interest in anime and manga – so exotic at first, but now part of the media furniture.

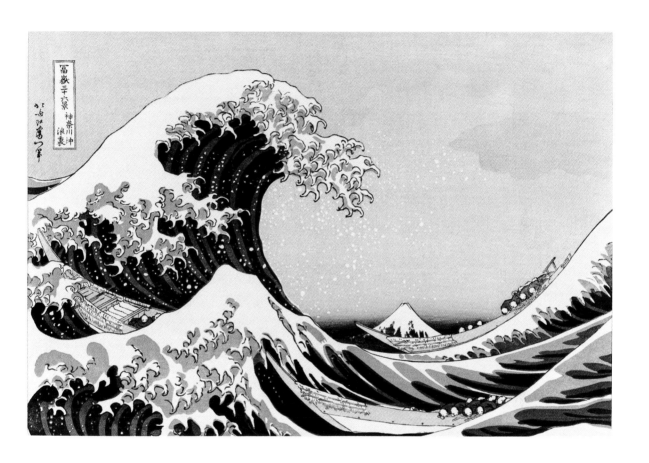

ABOVE: The depiction of fantastic waves crashing against rocky shores was a familiar subject for Japanese printmakers from the sixteenth century – tsunami is derived from a Japanese word meaning "harbour wave". Hokusai drew many great waves in his career and was particularly influenced by the work of Shiba Kokan.

ROYAL STANDARD

TAVERN

AND

PLEASURE GROUNDS,

SHEPHERDESS WALK,

CITY ROAD.

Licensed pursuant to Act of Parliament of the 25th of King George the Second.

H. BRADING, PROPRIETOR.

Extraordinary Attraction!

FOR THE

BENEFIT OF MR. GYPSON,

The Nocturnal Æronaut, who will make

AN EQUESTRIAN

BALLOON ASCENT

On *MONDAY*, Sept. 2nd, 1839.

This will be the First Equestrian Flight this Ten Years, and positively the Last Ascent that will take place at these Grounds this Season.

The Arrangements under the Superintendence of Mr. GREEN.

MR. DUCROW

HAS KINDLY OFFERED THE USE OF HIS

CELEBRATED PONY, "FIRE-FLY,"

But in consequence of an accident, the above Arabian has been procured for the purpose.

H. B. respectfully informs his numerous Visitors, that, at the solicitation of some of his most intimate Friends, the Balloon on this occasion, will be inflated in the Gardens, in order that the Company may have an opportunity of witnessing the same.

During the Inflation there will be a succession of Amusement; and in the course of the Evening the following Entertainments:

ABOVE: At the beginning of the Railway Age, when locomotives would travel at "dizzying speeds" of up to 25mph, there was no more thrilling sight than to see an aeronaut make a balloon ascent and further challenge the laws of nature.

OPPOSITE: By the late nineteenth century balloonists were competing to offer thrill rides to the public in their tethered balloons.

Balloon Trips

(1839–1878)

Balloons powered by hydrogen or hot air were mankind's first opportunity to escape the surface of the Earth. Their invention was a historical moment, as significant in its own way as the first landing on the Moon. Showmen were quick to capitalize on their attraction to thrill-seekers.

Ever since the invention of the wheel, forms of transport have been used as much for pleasure as for carrying goods and passengers from A to B. From chariots to rowing boats, from sledges to steam trains, each new arrival has been a source of fear, excitement and laughter.

As the possibility of taking to the air in a balloon became real, there was a race in Paris to be the first. Jacques Charles and the Robert brothers Anne-Jean and Nicolas-Louis won when they launched an unmanned hydrogen-filled balloon on 27 August 1783, which so terrified the villagers where it landed that they stabbed it to death with pitchforks.

Charles and the Robert brothers crowd-funded their early flights. The ability of this new wonder to attract large sums of money soon came to the attention of promoters and pioneering flyers. In the nineteenth century, tethered balloons, raised by hydrogen and reeled back in by powerful winding machines, became popular attractions on their own or as part of fairs and circuses. People paid to watch, and paid more to experience flight for themselves.

One of the great British showmen of the age was Richard Gypson. On 3 June 1839 he undertook a series of tethered balloon flights by night from the pleasure grounds of the Royal Standard pub in Finsbury, London, where it seems he made regular appearances. On 2 September that year he was back at the Royal Standard, now billed as the Nocturnal Aeronaut, for his final show of the season. Determined to outdo himself he was promising to fly not only humans but a horse.

Posters advertising Mr Gypson's exploits were typical of the age. Large-scale images could not be reproduced and so posters had to do almost all their attention-seeking with lettering. Were it not for the small plate of a balloon, they might just as well have been announcing the date of the next vegetable market.

In France, new generations of balloonists were following in the footsteps of the brothers Robert and Montgolfier. Henri Giffard was the first flyer to add power and steering to his vehicle, although the technology had not yet been invented which would have made his 1852 experiments a success. He remained committed to balloon flight, however, and in 1878 he took up a residency in the Tuilleries, the public gardens in Paris. Flights in his tethered balloon were the centre of a multimedia extravaganza featuring a seventy-piece orchestra. By then printing technology at least had advanced; the development of lithography allowed M. Giffard to advertise in colour the spectacular experience which he was offering the Parisian public.

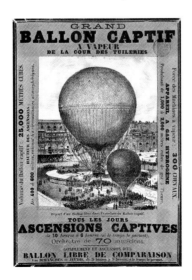

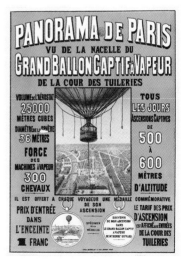

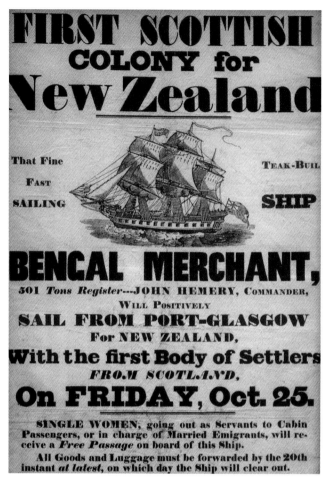

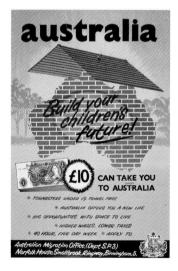

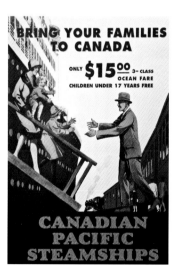

LEFT: An 1839 poster advertising for Scottish colonists to take passage to New Zealand in the security of a teak-built ship.
BELOW LEFT: An advert for "£10 Poms", the colloquial term for the Assisted Passage scheme started up by Australia in 1945 and New Zealand in 1947 to attract migrants from the UK.
BELOW RIGHT: As early as 1912 the Canadian Pacific Steamships company had been advertising "ready made farms on virgin soil" for British farmers of "moderate capital". This more general poster was from 1929.

Emigration Posters

(1839–1955)

A new colony, with wide open spaces to farm or mineral wealth to extract, required the practical skills of strong men to exploit its potential. The trappings of civilization – religion, politics, even finance – can wait when there are fields to be ploughed, horses to be shod and homes to be built.

The New Zealand Company was formed early in the nineteenth century to develop the islands, along the lines of the East India Company which exploited the Indian subcontinent in the name of Great Britain. Its plan was to buy land cheaply from the Maori population and sell it on to gentlemen farmers at a much higher price. Labour would be provided by poor immigrants looking for a better life, or at least escaping a worse one back home.

The Company undertook its first land-buying expedition in 1839, and in the same year potential settlers and their maid servants were sought in a poster circulated by the Company's Glasgow office. New Zealand still has a high proportion of Scottish descendants today, especially around Dunedin, the South Island's Edinburgh.

It was a similar story elsewhere. In South Australia, it was not Scots but Cornish men who emigrated to Port Adelaide, "a free colony where there are no convicts sent", according to one poster. It appealed for men with families, the bigger the better, suggesting that this was to be a permanent settlement. By 1865 more than 40% of South Australian migrants had come from south-west England, and the state's Yorke Peninsula was known as Little Cornwall.

Cornish men were sought because of their skills as miners in the county's tin mines, and posters stuck up locally were more likely to catch their

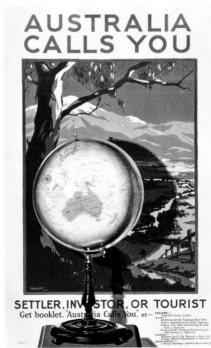

eye than small advertisements in newspapers which they were unlikely to read. A few well-placed posters had a better chance of recruiting the sort of men the advertisers were looking for.

There was renewed need in Britain's colonies for immigrant men and their families after the devastating losses of World War I. In the 1920s, Canada and Australia were both looking for boosts to their populations and to capitalize on the economic depression which had started to bite in Europe after the war. At the time, many men went on their own from Britain to Canada in the hope of improving their fortunes; and a 1929 poster encouraged them to make the move permanent by bringing their families over to join them. A 1926 Australian poster appealed to unemployed British miners just as earlier posters had been aimed specifically at Cornish tin miners.

As Britain struggled to reconstruct after World War II, Australia saw another opportunity to lure rationed, war-weary British citizens away with the promise of a better life Down Under. Australia was planning its own programme of reconstruction and needed the extra manpower that a new wave of immigration would bring. It originally hoped to attract some 70,000 people from Britain and Ireland in the years immediately after the war, but as one poster current between 1955 and 1960 proves, Australia was still short of its target even after rationing came to an end in 1954.

Circus Posters: Being for the Benefit of Mr. Kite

(1843)

Little did Pablo Fanque know when he stuck posters around the town of Rochdale, Lancashire, in 1843 that he was writing a Beatles classic. The poster announced "Positively the Last Night but Three!" of his travelling circus's visit to Rochdale, "Being for the Benefit of Mr. Kite".

During a break in the making of promotional films for the Beatles' "Strawberry Fields Forever" and "Penny Lane", John Lennon bought a copy of the poster from an antique dealer. The two songs were intended for inclusion on the album *Sgt. Pepper's Lonely Hearts Club Band*, but were omitted because of their release as a double A-side single in early 1967. While trying to write a new song for the album, Lennon's eyes fell on his new poster. As he read the inflated language of the playbill, the song "Being for the Benefit of Mr. Kite" all but wrote itself.

Circuses have not changed so very much since Roman times. They're still with us, and vaudeville, variety and Saturday night television all owe them a debt. There are, thank goodness, fewer deaths on-stage than in Roman amphitheatres, and fewer animal acts these days, although dog acts have won both *Britain's* and *America's Got Talent.*

The big difference between the Roman circus and Pablo Fanque's Circus Royal was that Mr. Fanque had to carry his arena with him. As a touring entertainment, circuses had to put a lot of effort into drumming up an audience in each town they visited. Their arrival in a new town was often announced with a loud parade of colourful wagons, performers and animals and prefaced by posters distributed in advance.

The poster for Mr. Kite's benefit performance is not an advance poster however; it was printed locally during the Circus Royal's run in Rochdale, which must have been successful for Fanque to afford a benefit for anyone but himself. Although Pablo's poster predates the golden age of full-colour lithography, he did what he could to make a splash by including large woodblock illustrations in his advertising.

Colour printing transformed circus advertising. With a colourful painting which filled the whole poster there was no end to the thrills which you could suggest your audience might expect. The poster played the same role as the entry parade – big, bright, brash. Large-scale colour printing came at a price, and to keep costs down circuses did not print different posters for each new venue. It was much cheaper instead to paste a separate black and white banner across the bottom of each poster with local dates and times. The same practice continues today.

And what of Mr. Kite? Circus was in William Kite's blood; his father had been a circus proprietor like Pablo Fanque. He would eventually be "late of Pablo Fanque's Fair" when two years later he quit the Circus Royal in favour of John Sanger's Circus. His daughter Elizabeth Ann Kite continued the family tradition by performing on horseback in the circus ring, and marrying Eugene, the son of another circus dynasty, the Gaertners. What a scene!

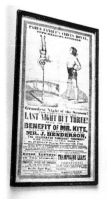

Vaccination Posters

(1851–1999)

As the world has rediscovered during the recent coronavirus pandemic, health matters may require urgent action. If you need to issue an alert, even in the television age, it can be quicker and more efficient to print posters and put them where those affected – or infected – can see them.

In the eighteenth century smallpox was the biggest cause of death in Europe, taking the lives of 400,000 people a year. Those it didn't kill were usually left blinded or disfigured. After Edward Jenner produced the first smallpox vaccine in 1796, the government wanted it to be used as widely as possible to bring the terrifying disease under control. Vaccinations were made free for the poor in 1840, and the government passed the Vaccination Act of 1853, which made immunization compulsory for infants in their first three months of life.

The nineteenth century was an era when the modern state was coming into being, and the vaccination issue provided a focus for anxieties about power, class and liberty, as well as the patronizing bearing of the Victorian medical establishment. Concerned parents feared putting their children through the procedure and other groups felt that mandatory vaccination was a violation of their personal autonomy. Others objected on religious grounds, or in the belief that vaccines were ineffective and based on bogus science. In 1885, 100,000 protesters marched through Leicester and beheaded an effigy of Edward Jenner.

As numbers of those taking up the vaccine fell, the government had to increase its efforts to persuade the population of its necessity. Fortunately, those efforts worked. From the 1930s onwards, the disease was virtually non-existent in the United Kingdom and smallpox was finally eradicated throughout the world in 1977.

In 1998 history repeated itself when physician Andrew Wakefield convinced large numbers of people of a link between the MMR (Measles, Mumps and Rubella) vaccine and autism. Wakefield had falsified his test results; his thesis was completely discredited and he was struck off the medical register in 2004. But public confidence in MMR and other vaccination programmes was seriously shaken.

Fearing the loss of the country's immunity to three childhood diseases, Tony Blair's government set aside millions of pounds to educate parents. As well as posting advice on the internet, it continued a conventional paper campaign of leaflets and posters which had been run since the introduction of the vaccine in 1988, urging parents to "give your child something you never had" – the triple vaccine. Despite the poster campaign, bogus stories have re-emerged on social media and the fact that the WHO have now withdrawn the UK's measles-free status shows how the disease can spread thanks to the vector of Twitter, Facebook and Instagram.

GIVE YOUR CHILD SOMETHING YOU NEVER HAD.

THE MMR VACCINATION.
(Measles, Mumps and Rubella)

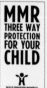

MMR
THREE WAY
PROTECTION
FOR YOUR
CHILD

OPPOSITE: A vaccination poster from 1851 pleading with parents to get their children immunized. In a time before scientific education, that reluctance might have been understandable; the need for the poster at left is not.

VACCINATION
PARISH OF LIVERPOOL.
SMALL POX

Having made its appearance in the Parish, and caused the deaths of several persons who had not been Vaccinated, the SELECT VESTRY, desire to urge upon Parents of Children, and all other Persons, the importance of Vaccination as the only security against this dreadful malady.

Vaccination, if properly performed, effectually protects the Child from Small Pox, or renders the attack comparatively harmless, and thus prevents the suffering and disfigurement which so generally result from the Disease, where Vaccination has been neglected.

To secure the benefits of Vaccination it should be performed and its progress watched by a Medical Man.

The following Medical Gentlemen have been appointed by the Select Vestry to attend as stated, for the purpose of Vaccinating, FREE OF CHARGE, all persons resident in the Parish who may apply.

Mr. A. B. STEELE,	5, Virgil-street	10 to 11 o'clock, a.m. daily
J. E. DONLEVY,	66, Bostock-street	10 to 11 o'clock, a.m. daily
GEO. GILL,	2, Soho-street	9 to 10 o'clock, a.m. daily
	19, Marybone	9 to 10 o'clock, a.m. daily
JOHN CALLAN,	137, Vauxhall-road	10 to 11 o'clock, a.m. daily
	9, Hunter-st.	10 to 11 o'clock, a.m. daily
HENRY EMETT,	4, Sawney Pope-st.	11 to 12 o'clock a.m. daily
	111, Dale-street,	9 to 10 o'clock a.m. daily
FREDERICK CRIPPS,	14, Eldon-place,	10 to 11 o'clock, a.m. daily
THOMAS NORRIS,	2, South Castle-st.	10 to 12 o'clock, a.m. daily
HENRY SWIFT,	75, Adlington-street,	9 to 11 o'clock, a.m. daily
	45, Islington	2 o'Clock p.m. every Tues. and Thurs.
HENRY BRADSHAW,	2-Court, Pembroke-pl	10 to 12 o'clock, a.m. daily
JAMES GARTHSIDE,	18, Parr-street,	9 to 11 o'clock, a.m. daily
	10, BackColquit-st.	10 to 12 o'clk. every Tuesday & Thursday
J. B. HYAMS,	155, Duke-street,	8 to 10 o'clock, a.m. every Monday, Wednesday and Friday
T. B. GILDERSLEEVES,	51, Great George-st	9 to 11 o'clock, a.m. daily

Every Child, even Infants a few days after birth, and every Person not already Vaccinated, should be Vaccinated without delay. To Expose or Carry About, at the risk of Infecting others, any Person having Small Pox, is punishable by Law.

It is the duty of all Persons, therefore, to give information at the Police Office, of any Person who may have been guilty of the offence, that effectual means may be taken for the protection of the Public.

AUGUSTUS CAMPBELL,
RECTOR OF LIVERPOOL, CHAIRMAN OF THE SELECT VESTRY.

R. H. FRASER, PRINTER, 13, CABLE STREET, LIVERPOOL

WANTED

JOHN HERBERT DILLINGER

On June 23, 1934, HOMER S. CUMMINGS, Attorney General of the United States, under the authority vested in him by an Act of Congress approved June 6, 1934, offered a reward of

$10,000.00

for the capture of John Herbert Dillinger or a reward of

$5,000.00

for information leading to the arrest of John Herbert Dillinger.

DESCRIPTION

Age, 32 years; Height, 5 feet 7-1/8 inches; Weight, 153 pounds; Build, medium; Hair, medium chestnut; Eyes, grey; Complexion, medium; Occupation, machinist; Marks and scars, 1/2 inch scar back left hand, scar middle upper lip, brown mole between eyebrows.

All claims to any of the aforesaid rewards and all questions and disputes that may arise as among claimants to the foregoing rewards shall be passed upon by the Attorney General and his decisions shall be final and conclusive. The right is reserved to divide and allocate portions of any of said rewards as between several claimants. No part of the aforesaid rewards shall be paid to any official or employee of the Department of Justice.

ABOVE: There were many different Wanted posters issued for the arrest of John Dillinger, with the reward money increasing from $10,000 to $15,000 and finally $20,000. After a tip-off, he was shot by police in an alley to the side of the Biograph Theatre in Chicago.

Pictorial Wanted Posters

(1865–1934)

One of the purposes of distributing Wanted posters with a picture of the fugitive is to put psychological pressure on the outlaw. It is hard to lie low with a high profile. But all this attention can also spur on those criminals who revel in their notoriety.

Having his mug shot on Wanted posters all over the United States did little to curtail the movements of the Depression-era gangster John Dillinger. On 22 July 1934, he fatally demonstrated the sort of Devil-may-care swagger he was becoming famous for by breaking cover to see a film. Dillinger was shot dead by Bureau of Investigations (BOI) officers who had been tipped off and were lying in wait outside Chicago's Biograph Theatre.

Over the course of the previous year, Dillinger and his gang had carried out multiple bank robberies, killed several people, including law officers, and broken out of jail more than once. His escapades made the authorities look incompetent. Perhaps more dangerously, some sections of the public saw him as a people's hero who was striking back at the banks, organizations they blamed for the Depression.

Dillinger enjoyed the infamy. He also enjoyed taunting J. Edgar Hoover, the Director of the BOI, to whom he sent a series of mocking postcards. Hoover was determined to get his man and designated Dillinger "Public Enemy Number One" a position previously held by Al Capone. Use of the "public enemy" term was a precursor of the FBI's Ten Most Wanted Fugitives list.

Dillinger became famous for his crime spree. As a successful stage actor, John Wilkes Booth was already famous on 14 April 1865, when he shot Abraham Lincoln at Ford's Theatre in Washington, D.C. Lincoln was the first American president to be assassinated and the

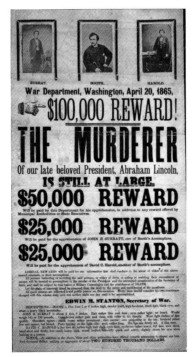

subsequent manhunt for Booth and his accomplices was swift. Booth was tracked down to a farm in Virginia. He resisted arrest and was shot dead on 26 April, twelve days after the assassination.

The broadside Wanted poster for Booth and the accomplices John Surrat and David Herold (the poster misspells his name) was issued by Lincoln's Secretary for War on 20 April, six days after their crime. It has many similarities to the tabloid newspapers which were becoming popular in America at the time. Just like a tabloid layout, the pictures are at the top of the page (glued on, in the days before photographs could be reproduced in print) while the headline screams "Murderer" in capital letters. Booth was a well-known actor and while using his image would have aided with identification, it also helped generate even more interest. This murder was not committed by a nobody. It was carried out by a celebrity.

The language used is sensational and underlines the human interest of the crime rather than the legal situation. The President is "beloved" while the crime has left a "stain of innocent blood" on the land. The punishment will be DEATH, again written in capital letters. Just as with tabloid newspapers, there is a moral element to this plea for "good citizens" to consider their "own conscience" in this "solemn duty". And as with the monetary prizes used to sell today's tabloids, the significant bounty on offer is mentioned prominently and repeatedly.

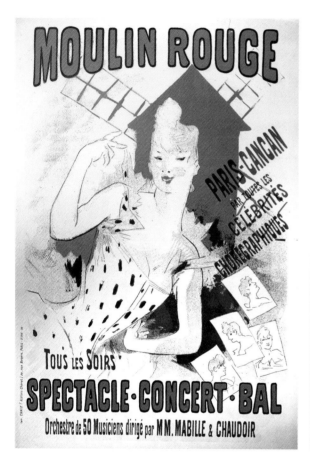
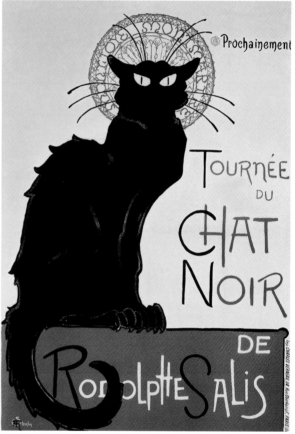

*ABOVE: The Moulin Rouge may have become the most famous Paris nightclub in
the Belle Époque, but it all started off at Le Chat Noir.*

French Litho posters

(1881–1890)

It is a satisfying coincidence that it was a playwright, the Bavarian Alois Senefelder, who invented lithographic printing at the end of the eighteenth century. A century later, the plays, theatres and music halls of Paris were being advertised on mass-produced posters made possible by advances in Senefelder's process.

Searching for a method to publicize his own plays cheaply, Senefelder developed a printing technique based on the fact that oil and water do not mix. Unlike previous processes such as intaglio or raised relief, Senefelder's method meant that an artist could draw directly onto a flat limestone or print plate using familiar pens or crayons. This did away with the need for more laborious etching with a chisel or needle and lent itself to more natural, fluid lines.

Godefroy Engelmann built on Senefelder's work in the 1830s and perfected sharp, accurate multi-colour printing using separate stones or print plates for each colour. Steam-powered presses and the invention of the offset lithographic press speeded up production and increased capacity while bringing down costs.

Parisian cafés were convivial locations for musicians, writers and performers to meet and share work. In such places of creative exchange, ideas grew and often found expression in inpromptu café-concerts of popular song.

Rodolphe Salis, leader of one group of artists, *l'école vibrante* (the Vibrant School), took such performances a stage further. In the Montmartre district in 1881 he launched Le Chat Noir, regarded by many as the first cabaret club. Salis took on the role of MC and entertained an avant-garde, enthusiastically hard-drinking crowd with a mix of satire, song, poetry and shadow plays. The latter appealed especially to the illustrators, printers and caricaturists who frequented Le Chat Noir: Henri de Toulouse-Lautrec, André Gill and Adolphe Willet were regulars.

Sometimes literary, often lewd and always stylish, the nightlife in Belle Époque Paris was arguably the most vibrant in Europe. The evocative poster art which promoted this bohemian scene also helped shape it. Willet introduced designer Théophile Alexandre Steinlen to the club and Steinlen began to design posters for the venue. His silhouette of a fierce-looking but dishevelled black cat is the perfect visual shorthand for the club's non-conformist spirit.

Music halls flourished in Paris and venues such as The Olympia, Folies Bergère and, of course, Le Moulin Rouge were larger and more commercially viable than Le Chat Noir but rather less respectable than the grander theatres and opera houses. The acts were as diverse as the crowds they brought in. A typical bill might include spectacular dance numbers, songs, acrobats and novelty acts such as Le Pétomane who would perform *La Marseillaise* by breaking wind in tune. On-stage nudity was not discouraged.

In less enlightened times, actresses and dancers who performed in theatres were seen as morally on a par with prostitutes. By contrast, lithographer Jules Chéret, who designed many posters for the Moulin Rouge, portrayed them as celebrities.

Chéret, sometimes called the father of the modern poster, brought empathy to his portrayal of the theatrical profession. He depicted strong independent women, women to be admired rather than looked down upon. The dancers in his posters gazed coolly back at the viewer, refusing to be labelled or shamed. Wearing brightly coloured and often revealing dresses, they owned their sexuality just as they owned the stages they performed on.

Women who copied the performers' daring dress style and their refusal to conform became known as Cherettes, and it was said that Paris would not be Paris without its Cherettes. Such was the impact of Chéret's posters.

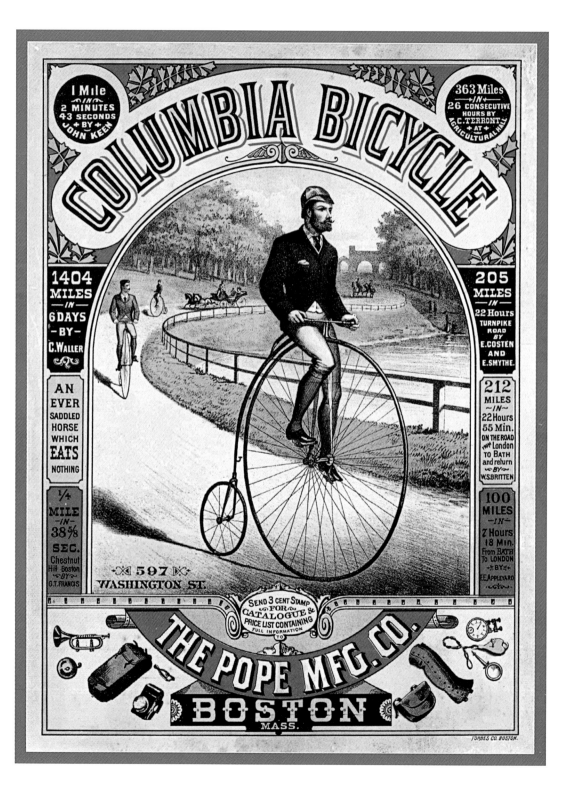

Columbia Bicycles

(1886)

Advertisers took advantage of the increased sophistication of printing processes to start advertising high-end consumer products in posters. The new Columbia High Wheeler bicycle was the Victorian equivalent of a motorbike.

Starting production in 1878, Pope's Columbia Bicycle Company of Massachusetts is credited with establishing the bicycling industry in America. Over the course of the nineteenth century in Europe, prototype bicycles had evolved from a sort of pedal-free, wheeled running contraption to the machine we recognize as the penny farthing.

The large front wheel was made practical by the invention of wire-spoke wheels and solid rubber tyres. Its outsize circumference allowed the rider to travel further and faster for each revolution of the pedals. As ever, young men were quick to seize any opportunity to speed.

Like all such bikes, Pope's High Wheeler was difficult to mount and easy to fall off. Going over the wheel was known as "doing a header". Of course, the potential jeopardy only endeared the bike more to daring young men and newly formed cycling clubs thrived. Very few women rode penny farthings. Lifting their skirts to mount the bicycle would be seen as unbecoming while straddling a bike seat was considered a threat to both their physical and moral wellbeing.

Manufactured in Boston, the High Wheeler was also exported to Britain where it got its nickname, derived from the fact that a British penny was much larger than a farthing coin (worth a quarter of a penny), just as the front wheel of the new bike design was much larger than the back. Among the boasts on an 1886 poster for the contraption is the time over one mile of John Keen, an English cyclist who was in the habit of racing against horses and almost always won. And so the poster also points out that the High Wheeler is "an ever-saddled horse which eats nothing", and pictures three bicycles and their smartly dressed riders speeding ahead of the horse-drawn vehicles in the background. The suggestion is clear: horses are in the past and, as Paul Newman said to his bicycle in the film *Butch Cassidy and the Sundance Kid*, "The future's all yours".

The craze for cycling took off in the last two decades of the century and other manufacturers entered the market, among them another Massachusetts firm, the Overman Wheel Company. The development of gears meant that one revolution of the pedals could drive several revolutions of the wheel. This removed the need for outsize wheels and in 1887 Overman was one of the first to produce the new "safety bicycles" with smaller, lower wheels, chain-driven gears and (later) pneumatic tyres.

Both Pope's and Overman's publicity was produced by the same Boston printing business, Forbes & Co, which had been an early adopter of the new lithographic printing process. Pope eventually followed Overman's lead, and both firms also moved into the early production of motorized vehicles. Columbia bicycles are still manufactured today.

OPPOSITE: *Before the advent of the automobile and the motorcycle, young bucks looking for speedy independent travel could buy a High Wheeler, thus making this poster the Victorian equivalent of a Harley-Davidson advert.*

Toulouse-Lautrec and Advertising

(1890–1896)

During the last decades of the nineteenth century in France, advances in printing coincided with the material boom and thriving art scene of the Belle Époque era. One of the results was the birth of the advertising poster as we understand it today.

More traditional artists were suspicious of this new technology and argued that mass-produced images could not be real art. In fin-de-siècle Paris, where the distinction between artists and advertising designers was rapidly becoming blurred, less established members of the creative community were quick to realize the benefits of lithography.

The Art Nouveau movement was firmly established by 1890 and its organic, curvilinear designs promoted everything from biscuits to plays starring big names such as Sarah Bernhardt. Many artists made their names through advertising commissions, which spread their work further than any single painting in an exhibition could. Among them, Henri de Toulouse-Lautrec, Alphonse Mucha, Théophile-Alexandre Steinlen and Jules Chéret helped influenced the direction of Art Nouveau.

Toulouse-Lautrec was, like Chéret, commissioned to produce posters for Le Moulin Rouge. His depiction of famous dancers such as Jane Avril and La Goulue, creator of the Can-Can, did much to cement the reputation of Le Moulin Rouge and all Paris for sexual liberation and racy entertainment. If he and Chéret achieved lasting fame with their theatrical posters, they made their money from commercial advertising.

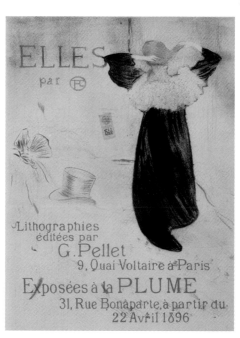

Inspired by Japanese woodblock prints, Henri de Toulouse-Lautrec mastered lithography's ability to create vivid and contrasting colours. His 1894 advertising poster for a brand of confetti contrasts the shock orange of the woman's hair with her black gloves and the white of her dress. The image also makes evocative use of crachis, a technique in which the confetti is represented by little spatters of colour flying from the cropped hands at the top left. While the confetti showers down, the woman appears to be floating up. This is an image filled with movement.

Toulouse-Lautrec also produced a poster for *Elles*, an 1896 exhibition of pictures inspired by the artist's fascination with Parisian brothels and the women who worked in them. The poster (left) shows a woman unfastening her hair for an unseen client. His top hat is in the foreground while her blue hat is on the bed, implying a risqué relationship. The sweep of the woman's hair and the wave of her hands are reflected in the graceful lines of her blue robe. The overall effect is intimate, feminine but not erotic. The mood is melancholy, an emotion that Toulouse-Lautrec knew well and could express convincingly through lithography.

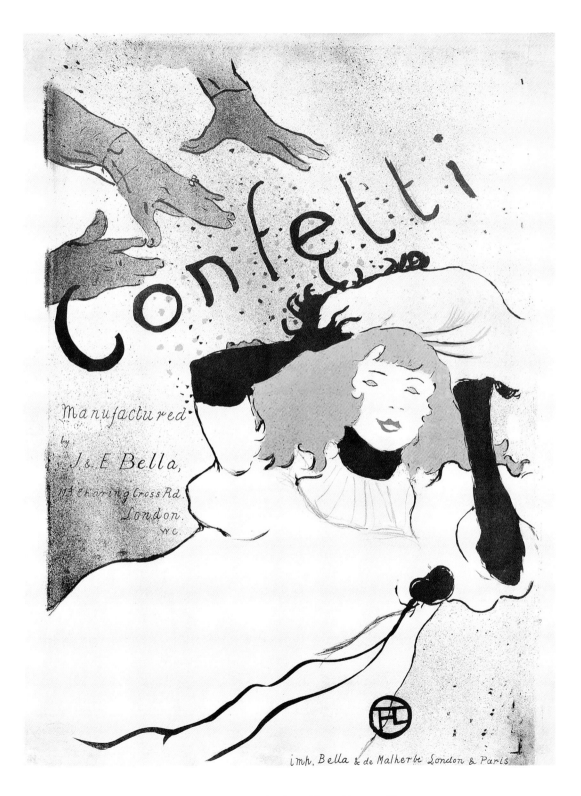

Imre Kiralfy's Spectacles

(1892)

Nineteenth-century travelling showmen tried to outdo each other for spectacular performances. Buffalo Bill re-enacted Indian attacks; Barnum and Bailey staged the entire Sudanese War. The forgotten Kiralfy brothers, Imre and Bolossy, recreated complete ancient cities on land and sea.

The story of the Kiralfy brothers would make an epic drama in itself. They were born Imre and Bolossy Königsbaum in Pest (now Budapest) and their father's participation in the failed Hungarian Revolution of 1848 made him a wanted man. He was ruined, and to make a little money the sons began to dance at circuses under the name Kiralfy. Eventually joined by their brother and sisters the Kiralfy Family toured Europe making a name for themselves. On a visit to Paris they were captivated by the sophistication and spectacle of French theatre and trained for a while with France's National Opera Ballet Company.

In 1869 the Kiralfy Troupe moved its operation to America. Soon their Parisian choreography skills led to an opportunity to direct a production for the stage. They added musical numbers with huge chorus lines of dancing girls in revealing new costumes to a proven hit, the early musical *The Black Crook*. The additions and some thrilling special effects created the Kiralfys' reputation for spectacular, classy staging.

They followed up with *The Deluge*, an interpretation of the biblical flood which featured real rain; and *Around the World in Eighty Days* in which they staged a sinking ship and a rising helium balloon (having convinced Jules Verne to add it to the storyline). Their production of *Excelsior* was not the first to use the new electric lighting, but it was the only one directed by the inventor himself, Thomas Edison.

The brothers' last production together was 1886's *The Fall of Babylon*, an ambitious staging of the clash of ancient civilizations which they presented at showgrounds all over America, complete with Babylonian defensive walls which opened up to reveal a city square full of dancers. The spectacle is said to have been the inspiration for D. W. Griffiths' epic silent movies, notably *Judith of Bethulia* and *Intolerance*. Griffiths lived near one of the venues for the show. *Babylon* later

became one of the attractions of the Barnum and Bailey Circus.

The Kiralfys had already presented productions in London's Olympia Hall (opened in 1886) when Imre was invited to mount an exhibition with a Venetian theme there. The venue was ideal, having been designed in an Italianate style. It was the largest in the country at the time with extensive grounds in which to build scenery and water features for the event.

The result was the "grand aquatic pageant" *Venice: the Bride of the Sea* which ran throughout 1892, complete with canals, boats and one hundred gondolas specially imported, from Venice of course. Nearly five million people came to see it in the course of the year. London took Imre Kiralfy to its heart. He returned in 1895, this time to Olympia's nearby rival Earl's Court, to stage the grand *Empire of India Exhibition* with Indian landscapes, an Empress Hall and a giant Ferris Wheel which could carry 1,200 passengers at a time. In 1901 he became a naturalized British citizen.

Although we don't remember the Kiralfy name today, his productions displayed a level of technical ambition which forever changed the way in which large-scale events are staged both indoors and out.

OPPOSITE: By the time that Imre Kiralfy put on the Venice-in-London spectacle in 1892 he was well-versed in producing extravaganzas. It was actually the brainchild of caterer Joseph Lyons, but Kiralfy was brought in because of his experience at mounting large productions. For the Venice event he imported 100 gondolas and gondoliers from Italy. Almost five million visited during its one-year run.

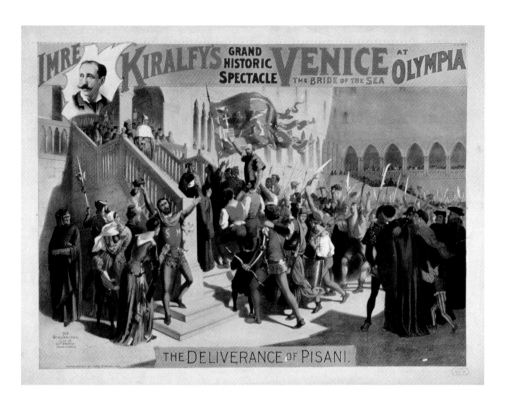

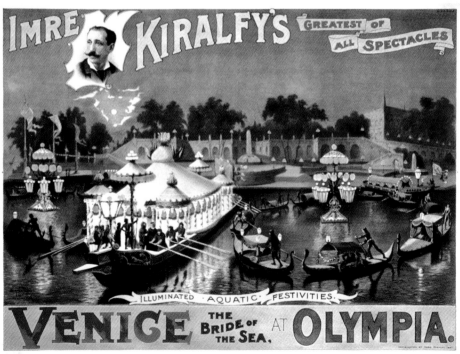

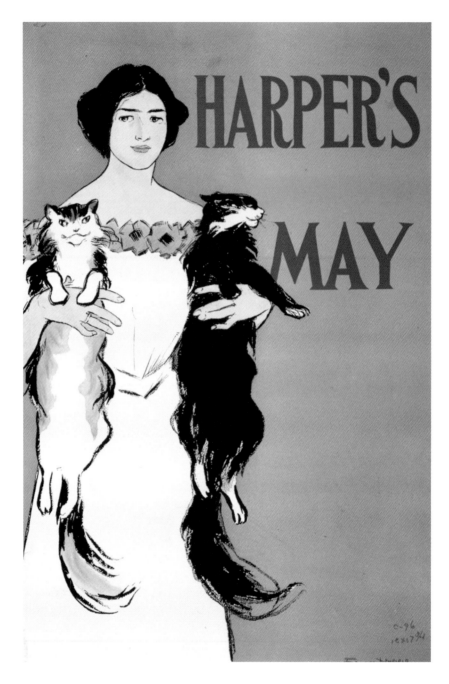

ABOVE: Penfield was at the height of his powers when he drew this poster/cover for
Harper's *magazine in 1896.*
OPPOSITE: Two different commissions from the artist's varied portfolio: a
University of Pennsylvania poster from 1908 and an American Lithographic
Company poster supporting the war effort in 1918.

Edward Penfield: *Harper's*

(1893)

One man is credited with single-handedly inventing the modern American poster. While Mucha and Toulouse-Lautrec were revolutionizing the medium in Europe, Edward Penfield developed an eye-catching style in the US which many imitated but none could match.

Penfield studied art in the 1880s at the Art Students League in New York, where his tutor was a portrait artist called George de Forest Brush. Brush portrayed his subjects in photographic detail while omitting any detail from the background, a lesson in focusing the eye of the viewer that Penfield applied to his graphic art, with detailed foregrounds and minimal surroundings to distract from them.

His work caught the attention of the art director at *Harper's* magazine, an American publication of sophisticated culture and commentary for the discerning reader. Throughout the 1890s Edward Penfield's posters for the monthly editions of the magazine defined the illustrative arts of the period. His cartoon-like images were bold, clear line drawings with a simplified palette of colours. The backgrounds were mere sketches, allowing the principal subjects to stand out.

Like Toulouse-Lautrec, an acknowledged influence, he drew his own lettering rather than relying on a printer's typeface; and like the Japanese prints which inspired Toulouse-Lautrec and Vincent van Gogh, he favoured atmosphere over verisimilitude. The result was a look all his own. He rose to become *Harper's* art director himself, and when he left the magazine in 1901, a lucrative career in advertising posters awaited him.

Freelance commissions also followed. Assignments to the Netherlands and to Spain resulted in two books, *Holland Sketches* (1907) and *Spanish Sketches* (1911). He also drew a series of posters of sportsmen from the Ivy League universities, emphasizing the physique of runners, throwers, rowers and pitchers among others.

With the involvement of America in World War I, Penfield rendered his services to the government. A doughboy, originally a sort of dumpling, was the disparaging nickname for an American infantryman, and his *The Doughboys Make Good* poster was an effective morale booster. At home, in the wake of President Wilson's declaration that "food will win the war", Penfield was one of several artists who designed posters encouraging the use of private land for food production. The School Garden Army that he advertised was organized by the Bureau of Education but funded by the War Department.

Edward Penfield died in 1925 from complications after a fall. Almost all his work from April 1896 onwards carries a distinctive logo, something else which was inspired by Toulouse-Lautrec. Lautrec's work carries a monogram of his initials, while Penfield's designs all contain a stylized image of a bull.

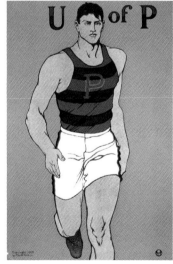

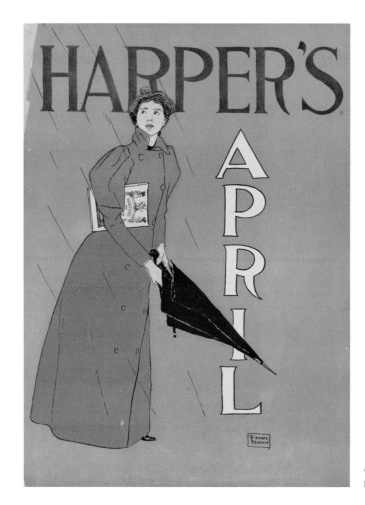

LEFT: Penfield's cover for Harper's *in April 1894.*

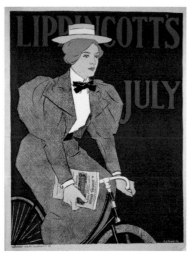

LEFT: Lippincott's *was a literary magazine, famous today for publishing the Sherlock Holmes adventure* The Sign of Four *in instalments, and Oscar Wilde's novel* The Picture of Dorian Gray. *It had a standard cover format listing the contents beneath a red title banner, without illustration; but it promoted its monthly editions with lavish full-colour posters of people (usually women) engaged in various activities and clutching a copy of the familiar red-bannered magazine. Many* Lippincott's *posters were by Will Carqueville or J. J. Gould. Gould adopted Penfield's approach, showing thoughtful, determined young women against plain backgrounds.*

US Magazine Posters
(1893)

Posters advertising the explosion of American magazines produced in the Gilded Age became collectors' items, almost from the moment they were placed in shop windows ...

A number of developments contributed to a boom in magazines after the Civil War: cheaper pulp paper production; the expansion of the railway network; and the invention of halftone printing in the 1880s. They resulted in lower production costs, access to a greater and wider readership, and the possibility of full colour, either on the cover or in a poster.

Edward Penfield, whose later designs for the American advertising industry transformed the genre, cut his teeth drawing monthly posters for *Harper's* magazine. His first, for the April 1893 edition, is regarded as Poster Zero for the ensuing explosion of American magazine poster art. His trademark style, a bold foreground figure and little or no background detail, was perfect for a medium which had only a short opportunity to arrest the potential reader.

Magazines brought art into the American home. Their posters were disposable, designed to be placed in a newsagent's window only for the month-long life of the current issue – hence no year dates in any of Penfield's *Harper's* images, for example. But their impact on the public was so great that almost from that 1893 debut the posters became collectable – one collector had by 1896 amassed some 1500 examples. Many magazine posters have been lost over the decades, but New York's Metropolitan Museum of Art recognizes their social and cultural importance by maintaining a collection of nearly 300 of the best surviving designs.

The boom created a greater demand for artists and many found they could make a better living with this "commercial" art than the "fine" art to which they aspired. There were different requirements of course – a magazine's advertisement needed to embody not some artistic truth or realism but the promise of excitement and interest within; but what they were advertising was not so much materialistic as cultural. Unusually for advertising, artists and even printers were allowed to sign their work.

BELOW: Maxfield Parrish designed covers for both Harper's *and* Scribner's Monthly, *as well as* Scribner's *successor when the title was sold,* The Century. *Parrish later clinched an exclusive contract with* Collier's *magazine before launching a very successful career in advertising posters. In 1910, when a new house might cost $2,000, he was earning $100,000 a year. Norman Rockwell, who began his own career creating covers for the* Saturday Evening Post, *regarded Parrish as his idol. When Parrish turned his back on illustration to concentrate on painting, he became one of the American public's three favourite artists, alongside Paul Cézanne and Vincent van Gogh. His trademark shade of vibrant indigo was known as Parrish blue.*

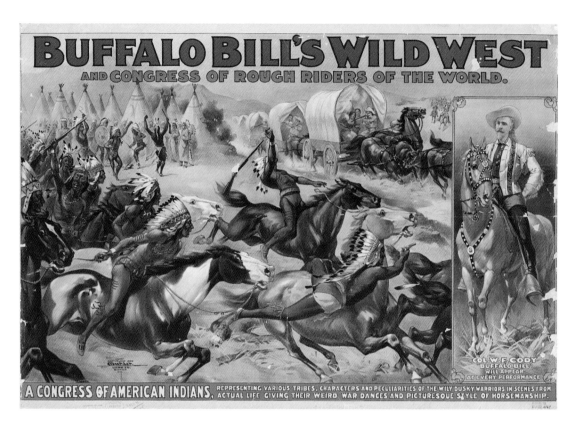

ABOVE AND OPPOSITE: Buffalo Bill's Wild West Show went down a storm in Victorian Britain, playing 300 shows in London and selling two and a half million tickets. A delighted Queen Victoria invited Europe's royalty to see the show in a Royal Command Performance in 1887. At the 1893 Chicago World's Fair he changed the name to Buffalo Bill's Wild West and Congress of Rough Riders of the World.

Buffalo Bill Posters

(1893–1903)

Although *Buffalo Bill's Wild West* was not the first cowboy show in the US, it was by far the most famous. It did more than any other to create and preserve the myths and legends of a disappearing tradition.

William Frederick Cody spent his whole life in the saddle. He got his nickname during a season of shooting buffalo to feed the men working on the Kansas Pacific Railroad. Long before he had any thoughts of showbiz, William Cody became famous in a series of books about his exploits as a scout and rough rider, written by journalist and publisher Ned Buntline. Buntline had gone to Nebraska to interview Cody's friend Wild Bill Hickok. But Hickok pulled a gun on him, so Buntline thought it wiser to speak to acquaintances of Hickok instead. When he met Cody, Buntline knew that he had found the central character for his stories. Buntline also wrote Wild West plays in which both Cody and Hickok appeared.

On one occasion on stage, Hickok again drew his gun, this time to shoot out a spotlight which had turned on him. But the theatre gave Buffalo Bill a taste for the limelight. In 1874 he formed *The Buffalo Bill Combination*, which featured a re-enactment of his alleged scalping of an Indian. In 1883 he set up a cowboy circus, *Buffalo Bill's Wild West*, and became a household name travelling all over America and, on eight separate tours, Europe.

By 1893 the show's title had changed to *Buffalo Bill's Wild West and the Rough Riders of the World* and featured horsemen of many nations performing dramatized routines for the paying public. A series of posters depicting lariat-spinning Mexicans, sabre-wielding Sudanese, bolas-throwing gauchos and acrobatic Cossacks may well have been printed to sell as souvenirs since there is no space to overprint with date or venue.

They were produced from 1896 onwards by the Currier & Ives Lithograph Company of New York, which otherwise specialized in prints of American scenes for home decoration. The firm were recommended by the arbiters of domestic taste of the age, Catharine Esther Beecher and Harriet

Beecher Stowe, in their book *American Woman's Home* (1869). Each print was hand-coloured.

As well as the international contributors, *Buffalo Bill's Wild West* featured some home-grown American stars. Annie Oakley was one of the regular guests to appear as a sharp-shooter; and Calamity Jane, an old friend of Hickok's, appeared late in her life as a teller of tales about the Old West. Given Cody's reputation as an Indian fighter, it is a little surprising that Chief Sitting Bull was also part of the *Wild West*'s company.

Less well remembered today is Pawnee Bill, so called to distinguish him from the principal Bill of the show. Gordon William Lillie worked briefly as the *Wild West*'s interpreter for its Pawnee cast members, before setting out on his own in 1888 with *Pawnee Bill's Historical Wild West Indian Museum and Encampment Show*. In 1903 one of his attractions was an albino buffalo and his show was approaching Buffalo Bill's in scale. But within a few years public interest in the Wild West was beginning to fade. In 1908 Cody and Lillie combined their acts as The Two Bills in an effort to keep going. But the tour lost money and fizzled out in Denver, Colorado, a sad finale for a great showman.

Alphonse Mucha: Sarah Bernhardt
(1894)

The posters of Alphonse Mucha (1860–1939) are the very essence of Art Nouveau. They have it all: decorative brilliance; flowing, natural botanical forms; allegorical, idealized femininity; sensuality, tipping towards decadence; a suggestion of mysticism; even a peacock or two.

Paris in the early 1890s was the place to be, and Mucha, an émigré Czech nationalist, was drawn to it. When his patron cut off his allowance, he was helped out by the city's exiled Slav community. Fellow Czech painter Ludek Marold was making a living doing magazine illustrations, so Mucha thought he'd try his hand at it. He proved to be quite good at it and began to get work in book illustration and then posters.

Towards the end of 1894 actress Sarah Bernhardt needed a poster in a hurry, to announce the extended run of her play *Gismonda* at Théâtre de la Renaissance. All of her regular artists being unavailable over Christmas, she turned to Mucha. The resulting *affiche* (poster) was sensational. It showed Bernhardt in an ornately patterned dress beneath exquisite lettering on a background of mosaics. Legend has it that by lunchtime on New Year's Day 1895, every copy had been torn from the walls and taken home. Bernhardt was delighted, and awarded Mucha a six-year contract. She always made sure to set aside part of the print-run of each new poster for collectors.

His Bernhardt posters – indeed, virtually everything he produced from this point on – are sumptuous, almost indecently pleasing to the eye. Informed by Baroque churches, Byzantine icons and the folk art of his native Moravia, they balance spaciousness with detail, and contrast precise geometric shapes with luxuriously flowing forms. Discreet at this stage, the Kabbalistic and occultist influences which would become more prominent in his later work are already apparent.

Other commissions followed, most notably from Moët & Chandon, Nestlé and Job cigarette papers, but there were a host more, for products as diverse as biscuits and bicycles. Having become a hugely successful commercial artist, Mucha experimented with mass-produced posters which advertised no product but were intended purely for decoration.

These works drew him into the world of fine art and allowed him to leave commercial work behind to devote himself to historical paintings, on a large scale and usually on a Czech nationalist theme. At the age of 43, he returned to Moravia and set to work on a series of twenty monumental canvases called "The Slav Epic". And they truly are epic: grand, evocative, richly symbolic and often powerfully moving. Although, to his frustration, the series never resonated with the public in quite the same way as his old posters selling booze, theatre tickets and roll-ups, Mucha considered The Slav Epic his greatest achievement.

ABOVE: Mucha's poster for Job cigarette papers was inspired by Michelangelo's Sybils *in the Sistine Chapel.*
OPPOSITE: Sarah Bernhardt bought the Théâtre de la Renaissance in 1893 and for six years became both its leading actress and artistic director. Alphonse Mucha was her poster designer.

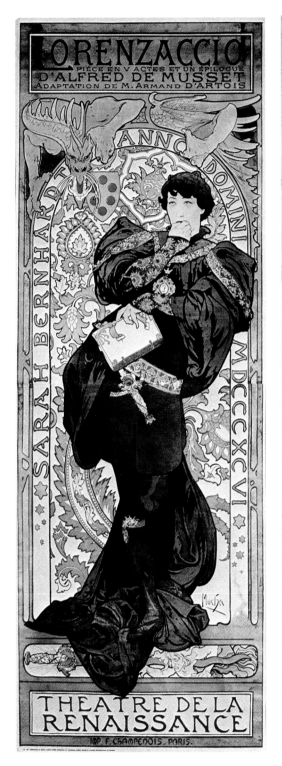

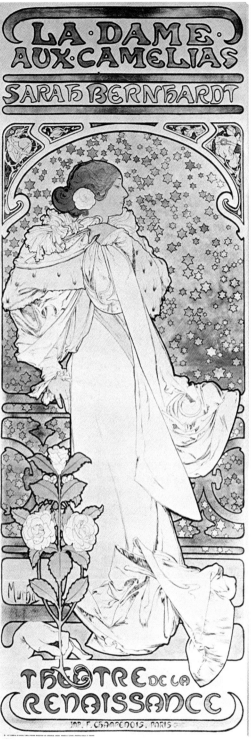

Barnum and Bailey Posters

(1895)

The Greatest Show On Earth! The strap line is synonymous with the Barnum and Bailey Circus, which in various guises toured its enormous caravan of delights across America and Europe for 146 years. Promotional posters helped show the sheer scale of the entertainment in store.

As a child, P. T. Barnum worked in the ticket booth for Hachaliah Bailey, one of America's earliest circus impresarios. In adulthood he ran a museum of curiosities in New York, to which over the years he added animals and a freak show. He periodically took some of the exhibits out on the road. But after the museum burned down twice in the space of three years he quit the museum business.

However, he had already made a name for himself, and in 1871 at the age of 61 he was persuaded to lend that name to a Wisconsin travelling circus which restyled itself as P. T. Barnum's Great Traveling Museum, Menagerie, Caravan, and Hippodrome. Barnum's showbiz know-how propelled the circus to success.

Its one serious competitor was the Cooper and Bailey Circus, established in the 1860s. James Bailey was an adopted nephew of Barnum's former employer Hachaliah; and in 1881, rather than compete, Barnum suggested a merger which really would make their combined attractions the Greatest Show on Earth. It was far, far more than a mere circus ring. The Big Top was just that, the biggest top of twelve containing all manner of sideshows, zoos and other wonders. At its peak it took four trains to move it from town to town.

In 1895 they devised a new show, the Grand Water Circus, which took place in and around a flooded circus ring. A variety of posters were produced for its extended run at the Coney Island Pleasure Beach that summer. If they are to be believed there were high dives, athletic swimmers, water football and water boxing, parachute drops, floating bicycles with paddle wheels and a great many scantily clad young women presumably offering the nineteenth-century equivalent of a wet T-shirt show. Clowns took to the water in half-barrels, with plenty of opportunities for slapstick.

Circus posters were rarely works of fine art. Their aim was to indicate the sheer volume and variety of entertainment on offer. The chaotic scenes in Barnum and Bailey's Coney Island Water Carnival amply fulfil that brief. Two years later they packed up the whole circus and shipped it to Europe for a five-year-long tour. In their absence from America the Ringling Circus moved in on Barnum and Bailey's strongholds on the East Coast. When the Greatest Show on Earth returned to the US, it found itself facing stiff competition from Ringling. Barnum had died in 1891, but at the age of 57 James Bailey fought back by taking his circus west, beyond the Rockies for the first time, in 1905. But life on the road is a young man's game. Bailey died in 1906 and his widow sold up to the seven Ringling brothers. Still, the show must go on; and as "Ringling Brothers and Barnum and Bailey – the Greatest Show on Earth" it did, before finally giving its last performance in 2017.

OPPOSITE TOP: *Apart from depicting the huge variety of acts on the bill, the poster for the Coney Island Water Carnival also features the 150-foot Elephantine Colossus, a hotel and observation platform that was a Coney Island landmark till it burned down.*

RIGHT: *An 1899 poster from the French leg of a European tour. It features the 12 "pavilions" of entertainment which were transported by up to four trains between each venue.*

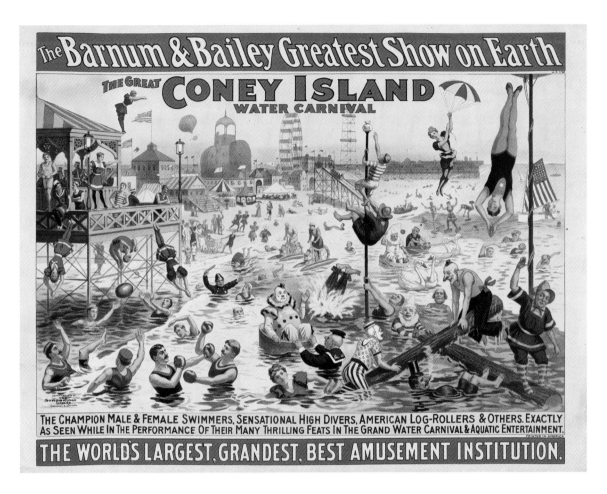

Film: Lumière Brothers
(1896)

Today's film posters often feature the digitally enhanced complexion of a globally famous star posing moodily against a backdrop of million-dollar CGI effects. In the late nineteenth century the pioneers of film publicity took a simpler approach.

The world's first ever fiction film was *L'Arroseur Arrosé* ("The Sprinkler Sprinkled"), part of a collection of short films by Auguste and Louis Lumière. The 49-second slapstick short was shot on the brothers' newly developed Cinématographe, an innovative device that could both record and, crucially, project film onto a screen which an entire audience could see. This was a step change from earlier devices which showed moving images via a one-person peephole. This was cinema for the masses.

The Lumière brothers unveiled their invention to the public at the Grand Café in Paris in late December 1895. *L'Arroseur Arrosé* was among the films shown alongside a selection of documentary-style clips showing street scenes, a baby crying and a train arriving at a station.

The initial screening was not exactly a rip-roaring success. Fewer than thirty people turned up for the world's first-ever public film show. Moreover, their reaction to one of the key moments in the birth of cinema was not universally positive. One eyewitness recorded that the films were met with shock, suspicion and even a shriek of terror from one lady. There were mutterings about trickery, magic and even sorcery.

Despite this challenging debut, subsequent press reports intrigued the public and, by the start of January 1896, thousands of Parisians were happy to pay one franc each to witness the Lumière brothers' new art form. Keen to build on this profitable popularity, the brothers commissioned two publicity posters which have earned their place in cinematic history.

In 1896, the lithographer Henri Brispot created a poster for Cinématographe Lumière which shows a crowd of fashionably dressed, Belle Époque movers and shakers jostling to get into the Grand Café screening. Hats are being knocked off, walking sticks brandished, and a gendarme appears to be turning away one would-be audience member. Actual attendees of the first screening, all twenty or so of them, would have struggled to recall such mob-handed enthusiasm. Brispot may have been one of the first people to recognize that cinema's appeal often rested on a carefully augmented version of reality.

Just as innovative, not to mention subtly persuasive, was another poster, by Marcellin Auzolle, which showed a raucous audience laughing at the man being squirted in the face by a garden hose in *L'Arroseur Arrosé*. Previous film posters boasted of the scientific wonders of this emerging technology rather than boosting the films themselves. Auzolle's poster was the first created for a specific film and the first to show the audience watching a scene from the film itself. It enabled potential customers to imagine themselves enjoying the film.

The posters certainly helped popularize this new-fangled cinema. Within a year, Lumière cinemas were welcoming customers in London, Brussels and New York City. Their role in movie history is secure, and when one of Brispot's original Cinématographe Lumière posters came up at auction in 2018, it sold for £160,000.

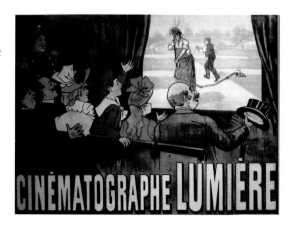

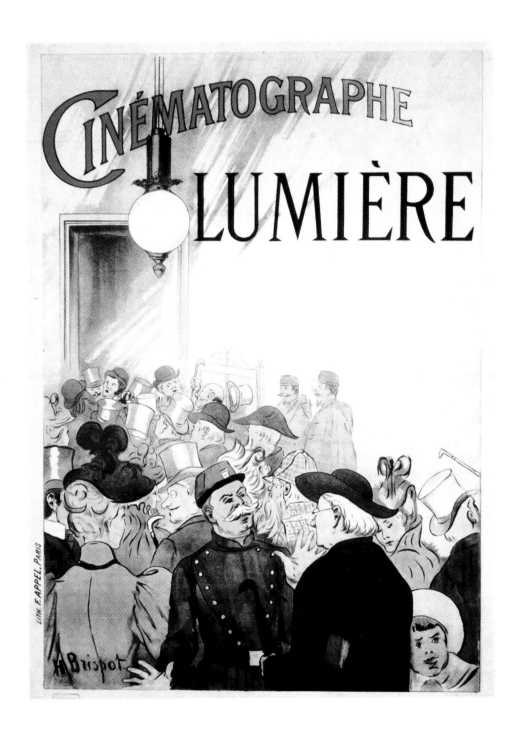

ABOVE: For cinema pioneers the Lumière brothers, the medium was more important than the movie.

ABOVE AND RIGHT: Three of Leonotto Cappiello's best-known advertising posters including the vaguely sinister one for Absinthe Pernot.
OPPOSITE: Henri Privat-Livemont's classic Art Nouveau poster for Absinthe Robette.

Belle Époque Advertising
(1896–1905)

Thanks to improvements in lithography, colourful posters could be produced cheaply and quickly. Advertisers covered street hoardings with radiant "affiches" and streets became galleries of cutting-edge visual culture, delighting fashion-conscious Parisians.

Paris at the end of the nineteenth century was booming. Until the outbreak of World War I, the French capital enjoyed nearly fifty years of relative peace and economic security. People had money in their pockets and innovative poster design was driven by the battle between brands to attract customers for an ever-expanding range of consumer goods and leisure pursuits from absinthe and cigarette papers to nights on the town.

Art Nouveau designers such as Henri Privat-Livemont made the most of lithography's capacity to reproduce delicate flowing lines and rich colours that could be graded to suggest dawning light or dissipating smoke. His sumptuous 1896 poster for Absinthe Robette encapsulates many of the characteristics of Art Nouveau style while effectively advertising the alleged psychoactive properties of the drink. Absinthe, nicknamed *la fée verte* ("the green fairy"), was something of a muse for the bohemians of Paris.

Jean Chéret's work for manufacturers, consumer brands and even railroad companies secured not only his fortune but the prestige of a Légion d'Honneur. But if Chéret fathered the modern poster, Leonetto Cappiello, an Italian who lived in Paris, may be said to have sired modern advertising technique. His first poster, created for *Le Frou Frou* magazine in 1899, still leaps from the page with its bold design and startling use of colour. It also marks an evolution from the more flowing, naturalistic Art Nouveau style.

Cappiello had no formal art training but knew how to use art to sell even the most mundane product. His 1900 design for Amandines de Provence focuses more on the attractive, fashionably dressed woman in the yellow dress than the actual product. This is persuasion by association. The yellow of the lettering and the dress pop against the dark blue background while the lace bow on her chest seems to be unravelling in ecstasy with

every mouthful of the biscuit.

To the modern eye his poster for J. Édouard Pernot's absinthe looks rather creepy. Is the older gent trying to get the younger woman drunk? It might be too much to imagine that Cappiello saw absinthe as the rohypnol of the Rive Gauche; but there is a suggestive element of menace to the poster.

Social attitudes change but "affiches artistiques" remain as sought after now as they were when they were first pasted up. Then, as now, the public would take the most attractive posters from the street to decorate their homes; and originals fetch high prices today.

Michelin Man

(1898)

The Michelin Man is among the earliest product mascots to be used in advertising, and is still going strong today. He has changed both diet and appearance with the times, having lost a lot of weight since his debut more than 120 years ago.

Today the jovial-looking Michelin Man is a slim, dynamic tyre brand ambassador whose only aim in life is to help motorists drive safely and economically. How things change. For much of his early life, one of his nicknames was the Road Drunkard and he looked like a menacing, cigar-chomping, Egyptian mummy who crushed commercial competitors under his tread.

The Michelin Man started life as a twinkle in the eyes of Édouard and André Michelin in 1894. Staring at a pile of their own tyres, Édouard noted that, with the addition of arms and legs, it would resemble a man. This simple observation formed the basis of the first Michelin Man poster designed by a cartoonist who went by the name of O'Galop – real name Marius Rossillon. Rossillon showed the Michelin brothers a design which had recently been rejected by a German brewery and the brothers asked him to adapt it for their Michelin Man.

The poster shows the pneumatic character proposing a toast while worried-looking caricatures of his tyre-manufacturing competitors cower on either side, beneath a Latin headline which Rossillon retained from his beer poster: "Nunc est Bibendum" ("Now is the time to drink"). The Michelin Man, or Bibendum to use his Sunday name, raises a glass full of nails and broken glass, and below him is the poster's laboured strap line "Le pneu Michelin boit l'obstacle" ("the Michelin tyre drinks obstacles").

The early Bibendum could be a belligerent and even exaggeratedly patriotic character. Subsequent posters showed him as a kickboxer, a knight out to conquer new territories, and a gladiator with his foot on the throat of a battered and bleeding commercial rival. Other marketing initiatives depicted him as a ladies' man who scoffed at the failures of other suitors.

He was also unashamedly elitist. Nowadays, the giants of Silicon Valley dress down in chinos and hoodies. Often pictured with a fat cigar, Bibendum's prosperously rotund figure and fashionable pince-nez identified him as a man of wealth. Early motoring enthusiasts had to be rich to afford their vehicles and Bibendum reflected his clientele.

As car ownership became more common and society changed, Bibendum moved with the times. Over the course of the twentieth century, focus moved away from the Michelin Man crushing his competitors towards him helping out ordinary families. In one later poster, he donates a tyre from his own midriff to a father replacing a damaged car wheel. The suitably grateful mother and children look on.

Bib gave up alcohol in the 1920s and stubbed out his last Havana during a tuberculosis outbreak in 1929. By the 1950s, his health kick had extended to taking up running and by 1998 he looked distinctly slimmer than he had a hundred years previously.

As well as reflecting changing attitudes to obesity, his trimmer outline is supposed to represent modern, low-profile tyres. Bibendum's tyres may be skinnier but they remain as white as when he was born. Tyres only became black from 1912 when carbon was added to the rubber mix.

ABOVE: Wide distribution of posters featuring Monsieur Bibendum in France helped establish the brand.

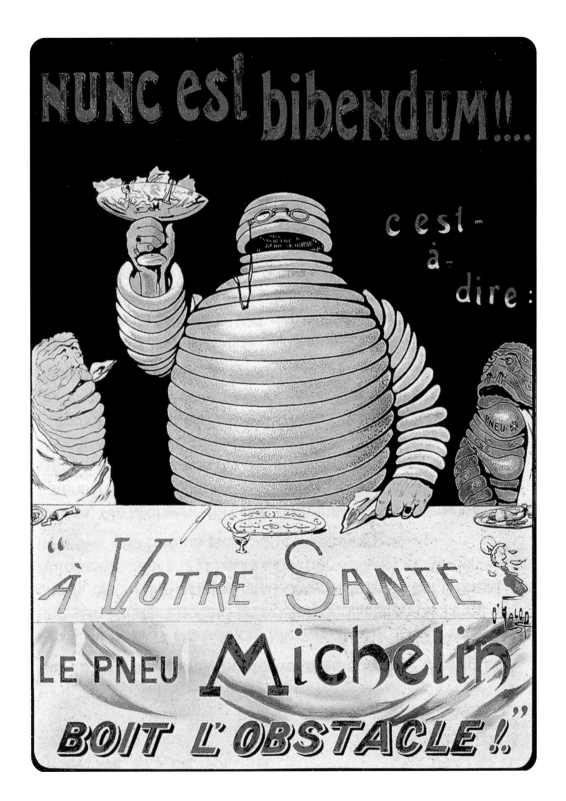

Magicians' Touring Shows

(1900–1920)

The Golden Age of Magic ran from the 1880s until the 1930s and the great showmen of the day dazzled their audiences with levitating princesses, voices from beyond the grave and beautiful women being sawn in half. The posters promoting the shows developed their own style.

Magicians who had honed their craft on the vaudeville circuit struck out on tour with their own shows, travelling from town to town in search of audiences. The posters' job was to draw in the paying public with promises of mysterious powers, exotic tricks and a sulphurous whiff of the supernatural. Could Harry Kellar really summon spirits that would play musical instruments in his locked "perplexing cabinet"? Cough up a dollar and see for yourself.

Kellar, known as the Dean of American Magicians, was the most successful illusionist of his time. Houdini cited him as a major influence. As was common practice then, when he retired in 1908 Kellar sold his show, complete with illusions, to another magician. His successor, Howard Thurston, known as the King of Cards, achieved even greater fame.

Kellar had been one of the first magicians to use little devils or imps on his posters; a practice which Thurston continued. Alluding to the story of Faust, the implication was that the magicians had sold their souls in return for arcane, mystical powers.

The shows were quick to tap into the zeitgeist. In a period when car ownership was still very aspirational but becoming more widespread, Thurston would make a car vanish. Magicians would also make unlikely things appear. The idea that the living could communicate with the dead was fascinating for many Europeans and Americans at this time. Unscrupulous charlatans posing as mediums used trickery to con the gullible and the bereaved; and elements of spiritualism featured in many a magician's act. "Do the spirits come back?" asked one of Thurston's posters while simultaneously showing the magician conjuring a suspiciously nubile apparition from a skull.

In a time when western explorers were discovering new lands and cultures, magicians reflected the public's interest in the Middle East, the Far East, Africa and indeed anywhere else that might be considered exotic. The poster for Brush the Mystic advertises the "Hindu Basket", an illusion in which the magician's assistant climbs into a basket which is then run through with several swords. Miraculously, the assistant would pop out of the basket unscathed or would mysteriously teleport from the basket to the back of the auditorium.

By the 1930s, the film industry was discovering sound and special effects; and the Golden Age of Hollywood ended the Golden Age of Magic.

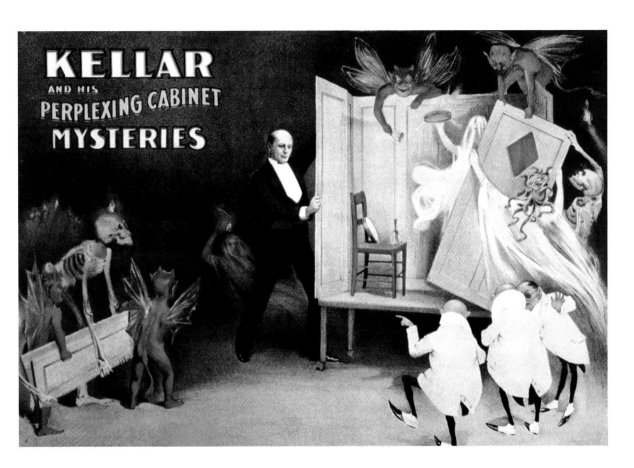

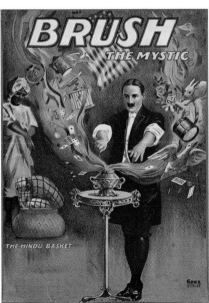

Heinrich "Harry" Kellar bought or developed highly complex illusory machines during his career. He worked with the Otis elevator company on a trick known as the Levitation of Princess Karnac. Harry Houdini was a great fan and called him "America's greatest magician". When he retired he sold his act to Howard Thurston.

Edwin Brush labelled himself "Brush The Mystic" and also "Brush The King of Wizards". Summoning mystical powers from the East, he performed the Hindu Basket trick in 1920.

US College Posters

(1900–1909)

Sporting achievement has always been as important in the life of American universities as academic reputation. At the beginning of the twentieth century the finest illustrative artists of the day were engaged to design posters and programme covers for the Ivy League's major fixtures.

Edward Penfield (1866–1925), the first great American poster designer of the modern era, was among those who turned their hand to sports subjects. Characteristically his posters featured only the subject at hand – for example a track athlete and a footballer for Princeton. Penfield dispensed with background in order to focus the public's eye on the matter at hand.

But he was not the first to enter this competitive field of sports illustration. That credit goes to John Sheridan (1877–1948). Sheridan began to illustrate sports programmes and posters while he was still a student at Georgetown University, as a way of making ends meet. He left Georgetown without a degree when he got a job in advertising, first in New York and then in Chicago, before securing the position of art editor back in D.C. for the *Washington Times*. Later he designed covers for many magazines including the *Saturday Evening Post* (where his work was overshadowed by that of Norman Rockwell).

Sheridan's favourite subjects were sportsmen and military figures. His early work was less bold than Penfield's and included much background detail. Sheridan ended his career teaching his skills to others at the New York School of Visual Arts.

One of the most memorable graphic artists in the field of sports illustration was Bristow Adams (1875–1956). Bristow was an extraordinary man, a polymath of astonishing diversity. He graduated from Stanford University in 1900 with a degree in literature, languages and art having already studied at Washington D.C.'s Corcoran School of Art and already founded two magazines. While he was at Stanford he illustrated a government report on the Bering Sea Fur Seal, and after graduation he edited a further three magazines (one of which, *Washington Life*, he also founded) and worked as a forester for the US Forest Service.

It was during his editorship of *Forestry and Irrigation* magazine, 1902–1904, that he also found time to produce distinctive sports posters for several universities. Adams' style combined the best of Penfield and Sheridan with bold figures in the foreground and lightly sketched surroundings to give his pictures some location. Unusually his athletes are often accompanied by female figures – this is particularly surprising in his images for Kiskiminetas Springs and St Paul's, two all-boys boarding schools. St Paul's sporting achievements include playing the first ever games of ice hockey in the US, and building the country's first squash courts.

Penfield and Sheridan both produced fine propaganda posters for the US during World War I. Adams was appointed a professor at Cornell in 1914, where he remained, teaching art and journalism, until the end of World War II.

LEFT: Bristow Adams' poster for Kiskiminetas Springs.
OPPOSITE: John E. Sheridan's poster boy for Columbia, 1902.

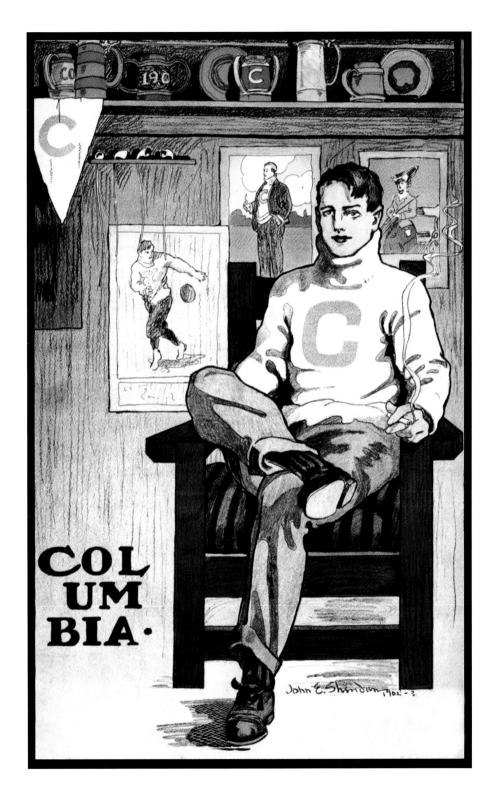

COL
UM
BIA·

Illustrated Directory Posters

(1905)

These days a phone with internet access can show you anything. But even the internet cannot show you everything at once. Illustrated directories, the posters that once lined the walls of every classroom offered a spread of visual information in which a curious child might immerse themselves for hours.

Illustrated directories are pictorial encyclopaedias that focus on one particular subject – educational wall charts designed to open a child's eyes wide with wonder at the diversity of the world. They might show a selection of aircraft, or national dress, or weapons, dinosaurs, the solar system or a historical timeline. They owe their origins, like so many developments in the history of posters, to advances in printing techniques.

In the nineteenth century, advances in printing technology made finely illustrated printed matter affordable to Europe's growing middle classes. Education was one of the virtues that the middle classes valued most; educational picture books and posters flourished in what became known as the Golden Age of Illustration. The world was being put on paper, and curious children could pore over everything from weights and measures to trees and toadstools.

One publication that fed this middle-class hunger for knowledge was the influential *Petit Larousse*, first published in 1905 by Éditions Larousse, who specialized in reference books. The French lithographer, painter and entomologist Adolphe Philippe Millot drew many of the natural history plates in the *Petit Larousse*. He was a senior illustrator at the National Museum of Natural History in Paris and a member of the Société entomologique de France.

Well-thumbed copies of the *Petit Larousse* could be found in most of the schools of Europe for much of the twentieth century. Such was its popularity that within a few years of its first publication Millot redrew many of the book's colour plates as posters for display in the classroom. He found a ready market for them and as a natural historian he was never short of material for a new poster to publish. Sea creatures alone accounted for five, and he designed no less than three charts of butterflies.

The market which Millot created attracted many imitators, and by the 1960s, illustrated directories on all aspects of history and science were commonplace in schoolrooms. None, however, could challenge Millot in his own field. Although you will still find wall charts in schools today, none aspire to the meticulous beauty of Millot's originals.

Science has changed too. In the natural sciences, where the first illustrated directories made their biggest mark, botanists and zoologists now use DNA sequencing rather than appearance to classify the natural world. Photography has replaced illustration as a scientific tool and online resources have replaced books and posters in places of learning. Millot's work may not be found in many of today's classrooms but his drawings of butterflies, eggs and insects are much sought after as works of art. They still inform, and now decorate the walls of homes instead of schools.

LEFT AND OPPOSITE: Even in the age of the internet, the engrossing amount of detail in one comparative image can fascinate children.

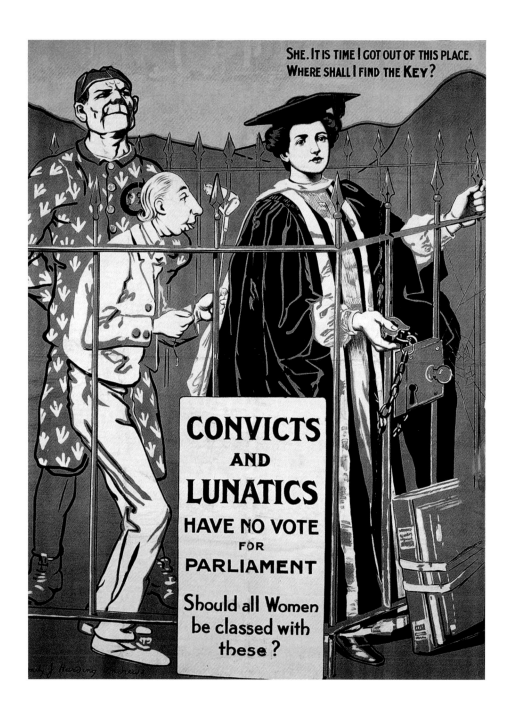

Women's Suffrage: UK

(1907)

The campaign for women's suffrage is notable for realizing the importance of visual art as a political weapon. Banners woven and embroidered, the growing use of postcards, coloured pamphlets, magazine or newsletter covers and posters were all pressed into the service of the cause.

Even a woman's choice to be an artist was restricted. With scholarships rarely available, only wealthy families could afford to send children of either sex to art schools. But female students faced further restrictions, on the subjects that were considered suitable for them. They were prohibited, for example, from attending life drawing classes.

Many male artists were in sympathy with their female counterparts and together they formed The Artists' Suffrage League in 1907. The League's posters, along with those of the artists' collective The Suffrage Atelier, publicized images of women denied opportunities open to men, or graphic illustrations of imprisoned women being force-fed by uniformed men via funnel and tube.

As a teenager Emily Jane Harding (1850–1940) had an initial arts education in Bristol before embarking on early work in London as a portrait miniaturist from the 1870s. She also began a career as an illustrator, particularly of children's books, both of which were seen as appropriate for a woman artist.

It seems that she also spoke French and German, getting to know the Polish poet and diplomat Alexander Chodzko whose *Fairy Tales of the Slav Peasants and Herdsmen* she translated into English and illustrated. The book has remained in print for well over a hundred years.

She was well into her fifties when she became an active suffragist and was arrested during the November

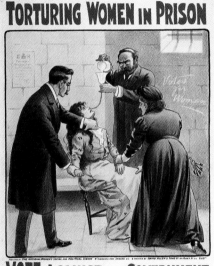

1910 demonstration outside parliament. The demonstration has become known as Black Friday, as many women were assaulted by the police, and by male bystanders. Under her married name of Andrews, Emily appears on the first page of the "Roll of Honour of Suffragette Prisoners 1905–1914". She was arrested and spent time in the cells again after another demonstration the following year.

It is, however, for her work with the Artists' Suffrage League, and the poster, "Convicts, Lunatics and Women!", for which she is best known. Drawn around 1907, it shows a young professional woman, with mortar board and in full academic dress, caged with a fearsome looking man in prison clothing and a feebler individual, clearly a man of unsound mind. This was one of many suffrage posters which argued that, whereas convicts and lunatics might legitimately be denied a parliamentary vote, responsible women should not.

Women were not only denied the vote; in Britain, women might study at university but could not be awarded degrees; so in Harding's poster the books lie outside her confinement. Oxford University began awarding degrees to women in 1920. In Cambridge, women could not become full members of the university until 1948. In the UK, it was not until the Representation of the People Act of 1928 that all women over the age of 21 were granted the vote on the same terms as men. Emily was widowed in 1915, and died in 1940.

Motor Racing Posters

(1908–1935)

Karl Benz invented the first car powered by internal combustion in 1885, and the first recorded race between such vehicles took place only two years later in Paris. Poster designers quickly rose to the challenge of conveying the excitement and speed of motorsport.

The *Chicago Times-Herald* organized the first US race on Thanksgiving Day 1895. From that day stems America's lasting love affair with the motor car. In 1904 America's first annual trophy race, the Vanderbilt Cup, was run on Long Island. The race was conceived by William Vanderbilt II, playboy and heir to the Vanderbilt railway fortune. Vanderbilt liked to sail yachts, but he loved to race cars; and in 1904 he set a new land speed record in a Mercedes at Daytona, the future home of NASCAR.

The Vanderbilt Cup attracted drivers from all over Europe, and large crowds hoping to see an American beat them. They were disappointed for the first three years; and the race was not run in 1907 while Vanderbilt constructed the Motor Parkway on Long Island, America's first purpose-built motor racetrack.

When the race resumed in 1908 its debut on the Motor Parkway course was heralded with an action-packed poster designed by Romanian watercolour artist Jean de Paleologu. Paleologu learned his craft painting posters of music hall performers in Paris before emigrating to the US in 1900. His pseudonym PAL can be seen on the image, which captures the danger to man and machine of the sport at the time. To the delight of the crowds that year an American driver, Long Islander George Robertson, won the Cup for the first time.

The poster advertising the Vanderbilt Cup became the template for advertising motorsport events, with the front wheels of the racecar up large approaching the viewer at speed, dust flying, tyres barely adhering to the road surface. This would be an exciting and dangerous event, because the poster portrayed it that way.

In 1933 the Monaco Grand Prix was the first to organize the starting grid according to time rather than by a simple lucky draw. The 1934 poster for the event was designed by French artist Georges Ham, whose signature is clearly visible. The 1920s and 1930s were the Age of Speed and a golden age for poster design, and in the world of motorsport Georges Ham was widely regarded as the finest of his profession at the time, along with Britain's Frederick Gordon Crosby, who captured the excitement of the Brooklands events.

The Kesselberg Run was a hillclimb south of Munich. It began in the very early years of the twentieth century and was revived as an annual event in 1928. Germany was a country in transformation in the 1930s following Hitler's rise to power, and it's no accident that the poster's colours are the red, white and black of the Nazi flag. Little is known about the poster's designers, Klotz and Kienast, or about "Kunst im Druck/KiD" ("Art in Print"), the Munich printshop whose monogram can be seen on the poster for the 1935 meeting. Klotz may be Clemens Klotz, a favoured artist and architect of Hitler's who designed several large-scale pre-war Nazi buildings, including Munich Railway Station. Hitler would have been delighted that a German driver, Hans "King of the Mountains" Stuck, posted the fastest time at that year's event.

OPPOSITE: From the very first iteration, motor racing posters had to convey a sense of movement, danger and, most of all, speed.

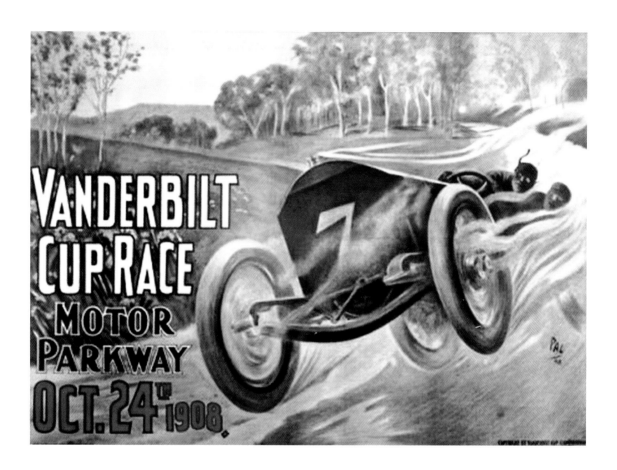

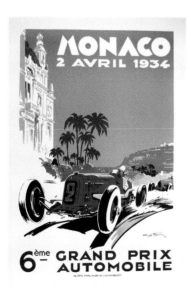

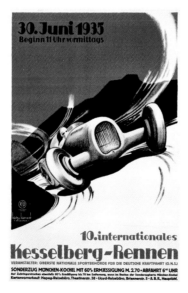

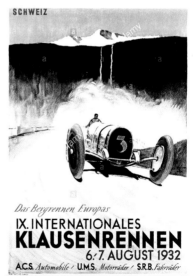

Women's Suffrage: America
(1909)

Although posters supplied by the British "Artists Suffrage League" featured in the American votes for women movement there were other, typically American, posters to be seen during the campaign. Rose O'Neill's "Kewpie" posters spoke in ways that no other media could.

Many US suffrage posters invoked Representation and Liberty, the issues which precipitated the War of Independence and, suffragettes argued, were the basis for society in America. Ranged against such images were anti-suffrage posters displaying a level of misogyny which would have been familiar to British suffragettes too. The cute Kewpie Doll seems at first glance an unlikely ally to the cause in such a hostile environment.

It was in 1909, in her *Ladies Home Journal* comic strip, that O'Neill introduced the cherubic Kewpie characters, their name deriving from Cupid and resonating with "cute" in name and appearance. Soon, her Kewpie strips were appearing in *The Woman's Home Companion* and *Good Housekeeping* too, and within four years the Kewpies were being manufactured and mass marketed as toys. But as well as being a visual artist (she was the highest paid female illustrator in America in 1914) and a shrewd businesswoman, Rose O'Neill was a committed suffragist, and enlisted her Kewpies in the cause. To energize the campaign in the South she commissioned the famous pilot Katherine Stinson to fly over a Nashville suffrage rally dropping Kewpie Dolls with parachutes and all wearing Votes for Women sashes.

She was asked to produce Kewpie posters by the National American Woman Suffrage Association. The result: Kewpies on the march, with O'Neill's new and distinctive "marching" signature. It alienated a few women who were uncomfortable at seeing their much-loved characters involved in politics. However, they carried the message through to a much larger audience that hadn't thought much about the issue before.

By leading with Motherhood and images of small children, O'Neill undercut the crude rhetoric of the anti-suffragists. MOTHER in bold capitals above OUR FOOD was another way of saying "Mom and apple pie", understood as a key principle of US life and values.

And of course, for women to get the vote they had to get those in power, the men, to vote for it. O'Neill's poster appealed to families. Small children seeing the poster would ask their mothers what it was about; children who could read could follow the argument; adult men would be prompted to think about their mothers and their own childhood, and reflect.

As a political poster it remains unique, a counter to attack ads and confrontational slogans. O'Neill's Kewpie majorette carried a flag reading not "Votes for Women", a slogan which had bred bitterness on both sides of the debate, but "Votes for Our Mothers".

The Nineteenth Amendment to the Constitution, "The right of citizens of the United States to vote shall not be denied or abridged by the United States or by any State on account of sex," was ratified in August 1920. A 46-year-old Rose O'Neill was able to cast her first vote.

THERE ARE ONE MILLION WOMEN TAXPAYERS IN NEW YORK
TAXATION WITHOUT REPRESENTATION WAS TYRANNY IN 1776
WHY NOT IN 1917?

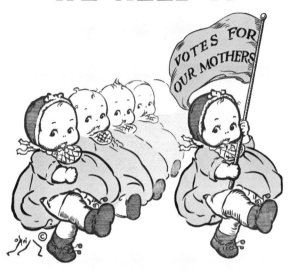

GIVE MOTHER THE VOTE
WE NEED IT

VOTES FOR OUR MOTHERS

OUR FOOD OUR HEALTH OUR PLAY
OUR HOMES OUR SCHOOLS OUR WORK
ARE RULED BY MEN'S VOTES

Isn't it a funny thing
That Father cannot see
Why Mother ought to have a vote
On how these things should be?

THINK IT OVER

Printed by National Woman Suffrage Publishing Company, Inc., 505 Fifth Avenue, New York

ABOVE: Rose O'Neill's Kewpie poster had none of the strident tone of the British suffragist movement, but contained a subtle message.
OPPOSITE: The hand-drawn figure 7 in the poster indicates that it had been in use for some time.

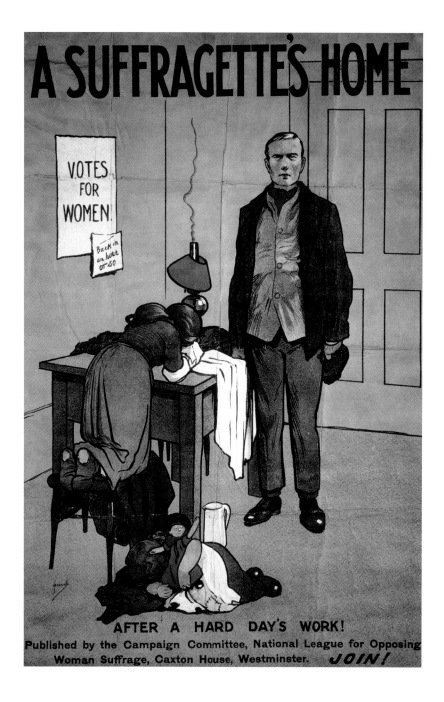

ABOVE: Anti-women's suffrage campaigners often played on the fact that prominent suffragette leaders came from wealthy backgrounds and could afford the time to attend meetings and rallies. This John Hassall-drawn poster emphasized what happened when working class women neglected their "duties".

Anti-Women's Suffrage

(1910)

From those whom the denial of votes for women benefited – men – there was patronizing opposition to granting women electoral suffrage. More surprising was the resistance to it from other women, domestically conservative, for whom "a woman's place was in the home".

The expression was first coined in the 1830s when an article in the *New Sporting Magazine* included the line "A woman's place is her own home, and not her husband's countinghouse." However, the view had been expressed in other ways since ancient Greek playwright Aeschylus wrote "Let women stay at home and hold their peace." It was the same argument which had been used in support of slavery – "we've always done things this way", "it's the natural order of things", "women/slaves are of inferior intellect" – and it's an interesting coincidence that the *New Sporting Magazine* article appeared at around the same time that slavery was finally abolished in Britain. Perhaps male masters needed a new group of people to oppress.

By the end of the nineteenth century, voices were being raised in favour of women's rights. In the years before World War I some women, frustrated by the lack of progress, were resorting to direct action – smashing windows, chaining themselves to railings, starting fires and disrupting sporting events. Emily Davison died in 1913 while trying to attach a suffrage scarf to a horse belonging to King George V during the Epsom Derby.

It was this move to more militant action in Britain that prompted the formation of the Women's Anti-Suffrage League (WASL) in 1908. There was in truth not much support for suffrage from ordinary women, for whom it was enough of a struggle organizing the home and family, and this was reflected in some of the anti-suffrage campaign's early posters. In 1910 they

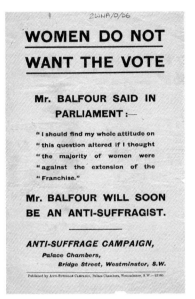

merged with the Men's League for Opposing Women's Suffrage (MLOWS) to form the National League for Opposing Women's Suffrage – the male leader of the MLOWS became President of the new organization, while the female leader of the WASL was relegated to the Vice-Presidency.

The National League raised its profile by commissioning full-colour posters from one of the leading illustrators and caricaturists of the day, John Hassall. Hassall, who cited Alphonse Mucha as an influence, began his career in the late nineteenth century by designing theatre posters for London's West End. His most famous poster, commissioned by the Great Northern Railway in 1908, is the image of the Jolly Fisherman, skipping along a sandy beach in his galoshes and oilskin hat above the slogan "Skegness is SO Bracing". (Skegness is a seaside resort on Britain's breezy east coast.)

For the anti-suffrage movement Hassall painted a scene which embodied everything the movement feared from women who sought a life outside the family home. In the image a man comes home "after a hard day's work" to find that his absent wife has left him a note saying "Back in an hour – or so" below a Women's Suffrage poster. His daughters are sobbing and neglected, their clothes in need of repair and no food on the table. The paraffin lamp has gone out for want of fuel, and the only thing being cared for in the room is the doll in the arms of a child sleeping on the floor because it has not been put to bed. It is, Hassall, wants us to believe, the end of family life as we know it.

World War I Recruitment Posters: Kitchener

(1914)

Lord Kitchener was appointed War Minister in the British Cabinet the day after Britain declared war on Germany. He was a national hero and his famous recruitment appeal, one of the most familiar and most parodied posters ever produced, did not even have to bear his name.

Herbert Kitchener enjoyed a high-profile military career in many parts of the British Empire, fighting victorious campaigns in Egypt, the Sudan and southern Africa. A subsequent posting in India made him many political enemies and thwarted his ambition to become Viceroy of India. On the point of returning to Egypt he was recalled on the eve of World War I to take up a government role.

While the popular opinion was that "it would all be over by Christmas", Kitchener's long experience convinced him that the war would last at least three years and he planned accordingly. His primary task was to build an army capable of fighting such an extended campaign – the peacetime British Army at the time was well below fighting strength. An initial poster campaign showing a simple Union Jack superimposed with the words "Your King and Country need you – enlist now", designed by Eric Field of the Caxton Advertising Agency, triggered a huge surge of volunteers to enlist in August 1914.

As that first fever of patriotic duty subsided, a second poster was circulated in September. It used an image of a masterful Kitchener pointing his finger at YOU, which had originally been drawn for a magazine cover by Field's colleague at Caxton, Alfred Leete. Kitchener's

ruthless victories were a source of British pride, and his face below a bold "Britons" was the perfect poster for the moment.

In fact recruitment never again reached the giddy levels of that first month of the war. Although two and a half million men signed up in the first seventeen months, it was not enough to wage war on the unprecedented scale of a global conflict. For the first time since the Napoleonic Wars a hundred years earlier, Kitchener was forced to introduce conscription in January 1916.

The poster, however, had secured its place in British imperial nostalgia and its very direct approach inspired many other campaigns, most memorably in Uncle Sam's "I Want YOU for US Army". Kitchener's pointing finger has also provided the material for innumerable parodies in the hundred years since his appeal.

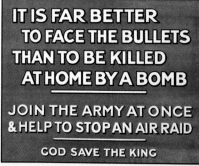

LEFT: By 1915, Britain had another strong recruiting sergeant. The Germans had started bombing raids using their fleet of Zeppelins. Wildly inaccurate, they caused minimal damage to military targets, but killed many civilians.

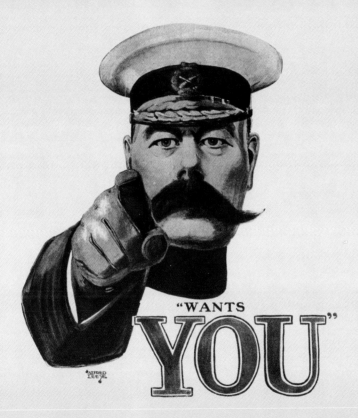

"WE ARE FIGHTING GERMANY, AUSTRIA, AND DRINK; AND, AS FAR AS I CAN SEE, THE GREATEST OF THESE THREE DEADLY FOES IS DRINK."

THE RIGHT HON. D. LLOYD GEORGE.

March 29th, 1915.

ABOVE: David Lloyd George was Munitions Minister at the time of the Shell Crisis in 1915, when the Army ran dangerously low on artillery shells. His speech was paraphrased in an advisory poster.
OPPOSITE: A British World War I poster aimed at Naval personnel.

World War I: Drink Campaigns
(1915)

In times of international conflict, governments need their workforce to have clear heads, especially those serving in the armed forces or manufacturing the weapons of war. Many countries ran anti-alcohol poster campaigns in the two World Wars.

Within four days of Britain's entry into World War I its government had passed the Defence of the Realm Act, affectionately known by its initials as DORA. Amidst a number of stringent new social controls – the power to requisition property, censorship on the grounds of morale and national security, and bans on kite-flying and feeding bread to wild animals – DORA severely restricted the public's access to alcohol.

Most of us have gone to work with a hangover at some point in our lives. But if your work involves assembling armaments for your country's war effort, or worse still if it involves pointing those armaments at someone, you really need to be sober. From 8 August 1914 onwards, beer would be weaker, and you could no longer buy alcohol in railway dining cars. Worse still, pubs would only be open at lunchtime and in the early evening.

It wasn't just sobriety which drove the new restrictions. As an island nation, Britain now faced potential disruption to food imports. The grain that went into making alcohol would be better used in feeding the population – hence the ban on feeding the ducks. In the US, President Wilson took a similar approach.

On both sides of the Atlantic, temperance campaigners saw an opportunity to push their cause. In Britain the Wesleyan Methodist Church pounced on a remark by Liberal politician Lloyd George that "we are fighting Germany, Austria and Drink, and as far as I can

Strength—Endurance—Skill; All Needed Here. Drink Hinders.

see the greatest of these three deadly foes is Drink." In the US the Anti-Saloon League, formed just before the war, seized its moment.

In Britain a disastrous shortage of munitions on the front line in 1915 placed extra pressure on munitions workers. The highly publicized failing forced Prime Minister Asquith to resign. In 1916 his successor, Lloyd George, took the extraordinary step of nationalizing the pubs in three areas of the country: at Enfield, site of the Royal Small Arms Factory; in and around Carlisle, which supplied workers for the nearby munitions factory in Gretna; and around the Cromarty Firth, an important natural anchorage for the British naval fleet.

Landlords were now reduced to site managers, paid a wage by the State Management Board. They no longer had an incentive to sell more drinks and increase profits. The change in hours transformed Britain's drinking habits, even in areas which hadn't been nationalized. The measure was so effective that it remained in place until 1988, long after the conclusion of both World Wars.

In the US, the Committee on War Temperance published a series of anti-drink posters, designed by Clifford Knight among others. Lobbying by the Anti-Saloon League, one of the Committee's member organizations, was so successful that the "noble experiment" of Prohibition was introduced in 1920, banning the production and sale of alcohol completely for the next thirteen years.

ABOVE: Given the short range of aircraft in World War I, the first aircraft recognition chart was of more use to troops in France and Belgium than in the Home Counties.

Recognition Posters

(1915–1942)

It is a common device of wartime government to engage civilians in the war effort. It's a way of giving them a stake in the outcome, whether through conservation of food or materials, diversion of labour to military needs, or simply through vigilance about possible enemy action at home.

Was that stranger in the village a spy? What was that ship lurking offshore. During World War I, flying machines were still a rare sight and a wonder of the age. It was all too easy to get over-excited if you saw one and to assume that it was the enemy come to rain down death upon you. To avoid false alarms, which wasted the time of the authorities, the British government produced a helpful poster contrasting the German and British airships and aeroplanes.

It's hard to believe now, but ponderous Zeppelins were actually able to carry out bombing raids on cities in the east of Britain if the winds were in the right direction. With the help of the poster it's fairly easy to see the difference between the dirigibles of friend and foe. But you had to look closely to distinguish a Fokker triplane from a Sopwith one – and the poster drew the public's attention particularly to the shape of the wings.

Aerial warfare was a far bigger element in World War II. In the early days of the conflict, only eight of the seventeen British planes lost were downed by German fire: the rest could be chalked up to the French. So the government issued a revised version of the aircraft poster. Plane design had come a long way in the intervening twenty years and Zeppelins were no longer to be expected. There was no mistaking the four-engined silhouettes of Britain's Lancaster and Halifax bombers; but there wasn't much between a British Blenheim and a German Heinkel III or Junkers 88 when seen from below.

As the war progressed and the US joined the fight in Europe, a new chart was issued which included American planes. In the Pacific theatre a similar poster helped to identify planes of the Japanese Air Force, as demonstrated by remote island observer Cary Grant in the movie *Father Goose*.

In 1933 the Nazi children's newspaper *Unser Schiff* ("Our Ship") gave away a poster illustrating the differences in the uniforms of the Sturmabteilung (SA, "Storm Detachment") and the Schutzstaffel (SS, "Protection Squadron"). No doubt small boys thrilled over the details. The SA, the Brownshirts, were the Nazi Party's early paramilitary wing; the SS began life as security teams at Nazi Party meetings. The latter went on to become Germany's most feared terror division in the German Army, as Gestapo detecting enemies of the state, or as masters of the death camps. After the war they were declared not a military force but a criminal organization.

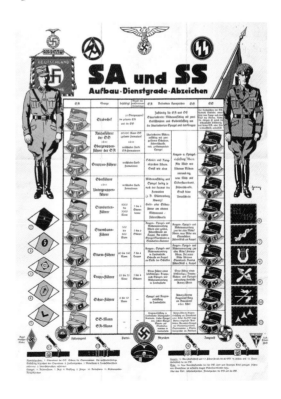

WWI Recruitment Posters: "What did you do in the Great War?"

(1915)

What made men enlist in the army in World War I? Patriotic duty? Belief in the cause? Recruitment posters appealed to those instincts. But if they couldn't attract you through your pride or passion, there was a third path to pursue: your shame.

Manliness – that sense of bravery, regardless of personal cost or fear, in defence of family, friends and country – was a powerful concept at the end of the nineteenth century. Two years after men had stepped aside to let women and children enter the limited lifeboats on the sinking *Titanic*, gentlemen were expected to do the right thing.

Physical bravery was the most admired attribute of manliness in a world in which empires were built. Within days of Britain's declaration of war with Germany in 1914, a 73-year-old retired admiral and a woman opposed to women's suffrage formed the Order of the White Feather, which handed out white feathers to men who had not yet enlisted, as a badge of their cowardice. It misfired when government workers supporting the war effort, and men injured in the trenches or on leave, were also given feathers merely for not wearing a uniform. The government stepped in to distribute badges and medals proving these men's loyalty or bravery.

Nevertheless this imputation of unmanliness was emotionally persuasive. When the wave of willing volunteers dwindled to a trickle in 1915, Britain's Parliamentary Recruitment Committee resorted to implications of cowardice in its posters. One way or another, such posters used

peer pressure to persuade. One pictured an embarrassed father whose daughter is asking him, "What did you do in the Great War?", while his son plays with tin soldiers at his feet. Clearly the answer is, "Nothing, and I'm too ashamed to speak of it."

Another portrayed a man's womenfolk – his wife and daughter perhaps – and his young son, watching a column of soldiers marching off to war. "Women of Britain say GO!", it announced. This was broadly true. The increasingly radical and violent movement in favour of women's suffrage suspended its campaign of disruption at the start of the war to support the nation's men going off to fight. Author Compton Mackenzie suggested at the time that some women were using accusations of cowardice to persuade unwanted husbands to go to war and leave them in peace.

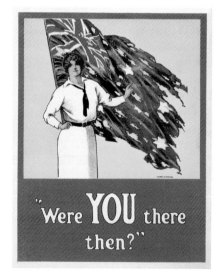

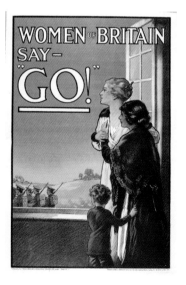

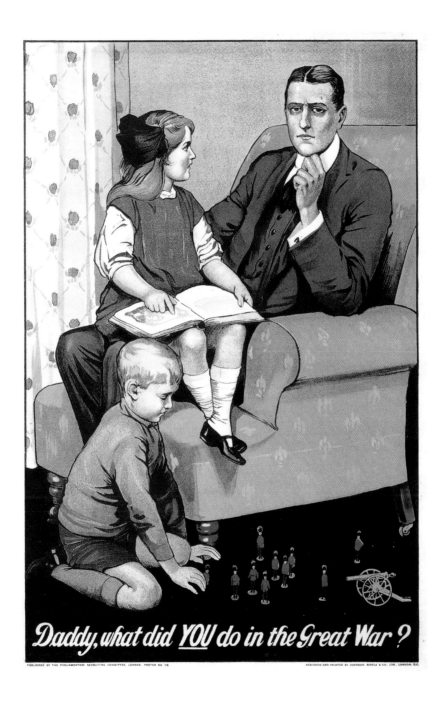

Daddy, what did YOU do in the Great War?

PUBLISHED BY THE PARLIAMENTARY RECRUITING COMMITTEE, LONDON. POSTER NO 79. DESIGNED AND PRINTED BY JOHNSON, RIDDLE & CO., LTD. LONDON, S.E.

ABOVE AND OPPOSITE: One Australian and two British recruitment posters that played heavily on a man's sense of self-worth. By 1915, the date of the above poster, 2.4 million Britons had volunteered, around 30% of eligible working men.

Armenian Aid Posters

(1915–1918)

Before America entered World War I, numerous non-governmental philanthropic organizations emerged in the United States to bring relief to the populations of Europe and the Middle East. These groups raised millions of dollars through charitable appeals in which posters played a vital role.

Formed in 1915, Near East Relief was a direct response to the humanitarian horrors of the Armenian Genocide, the murder or expulsion of fifteen million ethnic Armenians in Turkey. While state aid was not permitted, privately raised funds from America were distributed to displaced Armenians by the United States' Ambassador to the Ottoman Empire, Henry Morgenthau.

Refugees were scattered across the region, not just to Armenia but in Syria, Persia and Greece. The American response was extraordinary. From 1915 until Near East Relief ceased operations in 1930 Americans donated $117 million to the cause, the equivalent of over $2.5 billion today. The focus of most posters was on the millions of children orphaned by Enver Pasha's systematic killing of every adult male Armenian in the Ottoman Empire.

The graphic posters of innocent children in need were a far more effective fundraiser than any newspaper announcement. One showed a young girl whose outstretched hands reach beyond the frame to embrace the words "Lest we perish". Ethel Franklin Betts' 1918 painting creates a direct and personal relationship: the girl gazes directly at the viewer, defying us to look away. Her plea is irresistible. Betts was a children's book illustrator who had learned her craft, like so many graphic designers of the age, working for the American magazine industry. Her poster therefore worked on another level, reminding parents of their own children and the stories they read to them.

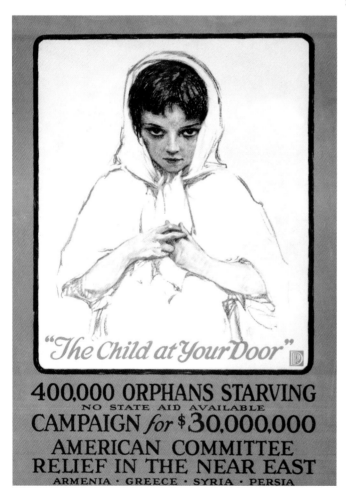

"The Child at Your Door"

400,000 ORPHANS STARVING
NO STATE AID AVAILABLE
CAMPAIGN for $30,000,000
AMERICAN COMMITTEE
RELIEF IN THE NEAR EAST
ARMENIA · GREECE · SYRIA · PERSIA

LEFT AND OPPOSITE: Illustrator Ethel Franklin Betts' direct, engaging style drew an amazing response. Like Norman Rockwell, she illustrated covers of the Saturday Evening Post.

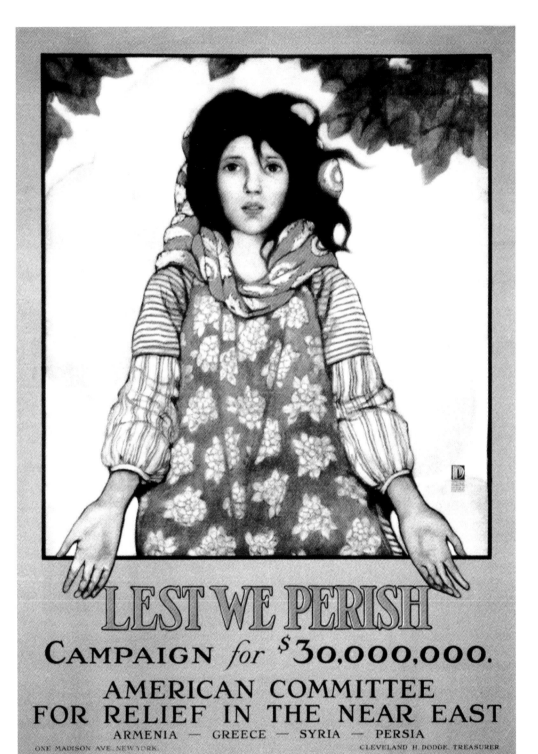

World War I: Winning US Public Opinion

(1917–1918)

Wartime propaganda past and present relies on portraying one's friends as the best of us and one's enemies as the worst. Posters produced by America during World War I were designed to shape public opinion by stoking sympathy or wrath as required.

Nuance had no place in the propaganda of World War I. The best example is Harry Ryle Hopps' poster, "Destroy This Mad Brute". Its message is as blunt as the club the Brute wields when he steps onto American soil, leaving behind him the wreckage of Europe. Such posters were highly effective for recruitment, although the dangers of anti-national propaganda were realized in the form of widespread discrimination against German Americans at home.

Germany's ruthless, violent invasion of neutral Belgium was one of the early shocks of the war, and many posters invoked outrage. They carried images of Innocence, personified by a young girl, being defiled or orphaned by some Mad Brute of a Prussian. The true extent of the "Rape of Belgium" only became clear after the war – mass executions, sexual violence and the wholesale destruction of towns entirely justified the moral crusade which posters tried to engender.

Other female personifications symbolized other causes to fight for. Liberty in statue form was a common element of designs. James Montgomery Flagg painted the sleeping figure of Columbia, the traditional representation of America, draped in the Stars and Stripes, sleeping carelessly against a symbol of western civilization, the fluted column. Flagg and other artists used classical symbolism to divide the "civilized" Allied Powers from the "barbaric" Central Powers.

The United States' entry into the war after two years of neutrality left many citizens unconvinced of the need to intervene, hence Flagg's call to "Wake Up, America!"

Sometimes, though, women were portrayed simply. Edward Penfield, regarded as the father of the American poster, was one of many established graphic designers who contributed to these morale-boosting poster campaigns. In his "Pulling for Victory", made for the Victory Girls United War Work Campaign, a woman rows a small boat through stormy seas. It's pure Penfield with the sketchiest of seas surrounding the central image, and just a hint of the boat below the waterline.

This came at a time when countless women were entering previously prohibited workplaces to fill roles left by men fighting in Europe. It also tapped into America's longstanding tendency towards isolationism, cut off from the rest of the world by two great oceans.

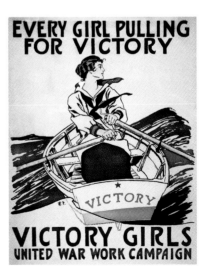

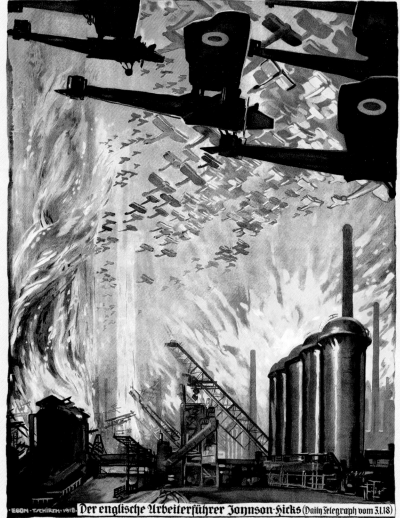

ABOVE: German propagandists used a speech from Conservative politician William Joynson-Hicks published in the Daily Telegraph *in January 1918 to frighten a war-weary public: "One must bomb the Rhineland industrial regions with one hundred aircraft day after day, until the treatment has had its effect!"*

World War I: German Propaganda Posters

(1914–1918)

The outbreak of war in Europe in 1914 enlisted the poster artist in a new role – propaganda dissemination. While British and American examples are now the best known to English-speaking audiences, many German posters were amongst the most innovative and influential of their kind.

Just as warfare was changed by the War to End all Wars, so too was the world of art and design. World War I was the first time that illustrated colour lithographic posters were used for propaganda, and the German war machine deployed them as an integral part of its arsenal.

German propaganda posters often depicted lone soldiers and personifications of Germania holding the line against foreign legions. Spades appeared in their hands as commonly as rifles as a manifestation of the civilian effort, and the use of medieval iconography – including coins forming a shield wall and a knight guarding a mother and child from spears hurled from the Bolshevik east – appealed to the very same Germanic nationalism that plunged Europe into war in the first place.

If attacks on Germany were depicted as personal, its enemies were deliberately de-personalized. Just as Germans were being portrayed in American, French, and British propaganda as insatiable spiked hat-wearing Huns, German posters featured ape-like beasts on the verge of defiling maidens who stood in for Germany itself. Others were overtly racial in reference to British and American soldiers of colour.

Some poster designers were enlisted from their peacetime professions in advertising to serve the war effort. One such was Lucian Bernhard (1883–1972), a pioneer of the minimalist Sachplakat ("object poster")

advertisement which featured little more than a flat-colour depiction of the product being sold, in his case for companies such as Bosch and Pelikan. His propaganda poster, in a more nationalistic style, promoted war bonds in 1917 with a gothic, armoured fist above traditional blackletter text proclaiming, "This is the way to peace – the enemy wants it that way! Subscribe to war loans".

Other propaganda designers came from a fine art background. After the war Egon Tschirch (1889–1948) became a leading figure in German Expressionism. His 1918 contribution "Was England Will!" ("What England Wants!") foreshadowed this with an unpopulated industrial landscape in which Royal Air Force bombers rain hellfire upon German factories. By quoting Britain's *Daily Telegraph* it also showed in passing that Germany already had men on enemy territory.

After the war, emotionally and physically exhausted by defeat, Germany turned away from Jugendstil – German Art Nouveau – in favour of modernist movements such as futurism, led by the Bauhaus School of Design. Lucian Bernhard relocated to New York where he would go on to create no less than thirty-six new fonts for American Type Founders including Bernhard Gothic. Egon Tschirch is currently enjoying a renaissance thanks to the rediscovery in 2015 of a large body of his work in a Berlin cellar. The first ever monograph of his work was published in 2020.

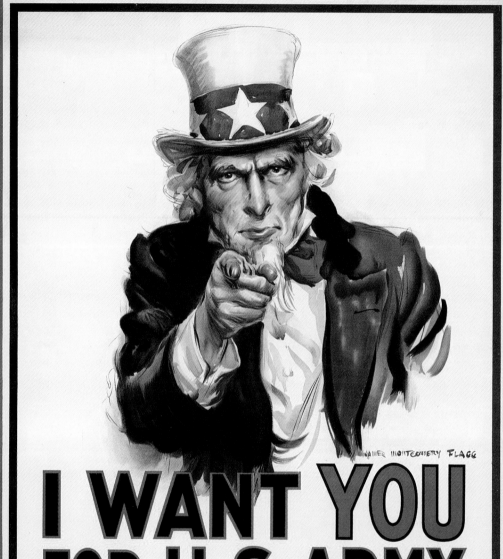

I WANT YOU
FOR U.S. ARMY

NEAREST RECRUITING STATION

World War I Recruitment Posters: Uncle Sam

(1917)

Uncle Sam, the personification of the United States, has adopted many guises since he first appeared at the start of the nineteenth century. It wasn't until James Montgomery Flagg's 1917 recruitment poster that a definitive likeness was agreed on by common consent.

Early personifications of America showed the country as a woman, Columbia, the name also given to all the lands of the New World in honour of their supposed discoverer Christopher Columbus. The character Brother Jonathan was also used, first in connection with New England and later with all the United States. It was originally a nickname applied to Puritans during the English Civil War, and travelled to America with them on board the *Mayflower*.

Uncle Sam referred more to the government and administration than to the American people. The earliest reference to him was in 1810, disproving the myth which places his origins to military rations issued in 1812.

Uncle Sam was depicted in cartoons, sometimes young, sometimes old, sometimes moustached, sometimes clean-shaven, sometimes looking remarkably like Benjamin Franklin. Gradually Jonathan and Sam became conflated in portrayals, both of them sporting a pair of trousers in a red and white pinstripe and top hat with a blue starry hatband.

Although America remained officially neutral at the start of World War I, it became clear that it would eventually join the fray. Based on the British recruitment poster featuring Lord Kitchener's commanding finger, Flagg's impression of Uncle Sam first appeared on a magazine cover in 1916, asking the question "What are you doing for preparedness?" When Uncle Sam did enter the conflict in April 1917, Flagg contributed to poster campaigns urging the public to buy war bonds and plant victory gardens.

He also designed a number of recruitment posters, although today he is remembered for one particularly effective design. Uncle Sam's face was ubiquitous on the now-famous poster, which was reproduced more than four million times in the course of the war. Little wonder that Flagg's take on Uncle Sam's appearance is the one that has stuck. Little wonder, too, that his steely gaze and pointing finger have been so often imitated or lampooned.

BELOW: The edition of Leslie's Illustrated Weekly *(previously* Frank Leslie's Illustrated Weekly*) from July 1916 that produced the definitive Uncle Sam. The publication closed in 1922.*

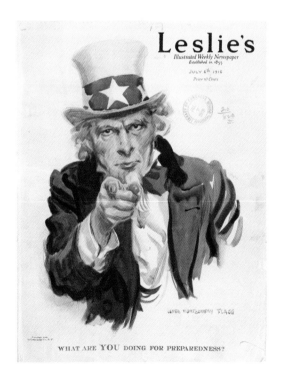

World War I: US Liberty Bonds

(1917–1918)

America paid for its involvement in World War I by borrowing money from the American people. Posters encouraging American citizens to buy Liberty Bonds during the war made appeals to their native patriotism, their immigrant gratitude and their righteous anger.

The war bond scheme was introduced and overseen by Secretary of the US Treasury William Gibbs McAdoo. He was reluctant to raise funds through taxation or by simply printing more money to pay for government purchases. The USA had only just emerged from an economic depression and McAdoo didn't want to jeopardize the fragile recovery. Liberty Bonds were government promises to repay loans from individual Americans with interest, after a fixed period.

They were marketed by America's new propaganda machine, the Committee of Public Information, popularly known as the Creel Committee after its chairman George Creel. Creel was a journalist who brought in other writers, artists, advertising designers and psychologists to devise and execute the Committee's strategy. His aim was to reach every single American with promotional materials about Liberty Bonds and thereby generate public support for America's involvement. If you are lending money for your government to fight a war, you really want it to win so that it can repay you.

One member of Creel's team was Edward Bernays, later known as "the father of public relations". He pioneered techniques that drew on the new psychology of the subconscious in order to manipulate public opinion. Publicity materials were designed to appeal to a range of innate human motives: competition, community, guilt, fear and patriotism. It is perhaps no coincidence that Bernays' uncle was Sigmund Freud.

The details of the scheme were designed to ensure investment was accessible to as many people as possible, from all walks of life and income levels. Small individual investors were given priority over large subscribers. For those who could not afford the minimum bond investment of $50, a War Savings Stamps scheme allowed them to save towards a bond in instalments of 25 cents.

Millions of posters were produced, almost every shop window featured a poster. Slogans such as "Beat Back the Hun" and "Crush the Prussian" reminded Americans why they were fighting. The view of the Statue of Liberty from a docking ocean liner tapped into the sense of obligation of recent immigrants: "Remember your first thrill of American Liberty? Your Duty? Buy Bonds". Liberty herself featured in many posters: waif-like and neoclassical in the work of society portraitist Howard Chandler Christie; muscular and almost masculine-looking in the work of *Saturday Evening Post* cover artist J. C. Leyendecker, himself a German-American; and leading the troops into battle, sword and shield aloft, in work by illustrator J. Scott Williams.

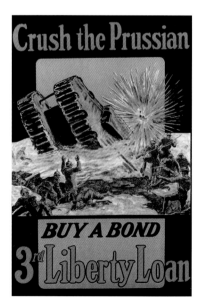

From its launch in 1917 to the end of the war in 1918, there were four issues of the Liberty Bond, and a final issue, the Victory Bond, to commemorate the Armistice. Twenty million individuals bought bonds at a time when there were only 24 million households in the US. More than $17 billion dollars was raised by the scheme, around 22% of GDP in 1918, and equivalent to $6.3 trillion today.

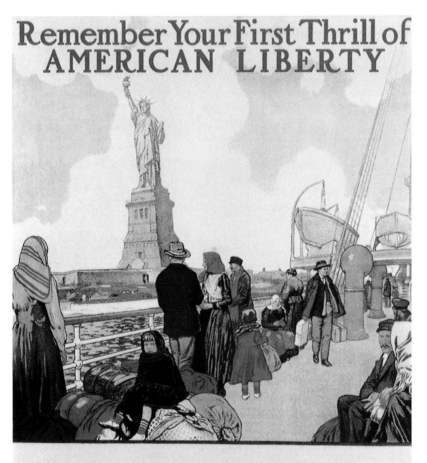

ABOVE: *The baggage and the shawls of the passengers on the incoming liner make it clear that this poster is aimed at immigrants to America.*

Temperance Posters

(1880–1920)

Prohibition was introduced in the US in 1920; but the move to prohibit alcoholic drinks in the United States began more than a hundred years earlier when puritanical Protestant revivalism led many to pledge total abstinence.

The word Prohibition conjures up images of 1920s American hoodlums machine-gunning each other as they fought for control of the speakeasies which sold illegal liquor, or government agents smashing barrels and pouring the beer down drains. But disapproval of "the demon drink" first spread with the Victorian values of the early nineteenth century.

As the century progressed, personal abstinence lead to broader social concerns. Members of the Women's Christian Temperance Union (WCTU) often picketed and held prayer meetings outside saloons, and their push for alcohol education led in 1880 to the establishment of their educational section, the Department of Scientific Temperance Instruction in Schools and Colleges.

Under the astute leadership of Mary Hunt, by 1900 the members had pressured all States to include anti-alcohol education in the curriculum and were endorsing appropriate textbooks and issuing temperance posters. While other anti-alcohol posters featured images of cigar-smoking saloon owners, destitute children or ailing drunkards, WCTU posters adopted a pseudo-scientific approach, presenting with impassioned certainty some less-than-certain scientific "facts".

More dispassionate investigators took issue with some of their claims. A group of scientists and businessmen called the Committee of Fifty, formed in 1893 to study the problem with liquor, took a more moderate stance. It criticized a WCTU poster which compared water and alcohol: "Water has no taste", the poster claimed, or "Alcohol Makes a Fire Burn More Freely". But seawater has taste, the Committee pointed out; and as for alcohol making a fire burn more freely, try tipping a glass of beer onto a few burning twigs.

In the end, tax and war led to the constitutional amendment that brought about Prohibition. Tax on liquor sales brought in huge funds for the government; but the introduction of a progressive income tax provided an alternative income stream for federal coffers, giving new weight to the prohibitionist argument. Then, during World War I, brewing and distilling were affected as grain was needed for food during the war effort, as well as alcohol sales being restricted in or near troop encampments. Moreover, most of the big brewers were of German extraction and their protests were snubbed.

The constitutional amendment was not enacted until 1920 and it lasted for thirteen years. By 1933 the ease with which intoxicating drinks could be obtained together with the surge in gangsterism provided evidence enough that the law was not working, but again it was tax and the economy that brought about Prohibition's end. The Depression had hit personal income and therefore tax revenue; and one of Franklin D. Roosevelt's first acts in March 1933 was to sign the bill allowing the legal brewing and sale of beer once again.

OPPOSITE: Some of the arguments put forward by the Women's Christian Temperance Union (WCTU) reappeared in a series of Temperance Lesson posters published by the Dominion Scientific Temperance Committee. These are Lessons, 4, 9, 10 and 12.

ALCOHOL

A BLESSING

A CURSE

GOOD FOR THE ENGINE, BUT NOT FOR THE
ENGINEER

GOOD FOR COMMERCIAL PURPOSES, BUT NOT AS A BEVERAGE

Published by The Dominion Scientific Temperance Committee Temperance Lesson No. 4

CHARACTER

WHERE THERE'S DRINK

THERE'S ALWAYS DANGER

PREVENTION IS BETTER THAN CURE

It is more glorious to build a Lighthouse
than man a Life-Boat

Published by The Dominion Scientific Temperance Committee Temperance Lesson No. 12

SAFE STIMULANTS

Tea

Coffee

Chocolate

Hot Water

Milk

It is Dangerous to Administer Alcohol Without
a Medical Man's Advice

Published by The Dominion Scientific Temperance Committee Temperance Lesson No. 10

THE GREAT
DECEIVER

WATER & ALCOHOL

ALIKE IN APPEARANCE
DIFFERENT IN EFFECT

WATER	ALCOHOL
Necessary to Life	Unnecessary to Life
Benefits the Body	Injures the body
Softens Food	Hardens Food
Quenches Thirst	Creates Thirst
Makes Seeds Grow	Kills the Seed
Cools the Skin	Inflames the Skin
A Constituent of all Food	Not Found in Food
Has No Taste	Has a Burning Taste
Puts a Fire Out	Makes a Fire Burn More Freely

Published by The Dominion Scientific Temperance Committee Temperance Lesson No. 9

Enhanced Colour Travel Posters
(1920–1963)

Lithography involves using a different plate for each colour on the page. Gradual shading was therefore difficult to achieve; and designers could have more control over the reproduction of their images if they used solid colours instead of gradients.

Before – and after – Art Deco, there was a style of poster design rooted in realism but constrained by the limitations of lithography printing. Faced with having to make choices about which colour to use, artists took advantage of the limits of lithography to come up with some creative solutions.

Henry George Gawthorn (1879–1941) was a fine commercial artist who worked for Britain's London and North Eastern Railway (LNER). Gawthorn painted one of the classic poster views of the famous Forth Bridge near Edinburgh for the company. In 1920 he won a commission for India's State Railways to design a poster aimed at the lucrative American tourist market.

The result was "A Street By Moonlight". By setting the scene at night he could add stark moonlit shadows and a cloudless sky, make the most of the few sources of artificial light to animate the scene, and be as outlandish as he dared in his choice of colours. The choice of mauve for the white cow and the white clothing of the street merchants is inspired. The outcome is a work of art AND an eye-catching poster.

Gawthorn's French contemporary Constant Léon Duval (1877–1956) already had a reputation as a fine artist, having exhibited in several Paris salons in the first decade of the twentieth century, before he began his commercial career. From 1920 he painted destination posters for many French railway companies before they were nationalized in 1937. In 1926 the profitable Paris-Orléans line commissioned a large series of paintings of the châteaux of the Loire valley, to which France's second city Orléans was the gateway. Since the line ended at Orléans the posters promoted car tours onward from there.

His portrait of Cheverny is typical. Faced with the impossibility of reproducing the myriad shades of autumn colour he reduced them to two shades of orange, reflected in the flower beds around the building, and two shades of green – three if you count the splash of blue-green which, economically, he also used for the roof shadows. The result is a harmonious view – and all once again under a cloudless sky.

What began as a creative constraint became a stylistic virtue. Printing techniques advanced considerably in the early twentieth century; but the visual clarity which simplified, enhanced colour brought to advertising was useful. Claude Buckle (1905–1973) is one of the most celebrated British exponents of the style.

He trained as an architect and his observation of shadow and light on buildings is a large part of the pleasure of his work. Taking advantage of more accurate printing processes he was able to use a far greater degree of detail, but adhered to the principle of flat, unshaded areas of colour, as seen, for example, in the folds of fabric in his picture of the East Gate over Fore Street in Totnes.

Such was the influence of Buckle and his posters that even today destination posters are produced in his style in order to evoke a particular sense of pre- and post-war nostalgia among the Brits. And always, always under a cloudless sky.

'THIS ENGLAND OF OURS'
Historic TOTNES · Devon GWR

RIGHT: Henry George Gawthorn's early 1920s poster for the Indian State Railway was produced in London. Gawthorn also created many posters for British railway companies, advertising destinations such as Felixstowe and Clacton-on-Sea.
BELOW LEFT: Claude Buckle's poster of Totnes. Between 1932 and 1963 he produced around 85 posters for England's Southern Railway and Great Western Railway companies.
BELOW: Designer Constant Duval did the same job as Buckle and Gawthorn for French railways until they were nationalized in 1937. This poster of Cheverny in the Loire Valley is from 1926.

ABOVE: Many years before Banksy used stencils, A. M. Cassandre employed them in his work (though for very different reasons) including in a series of posters such as "Étoile du Nord" and "Nord Express" (1927) which included elements of Cubism and Futurism. He also designed Art Deco typefaces: Bifur, Acier Noir and Piegnot. Cassandre viewed his typography as integral to the image he created.

Art Deco Travel Posters
(1922–1937)

The alignment of three strands of social history – the Jazz Age, Art Deco and the rise of leisure tourism – made the 1920s and 1930s a golden age of poster design. As the world emerged slowly from the Great Depression, travel posters of the era glowed with a carefree joy to which everyone aspired.

Art Deco made us look at the essential shape of things – the squares and circles, the straight lines and the curves which define what we see. In the world of transport new and wonderful machines were emerging: planes, trains and automobiles which were good to look at, as well as better at their core functions. Streamlining was applied to everything from fridges to fountain pens to imply ease of movement, smoothness and modernity.

French artists led the way in graphic design and two names in particular stand out. The first, Roger Broders, worked for the Paris-Lyon-Mediterranean Railway Company (PLM) from 1922 to 1932. He travelled the length and breadth of its network to produce almost a hundred posters advertising the destinations to which it could take you.

Like many railway companies of the day the PLM extended its reach by running a fleet of motor vehicles which connected the nearest station with resorts not served by rail; for example the Alps and the Côte d'Azur. Broders' posters often include jaunty charabancs speeding off on the next leg of your journey. Marseilles, the line's southern terminus, was also the jumping-off point for shipping to France's North African colonies.

In Broders' pictures geometry rules. A funnel becomes a rectangle, a ventilation shaft a rectangle and the sector of a circle. Tunnels are indicated by an arc; a spiral makes the tortuous drive into the mountains a smooth and focused journey.

Adolphe Cassandre, the greatest French graphic artist of his day, is best known for his travel posters for shipping lines and railway companies. His poster for the Nord Express is one of his finest. With a few thin white lines he captures the pistons and escaping steam of the locomotive. His telegraph lines need no poles and imply distance as well as any lesser artist's converging rails would.

Cassandre, a pioneer of airbrush use, also produced some classic advertising images and logos, including the YSL of Yves Saint Laurent. He was given the honour of an exhibition in New York's MoMA in 1936. The show led to a number of American commissions, one of which was the March 1937 cover of *Fortune*, the business magazine notable for its full-colour covers by leading graphic design artists.

Lucky Strike Cigarettes

(1928)

When American Tobacco hired Edward Bernays, nephew of Sigmund Freud and the "father of public relations", to manage their brand through the 1920s and 1930s, Lucky Strike cigarettes went from being a mere product to a cornerstone of American cool.

Smoking was traditionally marketed to men and considered a masculine activity. The name Lucky Strike harked back to the pioneer days of the gold rushes of the nineteenth century, when men were men and women stayed at home. The idea of women smoking was socially taboo. Bernays decided to target this neglected 50% of the potential market. Smoking adverts were placed in esteemed publications like *Cosmopolitan* and *Bohemia*, and in 1928 Bernays came up with a slogan which struck gold. "Reach for a Lucky instead of a sweet" let women know that cigarettes were less fattening than candy.

This was nothing less than the reinvention of advertising itself. What was being sold was no longer a product, but the solution to the lifestyle insecurities which drove consumers to consume. It struck home with its intended market, and sales of Lucky Strike rose by 300% in the first year of the campaign. Bernays compounded the message by sponsoring models to smoke Lucky Strikes during the 1929 Easter Parade in New York City. The media picked up on it and Luckies became a symbol of female empowerment; some even called them "Torches of Freedom".

The posters for Luckies put body-image anxiety front and centre. They showed slim, happy women – and very occasionally men – haunted by shadows of their larger, implicitly unhappier future selves. The message was that Luckies were not only socially desirable but medically beneficial, a strategy bolstered by

descriptors like "slim" and "ultralight".

American Tobacco was also the first cigarette company to show physicians in its ads. They spent lavishly in Hollywood, almost $700,000 (nearly $4 million in today's terms) in 1938–39 alone, to secure celebrity endorsements from film stars such as Gary Cooper and Bette Davis. They attained such a central place in American life that Luckies were included in the C-rations sent to US troops during World War II.

Legislative and congressional dealings in the 1990s, when American Tobacco executives denied the addictive nature of nicotine under oath, marked a turning point. Many nations now explicitly ban the type of advertisements that allowed Lucky Strike to dominate its market. They are no longer sold in the United States, but Luckies command a considerable international market. Their placement in the television show *Mad Men* – which fictionalized the sloganeering of real-life Lucky Strike ad man Albert Lasker – led to a dramatic spike in sales from 23 billion packets in 2007 to 33 billion in 2012.

Today the iconography of Lucky Strike – the red bull's-eye and distinctive green packaging (changed to white in 1942 on the advice of brilliant industrial designer Raymond Loewy) – has a dedicated collectors' following, with a single vintage pocket tin selling at auction for $715 in 2001. Like Campbell's Soup or Coca-Cola, Lucky Strike has secured a place in the pantheon of instantly recognizable twentieth-century brands.

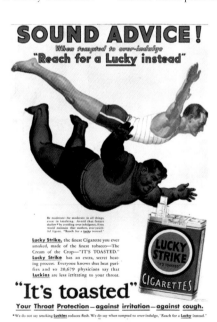

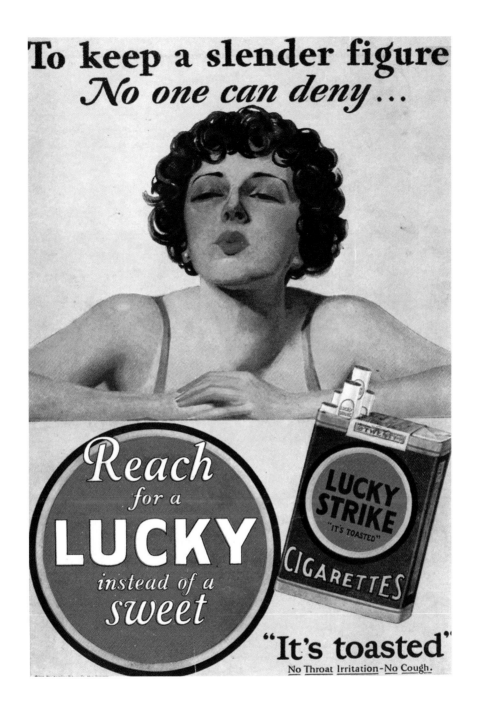

ABOVE AND OPPOSITE: *When the Lucky Strike advertising agency wanted a new poster they reached for a fat-shaming scenario.*

The Cult of Stalin

(1930s–1953)

The Communist Party of the Soviet Union was master of the political propaganda poster. During the Revolution, posters were effectively wall newspapers announcing the latest government thinking, and their role and appeal developed and changed during the Soviet era.

Some of the best artists were commissioned to create the posters, and the poet and playwright Vladimir Mayakovsky often said that if a poster could not bring a running man to a halt it had failed. Themes and representations included hard work, the vital role of peasants and workers, and that men, women and children all had their part to play in the revolution.

The red flag, the red star and hammer and sickle images were omnipresent, and when Stalin replaced Lenin as General Secretary, visual themes spread to include the collectivization of land, industrial production targets and the Five-Year Plans. Images of Stalin himself working and leading became increasingly evident. When World War II – known in Russia as The Great Patriotic War – began, posters of Stalin showed him in uniform beside tanks, artillery and rocket launchers, with aircraft overhead. The Communist Parties of other countries admired him, a triumphant war leader with his Soviet Empire extending into

Eastern Europe, and invariably featured Stalin on their posters, often with a soft focus image of Lenin behind him.

In 1943 Stalin made himself Marshal of the Soviet Union, the highest rank in the Red Army; and a poster from 1947 shows him in his Marshal's uniform wearing his Hero of the Soviet Union medal. There are other tell-tale signs of Stalin's vanity. He was a short man, 5' 4" in height, with pock marks on his face from the smallpox he contracted as a six-year-old, but in this poster he cuts an imposing figure with a flawless complexion. The caption reads, "A caress from Stalin lights up the future of our children." There was a communist cult of childhood, a metaphor for innocence and the promise of a new world populated by a new people, "homo sovieticus". It also presented Stalin as the father of the nation, requiring love and obedience.

Kindness to children was not always at the top of Soviet leaders' agendas: in 1936 Stalin was photographed with 7-year-old Engelsina Markisova when she presented him with a bouquet of flowers, but two years later he had her father executed as a Trotskyist. Stalin's henchman and state security chief Lavrenty Beria was a sexual predator with a predilection for underage girls.

Stalin's posters often echoed Russian Orthodox Church iconography; Stalin is the Madonna, cradling the child which brandishes the red flag rather than a manuscript of the law. Stalin's mother had her son educated in an Orthodox seminary, and shortly before she died said to him, "You'd have done better to become a priest."

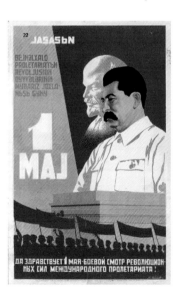

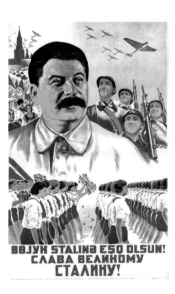

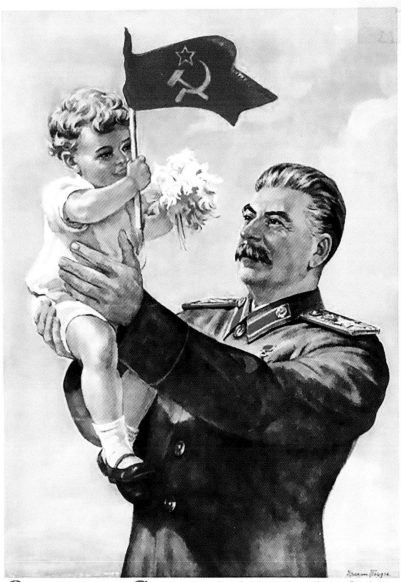

ОЗАРЯЕТ СТАЛИНСКАЯ ЛАСКА
БУДУЩЕЕ НАШЕЙ ДЕТВОРЫ !

ABOVE: By 1947 poster illustrators were allowed to introduce flecks of grey hair into Joe the Georgian's public image. The slogan for this poster reads: "Stalin's kindness illuminates the future of our children." Stalin's kindness only lasted another six years until his death from a stroke in 1953.

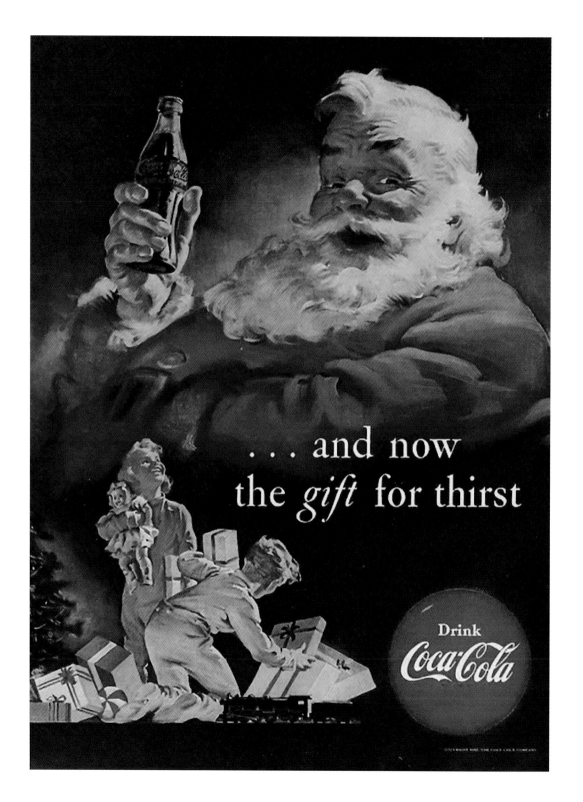

Coca-Cola Santa

(1931–)

Although it isn't true that Coca-Cola invented the image of Santa Claus which we all know and love, the soft drinks company have certainly fostered it over the past ninety years with its jovial Christmas advertising posters.

It sometimes feels as if the annual Christmas commercial for Coca-Cola is as traditional a sight as a decorated tree or a row of stockings on the mantelpiece. The familiar image of the big man in the red coat with the bushy white beard first appeared on Coke advertisements in 1931, drawn by an illustrator called Haddon Sundblom (1899–1976).

Christmas was at that time a slow period for effervescent soft drinks like Coca-Cola, regarded more as sources of refreshment during the summer months. Coke's move to adopt the central figure of the festivities, who after all already wore the company's colours, was a master stroke. They were not, however, the first, either to put Santa in a red suit or to use the image in advertising.

Red-coated Santas had been portrayed since at least the start of the twentieth century. A red Father Christmas was a regular feature on the Christmas cover of *Puck* magazine in the first decade of the century, for example. One was used to illustrate a Frances Hodgson Burnett short story called *Father Christmas* in 1905. It's thought that Sundblom based his version on the central figure of an 1822 poem called *A Visit from Saint Nicholas* by Clement Clark Moore, now more commonly known after its opening line as *'Twas the Night before Christmas.*

The first recorded instance of its use in advertising dates from 1915. White Rock Mineral Waters depicted a weary Santa sitting in the kitchen after a hard night's work, his empty sack beside him, wiping his brow and drinking a glass of White Rock dry ginger ale.

In early versions Coca-Cola's Santa Claus also used a glass, but by the 1950s he was drinking straight from the bottle, the better to show the product to their customers. Coke used words like taste and thirst not only for their meaning but for their sound, the sound of fizz being released. The phrase "the gift for thirst" in a 1952 poster does it twice – ffft and ssst.

In 1953 the Christmas ad returned to a well-established Coca-Cola slogan – "the pause that refreshes" (with more ssss and sssh sounds). The phrase was first used in the summer of 1929 and is evoked in other Christmas posters; for example, one in which a child has left Santa a glass, a bottle opener and a bottle of Coke with a note reading "Dear Santa, please pause here".

Coca-Cola's Christmas posters have now been superseded by its "Holidays are coming!" TV commercials. But for decades it was their posters which heralded the Christmas season, and which so successfully put Coke at the heart of it. The figure of Coke's Santa remained constant and instantly recognizable throughout that time, for one very good reason – Haddon Sundblom modelled it on himself.

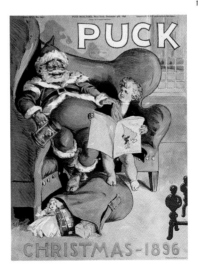

OPPOSITE: Santa takes it easy after doing his rounds in 1952.

LEFT: The original red-robed Santa from the 1896 cover of Puck *magazine. And that looks like a beer tankard in his right hand.*

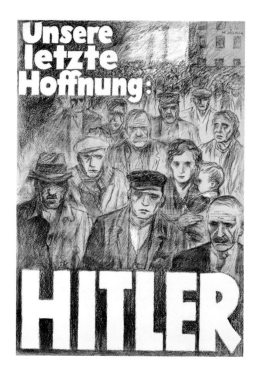

LEFT: "Our last hope: Hitler" showed the bleak destination the German people were headed, unless they voted him into power.

BELOW: Times were good in a newly confident Germany of the 1930s. They had the prestige of hosting an Olympic games and created the people's car.

BELOW LEFT: Red, white and black prevailed in this Nazi poster quoting a speech from Propaganda Minister Joseph Goebbels, "Now nation arise and let the storm break loose."

Nazi Third Reich Posters

(1932–1943)

Adolf Hitler's National Socialist Party, the Nazis, were masters of the art of propaganda and, to that extent, role models for political parties of every shade since then.

Germany's experience of the Great Depression of the 1920s and 1930s was deepened by the burden of war reparations. Reeling from high unemployment and hyper-inflation, the German people needed scapegoats. Hitler was only too eager to supply them by demonizing Jews and Communists.

In 1932's national elections to the Reichstag, the lower chamber of the German parliament, the National Socialist German Workers' Party (Nationalsozialistische Deutsche Arbeiterpartei or NSDAP) were the challengers, the outsiders. They had only to remind the public how miserable life was under the present government to seem like an attractive alternative. On NSDAP election posters, a drab grey portrait of the German people was not only cheaper to produce than a full-colour one but evoked exactly the sense of depression which Hitler, "Unsere letzte Hoffnung" (our last hope), wanted to remind them of.

The NSDAP won the largest share of the vote in the 1932 elections but not an overall majority. The German President appointed Hitler as Chancellor in the mistaken belief that he and his conservative allies would be able to control him in power. Through a series of wily political moves, however, Hitler soon turned Germany into a one-party state with him at its head.

Having seized power, the tone of Nazi propaganda changed dramatically. Its job was now to remind people how good life was under Nazism, while subtly reinforcing the racial ideas of Aryanism. Posters were now in full, joyful colour; skies were blue, blonde women were beautiful, blond men were handsome, and everyone was smiling. The Party's new slogan was "Kraft durch Freude" (KdF, Strength through Joy) and it was applied to several Nazi morale-boosting projects.

One of them was the Volkswagen, the "people's car". Originally launched in 1938 as the KdF-Wagen it cost only the price of a new motorbike, payable at five marks a week. Posters showed just how happy such a car could make you; and about 335,000 Germans bought into the scheme, joining the car-owning classes.

Having given the people cars, Hitler wanted to give them *lebensraum* (space to live) as well, by invading neighbouring countries. He underestimated the degree to which the international community would tolerate such actions, and by 1943 his war effort had stalled. On 18 February 1943, beneath a banner proclaiming "Totaler Krieg – Kürzester Krieg" (Total War – the Shortest War), Hitler's propaganda minister Joseph Goebbels urged the German people to redouble their commitment to victory.

A line from his speech was adopted as the slogan for a new poster campaign, one which ironically drew on Soviet-style imagery. The phrase "Nun, Volk, steh auf und Sturm brich los!" (Now, people, stand up and let the storm break loose!) was from a German poem written during the Napoleonic Wars. It had often been quoted by both Goebbels and Hitler. Now it was applied to a picture of German men handing their tools to women while they took up arms beneath a red Nazi banner.

By waging total war, however, Germany in fact prolonged the war and the suffering of the German people. Hitler committed suicide on 30 April 1945 and Goebbels killed himself, his wife and his six children a day later.

Transatlantic Liners

(1875–1935)

Ever since Columbus ran into America en route to the Far East, people have wanted to make the same crossing of the Atlantic Ocean. In posters advertising the journey, shipping lines cultivated an image of grandeur and reliability for a sea voyage which was not always a comfortable one.

In the early days of the transatlantic route, the journey between Europe and America was not something to be undertaken lightly. Charles Dickens' first trip to America in 1842 was endured not enjoyed. Poster advertisements of the time spoke more of safety than comfort. Images of the ships were often less important than the claims for speed and reliability.

The first two decades of the twentieth century saw changes in the clientele and in the ships in which they were prepared to sail. New liners were launched with luxurious first-class upper decks to rival the grand hotels of continental Europe. The ship was becoming the star, and sensational headlines accompanied disasters like the loss of the White Star Line's *Titanic*, famously sunk in the frigid North Atlantic in 1912, and the torpedoing of the Cunard Line's *Lusitania* by a German U-boat in 1915.

Demand for transatlantic travel survived the war and the Great Depression which followed. New grand ships were launched from the great shipyards of Europe – the RMS *Empress of Britain*, built in Scotland's legendary John Brown shipyard on the Clyde estuary in 1930, or the SS *Normandie* from Saint-Nazaire, France. The latter's maiden voyage in 1935 was the high-water mark of the golden age of the transatlantic liner. By then, Art Deco was bridging the gap between commercial and fine art and A. M. Cassandre's posters for the SS *L'Atlantique* and SS *Normandie* are high points of design. Most significantly, the poster was not a photo-realist view; it was an abstract representation of the ship. The travel companies were selling an idea of style, not a view of the deckplan.

The *Normandie* dominates its poster. The symmetry evokes stability, disrupted only by a tiny French flag. It appears enormous: seagulls fly around the waterline of its hull, a metaphor for the ship's dominion over the waves. The Art Deco geometry of rectangles and triangles is softened by rounded corners and the ship seems about to burst forth from its rectangular frame. Cassandre was a master of his craft and inspired many imitators. For example, a poster for the *Empress of Britain* by the Clement Dane Studio, a leading London advertising agency at the time, owes much to Cassandre.

The era ended with World War II. The *Empress of Britain* was the largest liner sunk during the conflict. The *Normandie* caught fire while undergoing conversion into a troop ship in New York and was scrapped. After the war, aircraft replaced the function of the great ocean liners. Today the largest passenger ships are built not to go anywhere but to cruise between ports, a pastiche of the luxury liners of the past.

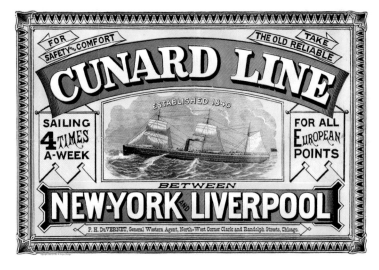

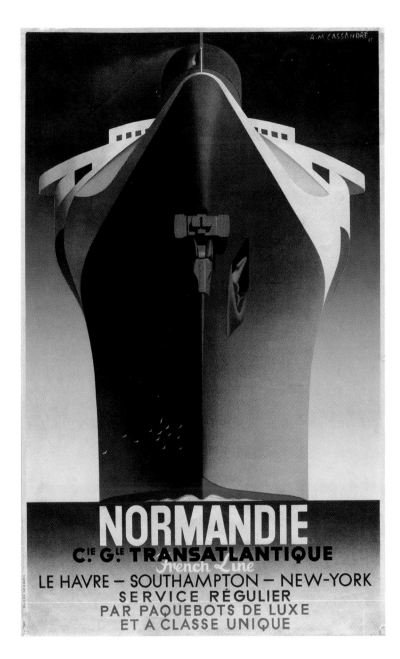

NORMANDIE

Cie Gle TRANSATLANTIQUE

French Line

LE HAVRE – SOUTHAMPTON – NEW-YORK

SERVICE RÉGULIER

PAR PAQUEBOTS DE LUXE

ET A CLASSE UNIQUE

LEFT AND BELOW: If imitation is the sincerest form of flattery, then Adolphe Cassandre should feel intensely flattered that his game-changing poster of the SS L'Atlantique *(1931) was copied by Canadian Pacific's advertising agency. Cassandre went one better with his poster of the newly launched* SS Normandie *in 1935.*

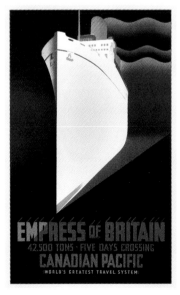

EMPRESS OF BRITAIN
42,500 TONS · FIVE DAYS CROSSING
CANADIAN PACIFIC
WORLD'S GREATEST TRAVEL SYSTEM

OPPOSITE: An early colour poster for the Cunard Line. Up until 1930 transatlantic liners were advertised with an emphasis on speed and safety, accompanying a splendid, realistic image of the ship.

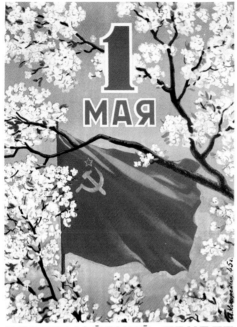

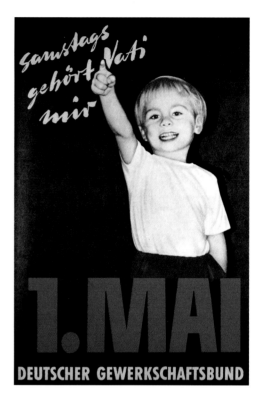

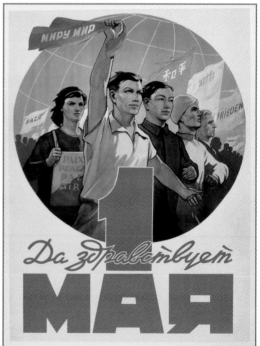

1 May Celebrations

(1936–1977)

The roots of May Day celebrations lie in pre-Christian rites to welcome the return of fertile Spring. However, over the course of the twentieth century, the sounds of revelry have sometimes had to compete with the din of May Day demonstrations and, often, their counter-demonstrations.

As far back as Roman times, people would celebrate the arrival of spring in May with dancing, banquets and devotional rites. In the industrial age, when the rights of labour were being given serious consideration, 1 May took on a new role as International Workers' Day, established by trade unions. Traditional festive May Day parades became marches for improved conditions and pay; thus a 1955 poster for the Confederation of German Trade Unions by Paul Reiff shows a small child beaming with delight as he realizes that "on Saturdays my daddy is mine".

The Soviet Union, which used posters extensively as its channel of ideological communication, always made great play of International Workers' Day. Alexei Kokorekin's 1945 poster shows the Soviet flag flying proudly among the blossom. "1 May greetings to heroes of frontline and back areas," says the strap line. During World War II, Kokorekin's posters tended to be rather more aggressive in tone with square-jawed Russian soldiers and sailors bayoneting Nazis or hurling grenades. The blossom poster suggests that after the terrible sacrifices of Russia's Great Patriotic War, the nation can now look forward to a peaceful future.

Harmony is also the central theme of Viktor Koretsky's poster showing various people of the world striding forward under banners which read "Peace" in many languages, including German. Naturally, Koretsky depicts Russia as leading the way in the march towards global friendship. Regrettably, such sentiments were in short supply when the poster came out in 1956, the year that Israel invaded Egypt and the Soviet Union invaded Hungary.

Not every May Day event had such noble objectives. The event has often been hijacked for propaganda and politicized in ways which would horrify those who first proposed it. In countries where the divide between differing political views is stark, May Day is often more notable for the smell of tear gas than May blossoms. The May Day poster by Gülgün Basarır shows a clenched fist holding a spanner filled with the faces of Turkish workers. It was designed in 1977 when a May Day demonstration in Istanbul's Taksim Square ended in bloodshed after an unidentified gunman opened fire on the crowd. At least thirty-four people died and the Turkish government banned May Day rallies in the square for the next thirty years. More recent May Day events in the city, when they have been permitted, have also been flashpoints for conflict.

OPPOSITE: A quartet of 1 May celebration posters. The Soviet poster with May blossom (top left) was an unusual subject for Alexei Kokorekin who produced many propaganda posters in World War II. He was a two-time winner of the Stalin Prize, but died in the smallpox outbreak of 1960, after returning from India with the disease.

WPA: Social Policy Posters

(1936–1943)

The economic and social wreckage wrought by the Great Depression in the US gave rise to a short-lived, nationwide regeneration project of breathtaking ambition and scope, unique outside totalitarian regimes. Poster art was at the very heart of this great experiment.

When Franklin D. Roosevelt was elected President of the United States in 1933, he took the helm of a country in the grip of the Great Depression, soon compounded by a cruel drought which destroyed the agricultural heartland of the country. Roosevelt introduced radical emergency measures in 1935 to restructure and stimulate the economy, including reform and regulation of the banking and securities sectors, and the federal control of agriculture production.

Dubbed the New Deal, this large-scale government intervention in the economic and industrial activities of the nation included the ambitious Works Progress Administration (WPA), which undertook major state-funded infrastructure, social and cultural projects, as a means of reducing unemployment. By the time the WPA was disbanded in 1943 it had employed 8.5 million people.

To characterize the WPA solely as a road-building and housing programme is to underestimate its nation-building ambitions. Its choice of projects reflected wider social and cultural aims as a means of addressing the social damage and threatened unrest caused by the Great Depression. Projects were chosen for their contribution to the creation of a more equitable and cohesive society, effectively reimagining America for a new age, in the hope of avoiding a disaster such as the Great Depression in the future.

Emblematic of these wider aims was Federal Project Number One, which employed musicians, writers, artists and actors in large arts and

literacy projects. The inclusion of the arts within a national programme shifted the status of art and artists in American society. Art took its place as a feature of national infrastructure and the work of being an artist took its place alongside the labour of any other citizen. Art and artists came to occupy a heroic position in the country, to the extent that Jackson Pollock, one of the artists supported by the FAP programme, could feature on the cover of *Time* magazine in 1940.

Federal Project Number One consisted of five different arts programmes: a Historical Records Survey, and separate projects for writers, theatre, music and art. The Federal Art Project (FAP), the largest of these, was led by Director Holger Cahill, a firm believer in the importance of art in everyday life rather than as a commodity of the wealthy. Cahill oversaw the production of an enormous body of more than 200,000 artworks, including murals, sculptures, paintings and drawings, all destined for public places such as schools, civic buildings, hospitals and parks.

In addition to producing decorative works, artists working in the FAP produced hundreds of public information posters encouraging everything from literacy to health and safety at home. The poster project within the FAP not only provided work for graphic artists and printers, it also created a collaborative community that developed and enhanced the technical and artistic quality of poster design, such that it became accepted as a fine art medium in its own right. Finally, it was the means by which other programmes in the WPA were promoted and established in public awareness.

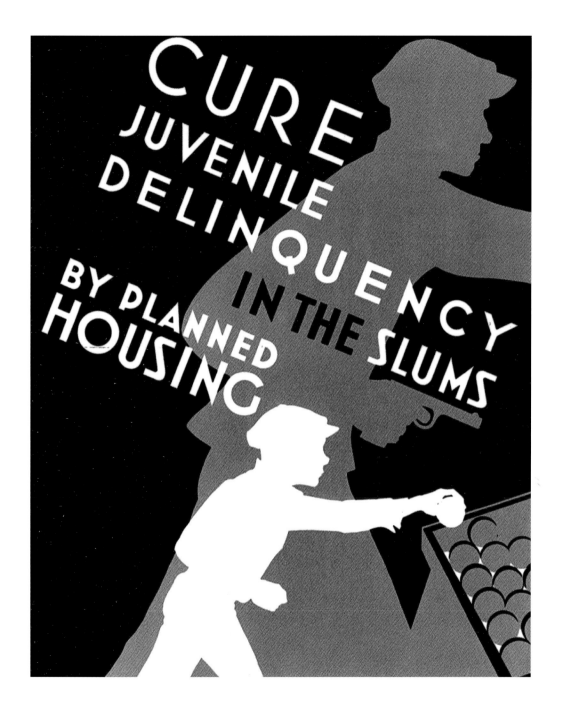

ABOVE: The rhetoric on some of the WPA social policy posters bears a distinct similarity to posters produced under Soviet and Chinese communism, targeted as they are at the decision-making elite.

RAIN
is bad for a book!

A
BOOK
MARK
would be better!

don't **GUM UP** a book

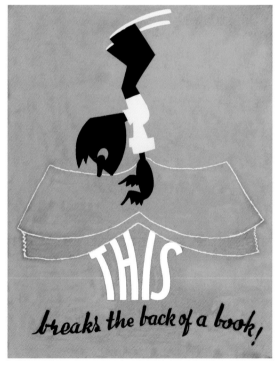

THIS
breaks the back of a book!

WPA: Books and Literacy Posters

(1936–1943)

Between 1936 and 1943 over 35,000 original poster designs were created by artists working for FDR's New Deal Federal Art Project. They announced events and exhibitions, conveyed public health messages and promoted public programmes such as housing and literacy.

Posters produced by the Federal Art Project (FAP) were designed in response to requests from other public bodies and national and state programmes involved in the New Deal. By 1938, there were FAP poster divisions in at least eighteen states. The New York poster project alone, which employed around fifty artists, produced more than 300,000 prints from 11,240 designs. This remained the most influential and innovative studio, technically and artistically.

Richard Floethe, an established graphic artist and illustrator who had trained at the Bauhaus, was the dynamic leader of the New York project and responsible for the building of a highly collaborative and inventive studio. He was committed to a utilitarian view of art in society. Good visual thinking should be integrated into all aspects of society, and the designer should be equally at home in industrial design as in fine art.

Artist Anthony Velonis is credited with introducing methods of commercial mass production, notably silkscreen printing, which radically expanded the capacity of the poster projects. Silkscreening was cheap, and could be undertaken in the same studio as the design work, overseen by the design artists who could attend to the quality of the finished work. The technique, using flat plains of colour layered on top of each other, also created an underlying stylistic unity in the posters, despite the variety of styles and artists – many of them European emigrés who brought their stylistic signatures with them.

As well as schooling and remedial classes, the WPA expanded

public library provision. In 1934, only two states provided public library access to their total population. Funding was provided on a state-wide basis and for individual library activities. In particular, libraries were introduced in rural areas, which had previously lacked any provision. A contemporary report from 1938 stated that 18,000 people were working in WPA library projects in thirty-eight states. In addition, 12,000 people were involved in book repair projects for school and public libraries in thirty-six states.

Posters were commissioned to promote reading and to advise appropriate use of this expanded library provision. The Illinois Statewide Library Project, for example, commissioned a series of posters from the Illinois Art Project (IAP) in Chicago to encourage reading by both adults and children. The IAP also produced a series of humorous posters to teach children that the books from the library should be cared for. Designed by artist Arlington Gregg, they showed how you shouldn't treat a book, for example by letting rain get to it, or turning pages with sticky fingers.

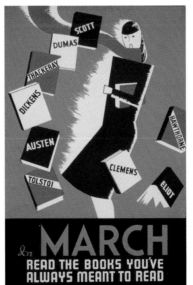

OPPOSITE: *Arlington Gregg's fun posters aimed at book preservation.*

LEFT: *Many great authors to read in March, but bizarrely Mark Twain is given his real name, Samuel Clemens. This may have something to do with Twain's great novel* Huckleberry Finn, *which has been on and off approved library lists since it was published.*

WPA: See America Posters

(1936–1943)

FDR's New Deal was designed to nurture a sense of unity and community in an America brought low by the Great Depression. Posters promoting the country's scenic beauty contributed to these nation-building aims by affirming a shared natural and cultural heritage.

The New Deal's Federal Art Project (FAP) recruited artists to produce posters which informed the public about programmes of interest, be they housing works, better health provision or improved access to education. Some of the best-loved images from the FAP's Poster Project, still popular in reprints today, celebrate the natural heritage of the United States.

The National Parks Service was established in 1916 as a means of protecting the natural resources and cultural heritage of the country and opening them up for enjoyment and appreciation of the general public. The Poster Project produced a series of works in praise of the NPS; and a further series, entitled *See America*, was commissioned by the United States Travel Bureau to promote internal tourism.

The *See America* series highlighted popular national monuments and areas of outstanding natural beauty and cultural interest and was created by several members of the New York studio. Martin Weitzmann, for example, created a strong advertisement for the mountains of Montana which seem to dwarf a mounted figure in the foreground. Richard Halls does the same thing with a native American at the foot of his Montanan mountains. And Alexander Dux used a similar technique to emphasize the scale of the Carlsbad Caverns in New Mexico.

Only around 2,000 designs survive from a total output during the life of the Project of more than 35,000; and most of them were unsigned as a matter of policy. Not all FAP artists

continued in the profession and few are remembered today. Like many, Richard Halls (1906–1976) served in World War II. His father was a sculptor of public monuments and Halls returned to his art studies after the war. He began a career in illustration and his quirky, sometimes comical figures brought him work advertising theatre productions. But like struggling artists the world over he found steadier income as a teacher.

Internal tourism in the US was encouraged by these posters, and made possible by the huge road-building programme of the New Deal. It was further eased by the returning prosperity of the middle classes thanks to the employment opportunities and fiscal stimuli which were part of the New Deal package. Thus, by a series of connected measures, the New Deal engendered a sense of a shared landscape, a people united from sea to shining sea by their common experience of the Great Depression and by the vast programme of works undertaken by them and their government in an unprecedented act of home improvement – their home, be they native or immigrant: their America.

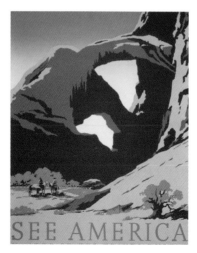

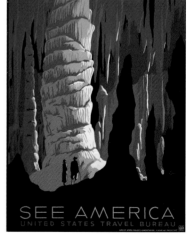

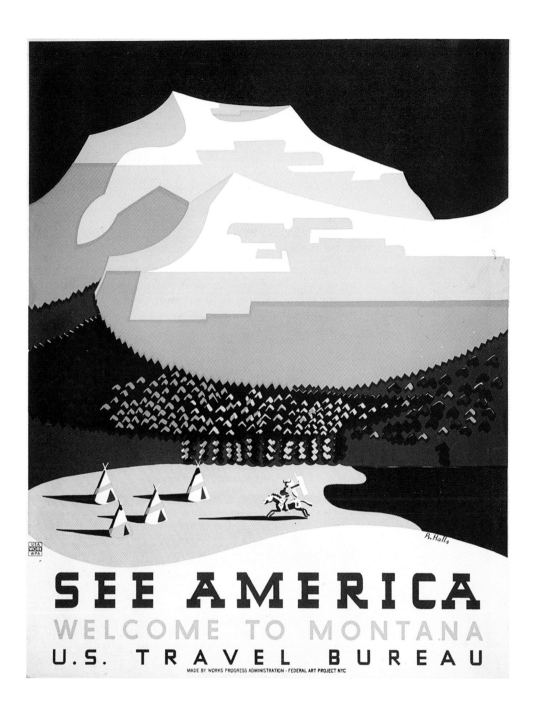

ABOVE: Richard Hall's vision of Montana.
OPPOSITE FAR LEFT: The Double Arch in Arches National Park, Utah, by Frank S. Nicholson.
OPPOSITE LEFT: Alexander Dux's 1937 poster of American caverns.

ABOVE: During the Siege of Madrid in 1936, Communist activist Dolores Ibárruri Gómez, gave an impassioned speech including the phrase "No pasarán" or "they shall not pass," an echo of French General Robert Nivelle at Verdun in 1916. Nivelle's phrase, "On ne passe pas" was also used in patriotic posters. When Franco marched into a defeated Madrid in April 1939, he is said to have declared, "Hemos pasado" — "we have passed."

Spanish Civil War Posters

(1936)

As fascism rose across 1930s Europe, a fledgling democracy briefly flowered and was brutally crushed in Spain. Its art is a testimony to revolutionary ideals and democratic principles; but even art wasn't enough to ensure victory over General Franco.

What began as a military coup against the democratically elected Republican government became a battle between socialism and nationalism, a microcosm of the ideological wars which characterized the whole of Europe at this time. The conflict attracted international combatants, often young and idealistic, to fight alongside Spanish Republican forces. It also caught the attention of artists, whether as fighters or simply documenters, who were drawn to the radicalism and utopianism of the Republican cause.

George Orwell wrote *Homage to Catalonia* about his fighting experiences and Pablo Picasso's painting about the bombing of Guernica remains one of the great anti-war works of art. Less celebrated but perhaps more significant were the thousands of propaganda posters produced by both sides as part of the war effort. In the battle for hearts and minds, these striking, vibrant posters from the many factions in the war were ubiquitous.

At the start of the war, the creation of the posters was ad hoc and spontaneous, but as the war progressed, the government and other Republican organizations created departments to oversee the production of posters. Many posters bore the stamp of the Fine Arts Section (Dirección General de Bellas Artes), part of the Ministry of Public Instruction which the government reactivated in September 1936.

Although the message of the posters was strictly dictated, the eclectic styles reflected the diversity of the artists who offered their services. Russia was one of the main international supporters of the Spanish Communist party, providing resources and weapons. Many posters

imitated Russian revolutionary propaganda of the early twentieth century: bold colours, stylized heroic figures of soldiers and the proletariat, and simple idealistic slogans.

There was other international support. One poster shows two male figures, arms draped around each other in fellowship, standing in front of the Basque and Catalan flags, above the slogan "Basque-Catalan Solidarity". The two regions are still united in their political aims today.

Following the outbreak of war on 19 July 1936, a succession of Republican leaders tried to form governments. But the Republican side was riven by internal ideological conflicts, resulting in a civil war within the civil war. Posters often bore the identity of one faction or another: the National Confederation of Labour (CNT), the International Workers Association (AIT) or the Iberian Anarchist Association (FAI). Thus one poster from the CNT-FAI brings together images of the peasant in the field and the armed soldier, declaring, "Comrade! Work and fight for the revolution!"

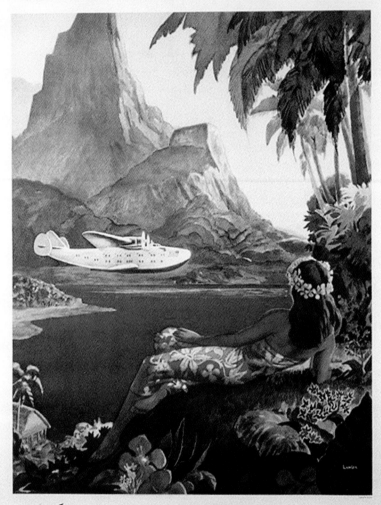

ABOVE: With expensive seats to fill, Pan American needed to attract a steady supply
of high-end tourists with an aversion to long sea voyages. Their posters set the
template for thirty years of airline advertising.

Pan American Clippers

(1939-1942)

Pan American's magnificent Boeing 314 seaplane, the Clipper, was the epitome of luxury air travel in the few years between its introduction and America's entry into World War II. The posters for its routes offered exciting destinations for the wealthy tourist.

Pan Am launched its flying boat services to South America in 1931. Over the next six years the airline added routes across the Pacific and the Atlantic; but it was clear that it was going to need a fleet of larger aircraft; and in 1936 Boeing won the contract to build an adaptation of its cancelled XB-15 long-range bomber prototype, with luxury accommodation for seventy-seven paying passengers. There were separate lounging and dining compartments and the seats could be transformed into beds for thirty-six. Passengers were encouraged to change for dinner, in separate male and female dressing rooms. Flight attendants changed for dinner too, into white coats, in which they served up to six courses cooked to four-star hotel standards. Staff were recruited only from the most experienced of Pan Am's pilots, navigators and cabin crews.

None of this came cheap. When the inaugural flight, from San Francisco to Hong Kong, took off on 23 February 1939, each of its passengers had paid $760 for the privilege, the equivalent of over $14,000 today. The trip took only six days compared to nearly three weeks by ship. Actual flying time was around nineteen hours, but the need to refuel and replenish required stops at Pearl Harbor, Midway Island, Wake Island, Guam, and Manila. As if the luxury of scheduled flights wasn't enough, the Rio service was offered in 1941 in the manner of a sea cruise, stopping at nine glamorous destinations en route from Miami – Cuba, Haiti, Santo Domingo, Trinidad, San Juan in Puerto Rico, Guyana, Pará, Recife and Bahia – and finishing with

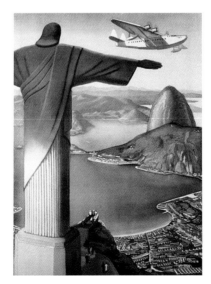

three days in the Brazilian city.

Little wonder that Pan Am insisted its new aircraft be prominently displayed in the promotional posters for the routes it served. Each empty seat represented a large potential loss of revenue and so Pan Am were keen to portray the glamorous, exotic opportunity their service promised to deliver. The Clipper, so called because it criss-crossed the oceans like the old tea clipper ships in the age of sail, opened up the world to the pleasure-seeking rich as never before.

The route to New Zealand island-hopped across the South Seas. Two Atlantic timetables were introduced later in 1939, one to Lisbon and one to Southampton via New Brunswick, Newfoundland and the Shannon estuary in Ireland. The Clipper service was a flagship for all of Pan Am's routes and it heralded a new era of airborne tourism.

But the era was short-lived. When war erupted in Europe the North Atlantic route was abandoned. And after the attack on Pearl Harbor the Clipper fleet was diverted into military service.

After the war the Clippers were obsolete. So many land runways had been built for long-distance bombers that there was no need for flying boats. The 314s were replaced by Douglas DC4s and Lockheed Constellations. Only twelve Clippers were ever built. The last flight landed in 1946 and by 1951 all the surviving planes had been broken up for scrap. But for two brief years before the war, they lit up the flight paths with new possibilities and high-flying glamour.

Keep Calm and Carry On
(1939)

Fifty-five years after the end of World War II, Stuart Manley, co-owner with his wife Mary of Barter Books in Alnwick, Northumberland, sat down to sort some books. This most mundane task would give the world a distinctly British poster so iconic that it is now as recognizable as Coca-Cola.

No one was ever supposed to see the poster telling the public to "Keep Calm and Carry On" during the Blitz. In 1939 a committee was commissioned by the Ministry of Information to produce a propaganda campaign that evoked a "state of mind" to see the country through the looming hardships of war. Designer Ernest Wall-Cousins received the brief and prepared twenty variations.

Five were presented to Home Secretary Samuel Hoare, who selected three for the HM Stationery Office to print just as Germany signed a non-aggression pact with the Soviet Union and war with Britain was formally declared.

The designs were simple: white text set in a slight modification of the font Gill Sans. The only graphic element was a George VI crown, rescued from an abandoned plan to issue a "royal message" sent by mail to every household. The red and white colour scheme was based on the belief that those colours would evoke a psychological reaction in the public – ironically, it shared this trait with Hitler's *Mein Kampf*.

Neither of the other concepts, "Your Courage, Your Cheerfulness, Your Resolution Will Bring Us Victory" and "Freedom is in Peril; Defend it With All Your Might" are remembered, despite the fact that they were widely distributed in public spaces. Keep Calm, meanwhile, was shelved, and most copies were pulped to help mitigate a paper shortage. It was forgotten until Mr and Mrs Manley displayed a copy of the poster, found in a box of books bought at auction, behind their shop counter. Their customers' curiosity was piqued, and a few years later they reproduced the poster and sold it through London's Victoria and Albert Museum.

This coincided with the 2008 financial crash when many in Britain experienced financial shock unlike anything since the war. In this context, Keep Calm became a cultural statement very much as originally intended, an embodiment of British stiff-upper-lip defiance in the face of adversity. Some termed it "austerity nostalgia". As Pink Floyd sang on their album *Dark Side of the Moon*, "Hanging on in quiet desperation is the English way."

Since then the slogan has been quietly subverted – another very British thing to do – with parodies displayed on everything from coffee mugs to mock British passports. It now appears in infinite variations such as "Keep Calm and Carry On Shopping" or "Now Freak Out and Panic". In 2009 Welsh rock band The Stereophonics named their seventh album *Keep Calm and Carry On*, and the loyalty card for the British supermarket Sainsburys was launched with the tagline "Keep Calm and Carry One".

Like everything in the consumer-driven twenty-first century, the spirit that inspired Keep Calm is these days little more than a marketing tool, plastic-wrapped and available to purchase. But every would-be humorous riff on the original phrase reminds us of the original need for it. So perhaps, 80 years on, Ernest Wall-Cousins' simple public service announcement can carry on doing its work in the post Covid-19 era.

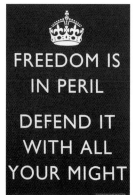
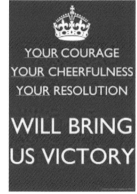

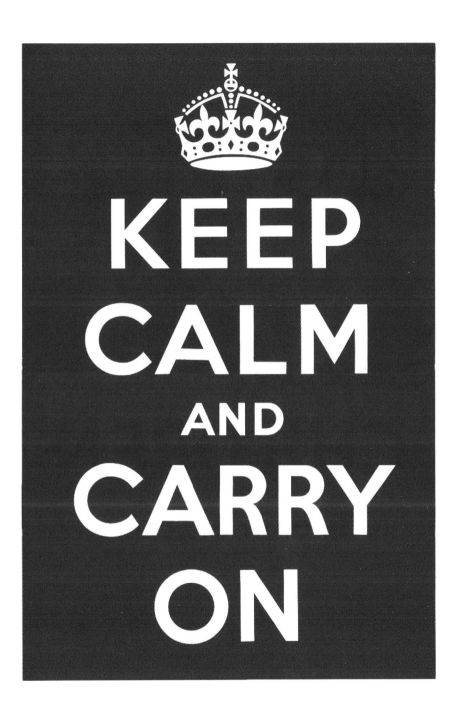

ABOVE: Keep Calm And Carry On has much in common with Rosie the Riveter.
Both posters were hardly seen when they first appeared and only became
popular retrospectively.

CHILDREN

are safer in the country

. . . . leave them there

ABOVE: After children were evacuated at the start of the war, parents immediately began to worry.

OPPOSITE TOP: In World War II, merchant seamen, who wore no uniform were sometimes unfairly targeted by the public as cowards, when in reality their service was one of the most dangerous of them all.

OPPOSITE BOTTOM: Despite the considerable flying distance, the Luftwaffe soon targeted the shipyards of Belfast, Glasgow and Merseyside for bombing raids.

World War II: Boosting Morale
(1939–1945)

Britain's Ministry of Information, originally formed at the outbreak of World War I, was revived in 1939 as hostilities broke out once more across Europe. Its role was threefold: to issue propaganda; to inform the public of wartime measures; and to bolster British morale.

Propaganda was designed as much for overseas consumption as domestic. It trumpeted victories and concealed setbacks to persuade Germany that its attacks were failing. Posters also reminded civilians of their wartime responsibilities such as not sharing information which might be of use to the enemy, or growing vegetables at home to help with food shortages.

However, the maintenance of morale was a subtle and complex business. Posters were one part of an information arsenal that included films, public exhibitions, and radio broadcasts. The British Broadcasting Corporation was rewarded for the comfort it brought into people's homes with the unquestioning trust of the public in its impartial accuracy. In fact the information which it broadcast was carefully managed with regular omissions so as to misdirect any enemy ears.

The government's message was reinforced with posters hung in town halls, libraries, village centres and church meeting rooms. Millions of posters were printed for the home front.

Morale, the government reasoned, was damaged by fear; so these posters' primary object was to allay any concerns in the public. During Hitler's bombing campaign of Britain's cities, the nation's urban children were evacuated to the countryside, and many parents, especially mothers left at home while their men were on the front lines, had plenty to worry about. Many were tempted to retrieve their children and posters tried to reassure them that their young ones really were safer where they were. (In fact not all children found happy surrogate homes during evacuation, but equally many lives were enriched by their wartime experiences of country life.)

Other posters were designed to demonstrate that Britain was up to the job of fighting a war. The government was so short of steel that it was asking people to donate the iron railings from their homes and gardens, although rumours spread that even that was just a way of engaging the public, that the railings were not fit for purpose and that they were simply dumped out at sea. In any case the claim of one poster that "Britain and America have over two million tons more shipping to-day than in August 1942" was intended to prove that Britain was keeping up, even if the inclusion of America masked the real state of Britain's ship-building, which was heavily reliant on Liberty ships built in American dockyards.

Nearly one third of the world's Merchant Ships fly the RED ENSIGN

BRITAIN AND AMERICA HAVE OVER TWO MILLION TONS MORE SHIPPING TO-DAY THAN IN AUGUST 1942

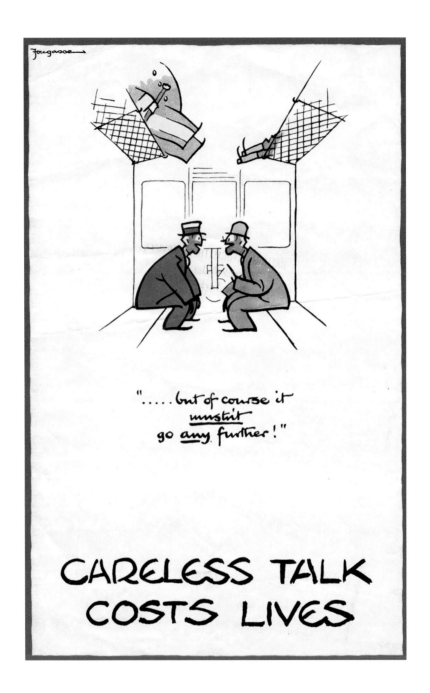

ABOVE: The British "Careless Talk" posters used humour to get the message across. American versions were more hard-hitting with slogans such as "Careless Word … A Needless Loss" and "Careless Word … Another Cross". Fougasse's work was also known in France and his poster illustrations were published in Paris Soir *before the Fall of France in May 1940.*
OPPOSITE: William B. Finley's poster for the Federal Art Project, from 1943.

Careless Talk Costs Lives

(1939)

At the start of World War II the need for vigilance on the home front was greater than ever. Posters urging the civilian population to watchfulness had to strike a balance between over-authoritarian commands and too-casual advice which might fail to get the message across.

World War II presented new threats. Aerial warfare had come into its own, as both the US and the UK found to their cost in Hitler's Blitzkrieg on London and Japan's attack on Pearl Harbor. The development of submarine warfare curtailed Britain's ability to import food and raw materials. And on both fronts the war was a premeditated act in which Hitler and Tojo had had time to establish agents of espionage in their chosen enemy's territories.

In Britain, some people were open in their admiration for Hitler. Oswald Mosley even imitated him as leader of the British Union of Fascists with his paramilitary force known as the Blackshirts. With all that in mind, and with so many civilians involved in various capacities in the war effort, the "Careless Talk Costs Lives" campaign urged discretion. There were several strands to the campaign and posters placed in and around British ports were sombre graphic illustrations of the danger to shipping. "Never mention ship sailing dates, cargoes or destinations to ANYONE," they demanded, beneath greyscale pencil drawings of spies in pubs and radio operators in sinking ships.

Those aimed at the general public had a lighter touch, and the best remembered of them were by a popular cartoonist of the day, Fougasse. Fougasse, real name Cyril Bird (1887–1965), was the editor of *Punch* magazine, a popular satirical weekly publication. His style was instantly recognizable and his series of eight posters about Careless Talk are remarkable for simply presenting his cartoons as they would normally appear in the columns of *Punch* – unembellished, unframed, the whole thing written and drawn by Fougasse without formal typefaces or government insignia. It was a very direct way of communicating the message.

Each cartoon showed two people gossiping, with a short punchline: a soldier and his girlfriend, who swears, "Heavens, no, I wouldn't tell a soul!" while a dog looking suspiciously like Hitler raises an ear; two women on a bus, one reminding the other, "you never know who's listening!", while Hitler and Goering are sitting two seats away; a man in a telephone box pleading, "… but for heaven's sake don't say I told you!" while surrounded by a dozen eagerly eavesdropping little Hitlers.

The campaign was tremendously successful in getting people not to talk carelessly. Germany became convinced that any information which it did glean from overheard conversations was probably deliberate *mis*-information and should be disregarded. The same slogan was adopted, with a more direct messaging style, in the US after it entered the war. Fougasse went on to design posters about not wasting wartime resources, and about easing travel on London's Underground system. After the war he was awarded the civilian honour of a CBE for his contributions.

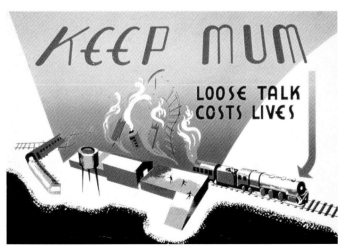

Dig for Victory

(1939)

Submarine warfare severely disrupted Britain's supply of food during World War II. Before the war, 75% of Britain's food was imported by ship. At the same time, domestic food production was hampered by the drain of labour into the armed forces, and the need to keep fighting men well fed.

As men and machines were removed from the land to serve the war effort, Britain's ability to feed itself was threatened. The government faced the challenge in two ways. Firstly, as it had done in other areas of economic activity, it encouraged women to enter the workforce.

Before the war had even begun it created the Women's Land Army, in June 1939, reviving an organization which had originally been set up during World War I. Women, volunteers at first but conscripted from 1944 onwards, were allocated to farms which needed labour for harvesting or animal husbandry. A similar task force, the Women's Timber Corps, was established in 1942 to maintain the supply of wood for construction and paper. The women were known affectionately as Land Girls and the WLA wasn't disbanded until 1949 as rationing was coming at last to an end.

During the war the priority for scarce food resources was the men at the front. Back home, every inch of suitable land was pressed into food production, whether of crops or of livestock.

Britain, Australia and the US all instigated "Dig For Victory" campaigns which encouraged citizens not only to help make unused public lands productive but also to make the most of their own under-developed resources – their gardens. Posters showed those not eligible for military service (women, the young and the old) getting involved, or advertised the bountiful vegetable produce which could be grown.

As rationing began to bite, those left at home were only too happy to try their hand at market gardening. In Britain the number of allotments grew from 815,000 to 1.4 million; in America it rose to 18 million. So-called Victory Gardens sprang up everywhere – on rooftops, in bomb craters, on any vacant piece of land. The British King and the American President dug up their own lawns to encourage the effort. Fully a third of all the vegetables grown in America during the war came from Victory Gardens.

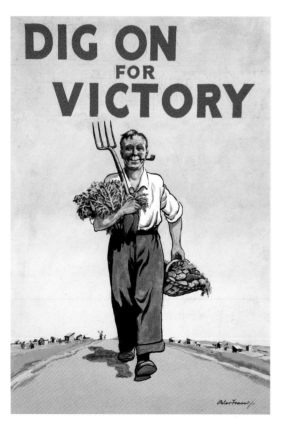

OPPOSITE: Three British posters from the "Dig for Victory" campaign, with an American Victory Garden poster, bottom right. Apart from the drive to grow vegetables, each county had its own Herb Committee to promote the growing of medicinal herbs.

LEFT: Peter Fraser's "Dig" poster with a slogan variant.

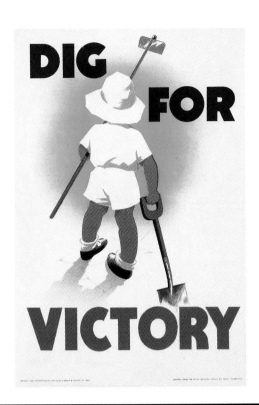

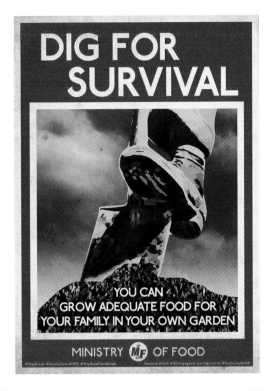

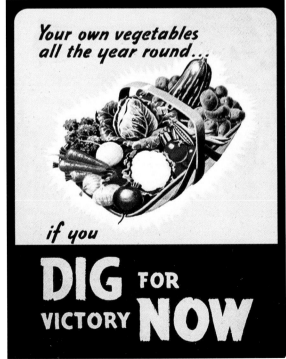

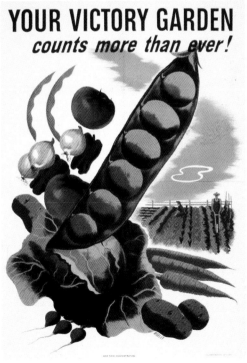

Chesterfield Cigarettes

(1940s–1960s)

Back in the day, when we didn't know that smoking was killing large numbers of the population, it was seen as a glamorous thing to do. To encourage that perception, tobacco companies fought and paid for the endorsement of the biggest radio and film stars of the day.

Chesterfield cigarettes were one of the top three brands in the US during the 1940s and 1950s and they spent a large proportion of their promotional budget in sponsoring Radio Hours, the celebrity musical programmes hosted by big stars, sometimes in their own names but more often under Chesterfield's. And posters helped give leverage to the brand. Thus in 1944 you could listen to the *Chesterfield Music Shop*, hosted by singer and songwriter Johnny Mercer. That was succeeded for the rest of the decade by the *Chesterfield Supper Club*, presented at various times by Perry Como, Jo Stafford or Peggy Lee.

Before Johnny Mercer took over the slot, it was known simply as the Chesterfield Hour, or Chesterfield Time. The programme was transmitted three times a week, and ran from 1939 to 1944, hosted by a succession of big band leaders. Fred Waring and Paul Whiteman were regulars; and when Glenn Miller played the Chesterfield Hour he was billed as Glenn Miller and the Chesterfield Orchestra. The orchestra's music stands were built in the shape of packs of Chesterfield cigarettes, even on the radio.

Fully a quarter of each broadcast was devoted to Miller's own performances, often in the company of the Andrews Sisters, who made their name on these shows with Miller. The Chesterfield Hour played its part in making Glenn Miller the most popular band leader in America, and naturally Chesterfield took pains to emphasize their connection with him on billboards. Such full-colour billboard posters were all the more eye-catching at a time when television was strictly greyscale. CBS and NBC began experimental colour broadcasts in 1940 and 1941, but the war interrupted any plans for making it available to the general public.

Miller was one of many celebrities whom Chesterfield cultivated as brand ambassadors. Among them was the folksy, ukulele-playing TV presenter

Arthur Godfrey, who endorsed the product so enthusiastically that he contracted lung cancer and died of emphysema. Bob Hope and Bing Crosby were also official spokesmen for the brand, and another powerful ally was future president Ronald Reagan.

In the 1950s, Chesterfield sponsored Frank Sinatra's TV show, where Sinatra himself would plug the cigarettes with phrases like, "Smokin' smooth, smokin' clean!" He even smoked during songs and his star guests often included other Chesterfield spokesmen such as Bing Crosby and Bob Hope. Chesterfield posters showed Sinatra in the same pose with which he would plug the brand during his show. Then at the very height of his powers, Sinatra was a perfect choice for Chesterfield – men wanted to be him, and women wanted to be with him.

As the dangers of smoking to the human body became apparent in the 1960s, tobacco companies transferred their sponsorship to events instead of people. Smoking moved to associate itself with thrills and action instead of health and sophistication. By the 1970s Chesterfield was heavily involved in motorsport, but pressure from the public and from governments has increasingly limited the arenas of public life in which cigarette advertising, and indeed smoking itself, are acceptable. Historians now look back on cigarette posters of the past as fascinating social documents of times gone completely by.

OPPOSITE TOP: A brand-reinforcing poster destined for in-store displays across America. The Frank Sinatra Show, sponsored by Chesterfield, appeared on ABC television between October 1957 and June 1958.
OPPOSITE BOTTOM: Glenn Miller and his band performed on the Chesterfield Broadcasts between 1940 and 1942.

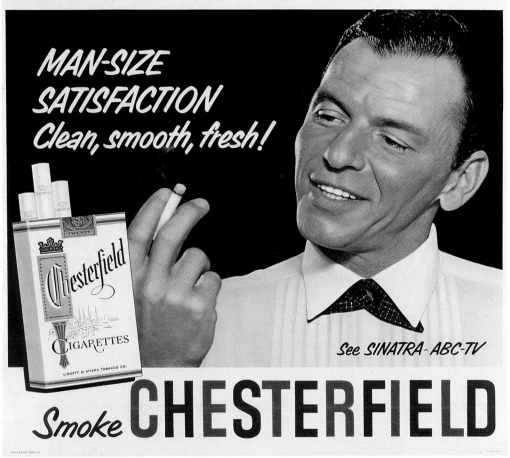

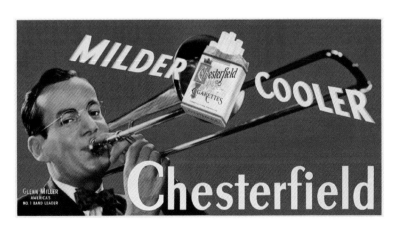

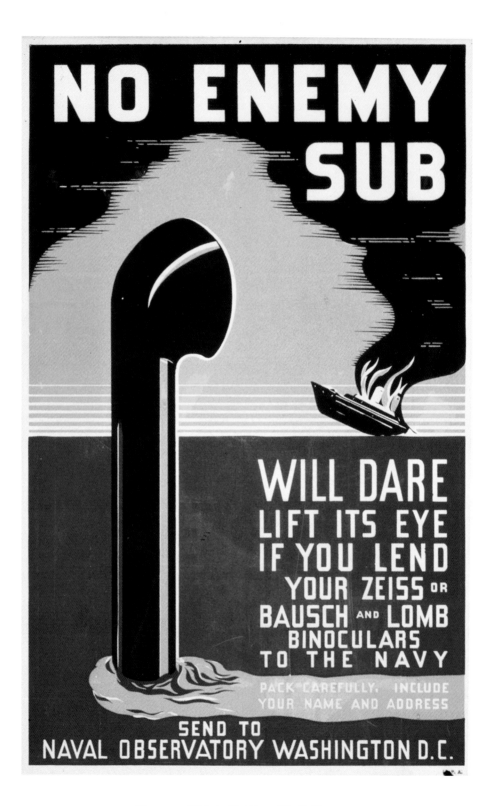

Appeal for Binoculars Posters

(1917 and 1942)

As the United States entered World War I, the US Navy suddenly realized that despite being one of the world's great industrial powers, it couldn't produce binoculars. If that was strange, then it was even stranger when 25 years later, exactly the same thing happened again ...

Although you might think that a pair of binoculars was part of the standard kit of any Navy vessel, the US Navy found itself short of this essential item when America entered World War I in 1917. The problem was that most of the world's optical lenses were produced by the firm of Carl Zeiss in Dresden, Germany, the country with which America was now at war. The leading American manufacturer, Bausch and Lomb of New York, bought all their lenses from Zeiss.

A poster appealing for patriots to lend their binoculars and spy-glasses was designed by renowned marine artist Gordon Grant (1875–1962). Grant is best remembered for his watercolour of the veteran three-masted frigate the USS *Constitution*, and he illustrated many books with a nautical theme. His poster resulted in donations of over 50,000 items with lenses, not all of them entirely useful in a naval context – spectacles, monocles, lorgnettes and opera glasses were also submitted by well-meaning Americans.

When the supply from Germany was again interrupted by another outbreak of war in Europe in 1939, efforts were made to improve domestic production of optical lenses. After Pearl Harbor, however, the US navy again found itself having to launch an appeal for binoculars. In an effort to save everyone's time, and to reduce the variety of spare parts required, posters on this occasion were very specific about what the Navy wanted – only Zeiss binoculars, or Bausch and Lomb ones which used Zeiss components, should be submitted.

The posters this time around were designed by artists of the Federal Art Project (FAP), part of Franklin D. Roosevelt's New Deal to help America out of the Great Depression. The results were consequently a mixed bag both in style and in quality. The bold, simple image in one of them of a periscope watching a ship sink sent out a clear message, and managed not to overcrowd the poster with the large amount of text which it had to include. The FAP posters were all unsigned, so it's not known how many of the artists continued to work in commercial design after the FAP was wound up in 1943.

The appeal was largely successful. Again, more than 50,000 item were submitted, of which around 8,500 were useful. All of them were engraved with a number so that they could be returned after the war – if they survived it. Since the US Navy was not allowed to accept gifts, it paid each contributor one dollar in rental. Almost all of the binoculars were reclaimed or replaced after the end of hostilities, and by 1951 when the scheme was formally ended, the Navy only held thirty-seven pairs for whom they had been unable to find the owners.

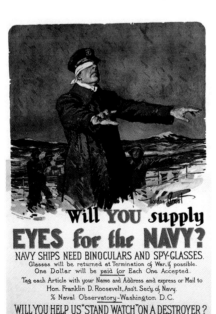

OPPOSITE: A call for binoculars from 1942.
LEFT: A 1917 call for binoculars from Assistant Secretary of the Navy Franklin D. Roosevelt.

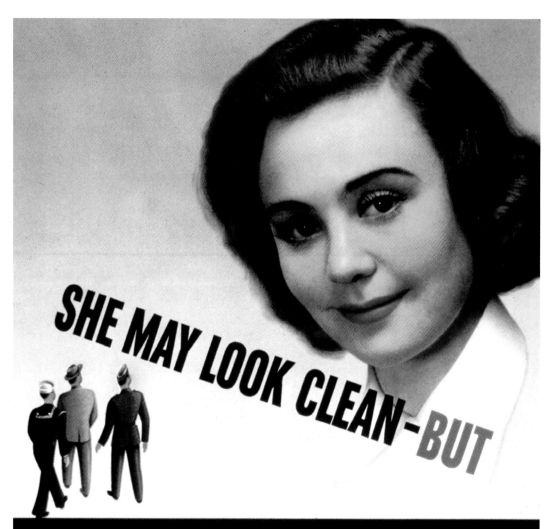

VD Posters

(1942–1946)

Huge armies were mobilized across the globe for World War II. That was a lot of troops, tension and testosterone; and both military and political leaders were concerned about the spread of venereal diseases among the men, which might then be brought home on leave to wives and families.

It was possible to test for syphilis and offer treatment to tackle its early stages, and penicillin became available to treat gonorrhoea before the war ended. But these diseases were taking men out of the front line and diverting medical services that should have been dedicated to those wounded in battle.

Between 1942 and 1946 the United States Army and Navy was engaged in an uneasy collaboration with the Surgeon General, the War Advertising Council and commercial advertisers to come up with a series of posters to warn about the dangers of venereal disease (VD). The assumption of the time was that VD would be passed on by heterosexual contact. The message was that soldiers and sailors should use condoms and avoid women sex workers and brothels. Some posters depicted glamorous seductresses; but others warned against even the ordinary, clean-cut, girl-next-door, the sort you could imagine bringing home to your mother.

Like all wartime posters the text was kept simple and direct. Men in the armed forces had more important things to do than read long messages. Early posters were designed by artists of the Federal Art Project FAP, part of President Roosevelt's New Deal. Typically these were simple, stylized silkscreen prints produced in bold colours, produced at one of over thirty Poster Project centres across the United States.

The FAP came to an end in 1943, and later VD posters show a distinct improvement in picture quality because they were now produced by commercial advertising studios. As the war came to an end the posters warned, as they had done after World War I, of the dangers of GI Joes being repatriated with the disease.

OPPOSITE: Previous imagery of "loose women" in VD posters had portrayed them as heavily made-up hookers, and so casting the likely donor of an STD as a girl next door certainly widened the net.

Franz Oswald Schiffers (1902–1976) painted many posters at this time, depicting American servicemen unable to go home until they had recovered from VD. Schiffers was born in Germany and learned his craft designing posters for German cinema and beer. His "Feind hört mit" poster was the German equivalent of the "Careless talk costs lives" campaigns. In occupied Germany at the end of the war, he transferred his talents to the United States Office of Military Government to produce those VD posters, a rare example of an artist painting, as it were, on both sides of the canvas.

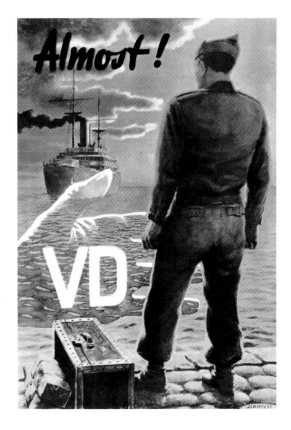

Rosie the Riveter

(1943)

Rosie the Riveter is a seventy-five-year-old feminist icon, a shorthand for female empowerment. Her image appears on posters, T-shirts, mugs and badges. But she languished in obscurity for forty years until her image was rediscovered for a nostalgic anniversary in the 1980s.

The US government launched a huge campaign during World War II encouraging women into the workplace to replace the men who were joining the armed forces. Between 1940 and 1945, the female percentage of the US workforce increased from 27% to 37%. By 1945, nearly one in four married women worked outside the home. The aviation and munitions industries saw the greatest increase in women workers. In 1943, around 310,000 women worked in the aviation industry, Rosie's place of work, making up 65% of the total workforce compared with 1% before the war.

Rosie the Riveter first gained public attention in a popular song from 1942, describing her patriotic actions as she works hard for victory on the assembly line, protecting her Marine boyfriend Charlie and spending much of her wages buying war bonds. The first poster to depict her was designed by artist J. Howard Miller in 1943 for display at the Westinghouse Electric plant, to encourage its wartime workforce to work harder. It was only on display for two weeks, one of over forty inspirational wartime posters used by the company, few of which displayed women.

It was a painting of her by Norman Rockwell later in the same year that Americans were more familiar with, after it appeared on the cover of the *Saturday Evening Post.* In Rockwell's picture, a sturdy, overall-clad Rosie sits nonchalantly in front of a US flag, rivet gun on her lap and sandwich in her hand, her feet resting on a copy of Hitler's *Mein Kampf.* On her head, there

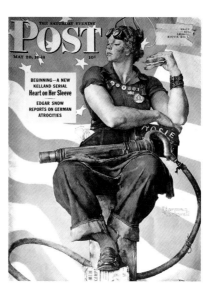

is no polka dot bandana but instead, her goggles and protective mask. Her name is written on her lunch box.

After the war, the government wanted to get women back in the home to make way for the returning men. Women who opted to stay in work were often demoted. But something had changed. It could no longer be argued that women were not equal to men in their ability to do the same jobs. Rosie and real-life women like her had laid the foundations upon which were built equal opportunities and equal pay for women in the workplace.

It wasn't until the 1980s that Miller's image re-emerged, when a nostalgic interest in the fortieth anniversary of the war persuaded the US National Archives to license it for use in merchandise. The bicep-flexing Rosie was now taken up by the feminist movement. Rather than being a call for patriotism and hard work, she came to represent a statement of female strength and ability.

Many women have co-opted it to convey their own feminist credentials: Beyoncé, Christina Aguilera and Kendall Jenner have all struck the pose in the image; Hillary Clinton used it in her presidential campaigns and Michelle Obama was pictured in a version with the statement "Yes We Can" in place of "We Can Do It."

LEFT: Norman Rockwell's Rosie on the cover of the Saturday Evening Post.
OPPOSITE: J. Howard Miller's original Rosie. The pin badge on the collar reads Westinghouse Electric Service.

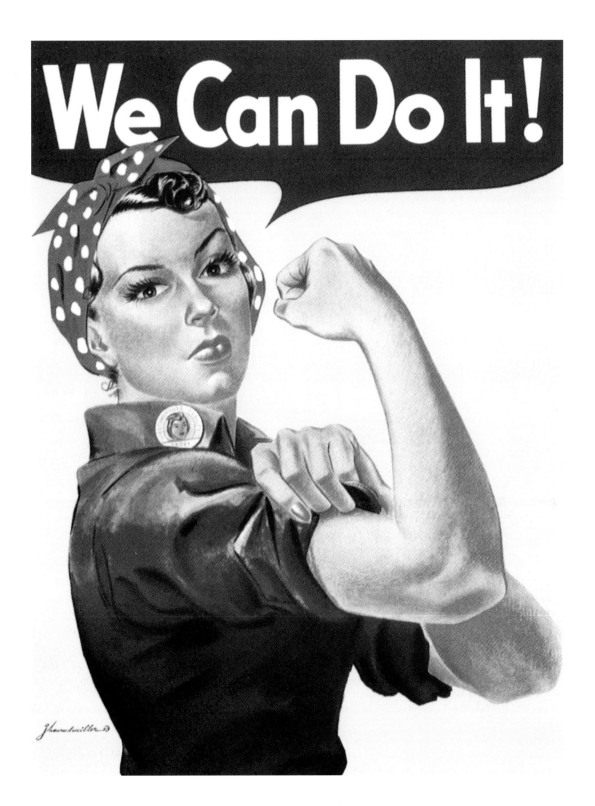

Tokio Kid Say…

(1943–1945)

It seems to be part of human nature to find ways of dividing our world into Them and Us. It's all too easy in times of hostility to whip up hatred of your enemy on the grounds of race or religion. In the wake of the attacks on Pearl Harbor, the Japanese became Public Enemy Number One.

Japanese residents in the US and Americans of Japanese descent were rounded up after 7 December 1941 and interned for the duration of the War in the Pacific. Most lived on the Pacific Coast. It was a different story in Hawaii, however, where Japanese Americans made up over a third of the population. Incarceration would have devastated the local economy and met with some resistance. On the Hawaiian islands only around 1,500 people were interned.

The real enemy of victory in the Pacific was industrial weakness. The US economy was retooled to serve the war effort and any inefficiency of production threatened the efficacy of US troops in the field of combat. Posters went up in the workplace canteens of America over the following months urging employees not to waste resources, including that of their own labour, because that was what the enemy wanted.

Typical of many poster campaigns was a series called "Tokio Kid Say", which was posted around the workshops of the Douglas Aircraft Company, a vital supplier of military hardware based in Santa Monica, California. It featured a grotesque but recognizable caricature of Japanese prime minister Hideki Tojo, who had advocated the raid on Pearl Harbor. Here he was portrayed as a wild-eyed, bespectacled, buck-toothed monster carrying a dagger

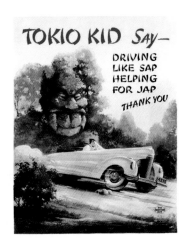

dripping with American blood. In a series of images Tojo encouraged Americans in pidgin English to waste materials and skip work to aid a Japanese victory. Lost rivets for example meant fewer planes, as did taking days off work. Accidents on the shop floor and broken tools meant delays in production which made Tojo "so joyful, thank you".

The effectiveness of the campaign may be judged by Douglas's remarkable wartime output: between 1942 and 1945 the company produced nearly 30,000 long- and medium-range bombers, transport planes and dive-bombers for American forces.

The "Tokio Kid Say" posters put words in Tojo's mouth which were the opposite of the US's needs. In this way they were an indirect and therefore more effective way of spreading the government's message. They tapped into an existing suspicion of the so-called Japanese Yellow Peril, fostered by US support of Chiang Kai-shek after Japan's invasion of China in 1937. This campaign and others like it galvanized patriotism everywhere from the factory floor to the Hollywood film lot.

The resulting sense of American pride persisted long after victory in the Pacific and influenced US policy in Asia for years to come.

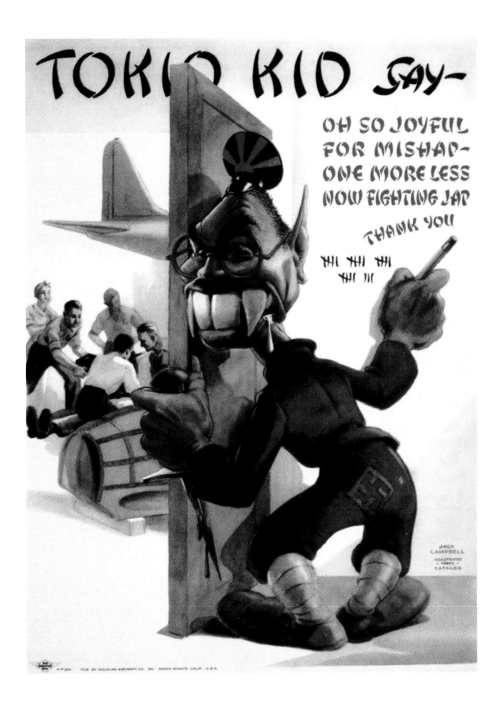

ABOVE AND OPPOSITE: *The Tokio Kid was a caricature of Japanese politician and general Hideki Tojo aimed at motivating Douglas Aircraft Company workers. The artwork was by Jack Campbell a Disney animator who had worked on* Snow White and the Seven Dwarves *and* Fantasia, *and would later animate* Lady and the Tramp.

Norman Rockwell: Four Freedoms

(1943)

For a large part of the twentieth century, Norman Rockwell (1894–1978) did more than any other artist to define the image of America. He showed Americans as they liked to be seen, as they needed to be seen: honest, wholesome, resourceful, optimistic, idealistic and inherently decent.

Some of Norman Rockwell's earliest publications were in the Scout magazine, *A Boy's Life*, when he was only nineteen. The "Mom's apple-pie America", which he painted, earned him a 64-year association with the Boy Scouts movement and in time the art editorship of the magazine.

But it was at the *Saturday Evening Post* that he forged a lasting bond with the American public. From 1916, over forty-seven years, he produced 323 covers epitomizing the charms of small-town America, innocent childhood pastimes and the dignity of its people, usually with benevolent amusement at its quirks. *The Gossips*, for example, was the *Post*'s cover in March 1948, a wry illustration of the dangers of Chinese whispers, the photo-realistic double portraits of his subjects clearly drawn with great affection.

Rockwell also painted presidents, but like most artists he earned a day-to-day living in commercial work. Some of his most familiar works were six adverts for Coca-Cola, which saw him as the perfect fit for their marketing image as the essential all-American beverage.

In World War II he boosted the nation's morale with the best-known rendition at the time of American heroine Rosie the Riveter. Based on a speech given by President Roosevelt in 1943 he also painted the "Four Freedoms" series. The whole set – Freedom from Want, Freedom of Speech, Freedom of Worship and Freedom from Fear – took him seven months, over which he lost ten pounds in weight. But they were a propaganda triumph, raising more than $130 million through sales of war bonds.

His art was every bit as truthfully American as Edward Hopper's, though his idealized and sentimentalized vision of his country denied him the kind of critical acclaim Hopper enjoyed. There was never any darkness or ambivalence about Rockwell's America. That is, until the early 1960s, when he suddenly became a supporter of civil rights and left the *Saturday Evening Post* to explore political themes of which the magazine disapproved. At that time, the *Post* would not publish images of African Americans in anything other than menial roles.

Look magazine proved a more congenial home for the politicized (or, as he would have it, "more adult") Rockwell, publishing his pictures on the theme of racism, including *The Problem We All Live With*, a stark painting about segregation which is so at odds with what people expect from Rockwell that it can still shock today.

By then Rockwell was a member of the National Association for the Advancement of Colored People, admired the ethos of the hippy movement and was fascinated by NASA. The man who so perfectly captured what it was to be American proved more able than many Americans not to cling to a romanticized past but to let it go, embrace change and move on into the future. As he said in 1968, "I couldn't paint the Four Freedoms now. I just don't believe in it."

ABOVE: Rockwell's "Four Freedoms" – Speech, Worship, Freedom from Want, Freedom
from Fear – were published in consecutive issues of the Post *from 20 February to*
13 March 1943, along with articles from prominent American writers.
OPPOSITE: One of Rockwell's most beloved poster prints, Girl at the Mirror, *started*
out as the cover for the Saturday Evening Post, *6 March 1954.*

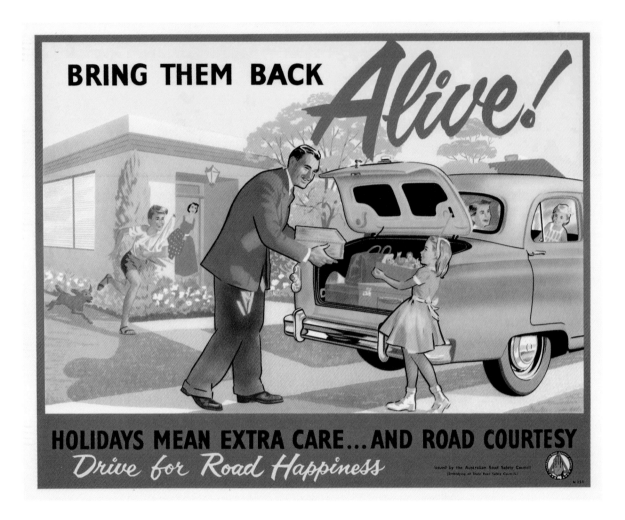

ABOVE: After petrol rationing ended in 1950, and equipped with their first Australian-built car, the Holden 48-125X, Australians took to the road in large numbers. But the authorities were soon worried by the number of road traffic accidents.

Australian Road Safety Posters

(1949–1954)

A well-meaning campaign to reduce accelerating death rates on Australian roads ultimately failed to convince the public, despite hard-hitting messages and appeals to moral responsibility.

When the dust settled on World War II, Australia entered a period of relative wealth and stability. Increased wages and greater security of employment were followed by legislation to introduce statutory annual leave of three weeks, compared to one week before the war. A time of restraint and self-sacrifice during the war was replaced by exhortations to spend on home-grown consumer goods, to boost manufacturing and the economy.

And what did Australians buy in their droves? An automobile. Australia's first car, the General Motors-Holden 48-125 FX was unveiled in November 1948. Within a year, it accounted for two in every five new cars bought, and in 1952 it became Australia's bestselling car. Car ownership tripled in the 1950s and with the end of petrol rationing in 1950, the car was used not just for commuting from the newly built suburbs but for leisure: going for a scenic drive or visiting the beach and touring holidays by car became the new thing.

Unfortunately, the steep climb in car ownership and use brought with it a steep climb in road accidents and fatalities. Already in the early 1950s alarm bells were ringing in government about the toll which road fatalities were taking on the nation. In 1951, the chairman of the newly formed Australian Road Safety Council called it "a vampire which draws the life blood of the nation" and pointed out that road casualties since 1945 were double the number of military casualties sustained during World War II.

The Australian Road Safety Council (ARSC) was an independent body formed in 1947 to educate the public about road safety. This was a visionary step in the very early days of increased car ownership. The ARSC used posters, radio and TV adverts, educational booklets for children and even a theme song: "The Safety Whistle" from 1949. Its slogans were often explicit about the risk of death, for example, "Better a minute late than dead on time" and "Remember the life you save may be your own". A conventional happy family scene in suburbia is disrupted by an appeal to fathers to take extra care driving during the holidays, in order to bring their children back alive.

The ethos of the Council's approach was one of courtesy and care, linking road safety to morality. The Queen's visit to Australia in 1954 was used as an opportunity for a nationwide advertising campaign declaiming: "Let courtesy reign on the Queen's highway" even though it had been the Aussie highway since 1901.

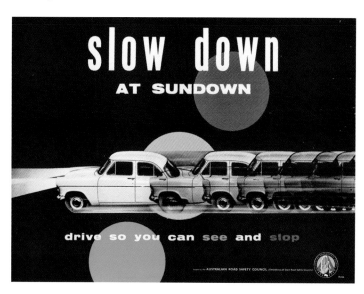

Einstein

(1951)

Einstein is a metonym for scientific genius. Albert Einstein was and remains the world's best-known scientist. Famously benign and humorous, even Einstein could grow tired of the constant attention of the press.

Einstein's humanity endeared him to the public as much as his phenomenal brain did. At a memorial service ten years after his death, nuclear physicist Robert Oppenheimer described him as "almost wholly without sophistication and wholly without worldliness … at once childlike and profoundly stubborn." His unkempt appearance – the wild hair, the wide-open eyes – became the stock caricature of a mad scientist. His gentle wisdom, not least in his regret that he encouraged the USA to build an atomic bomb, made him a point of connection between ordinary people and the scientific community.

It was the night of 14 March 1951, Einstein's seventy-second birthday. The great man attended a celebration in his honour at the Princeton Club and was going to be driven home with his friends the Aydelottes. Frank Aydelotte had served as Principal of Princeton's Institute of Advanced Study, where Einstein began his working life in America, and was instrumental in helping other Jewish intellectuals flee Nazi Germany. They were old friends.

Press photographers had been hounding Einstein all night for birthday portraits and he had generally obliged, although with an increasingly forced smile. Now, however, he was tired and he just wanted to go home. Other photographs taken during his departure from the club show him looking weary on the back seat of the car, wedged between Frank and Marie Aydelotte.

Photographer Albert Sasse, who worked for the news agency United Press International (UPI), was persistent. He shouted out a request for a birthday smile, and Einstein, willing but unable to raise a grin, stuck out his tongue instead. Then Frank closed the car door and they at last set off.

Some editors picked up on the shot, which originally showed all three passengers in the car. When Einstein saw the result in print he loved it. He ordered nine cropped copies from UPI, just of himself, which he used in various ways – as greetings cards, and as mementoes. He signed one for a reporter which in 2007 sold at auction for $74,324. Another signed copy, showing all three occupants of the car, was snapped up in 2017 for $125,000.

After Einstein's death four years later, his estate licensed the original photo for marketing and merchandising purposes. It wasn't until the 1960s, however, that posters became a fashionable form of domestic decoration. After film stars, any celebrity was fair game and in due course the classic photograph became a classic poster.

The image has also been adapted in the style of Andy Warhol, as a collage of nine copies of the photo, each coloured differently; and in the style of the Obama "Hope" poster in shades of blue, white and red. But why put a scientist on your wall at all? In the case of Albert Einstein it's a reminder that however complicated life is, however difficult to understand, it should not always be taken entirely seriously.

RIGHT: Many believe that Einstein would have loved the unorthodoxy of becoming a poster icon along with Farrah, Tennis Girl, and Che Guevara.

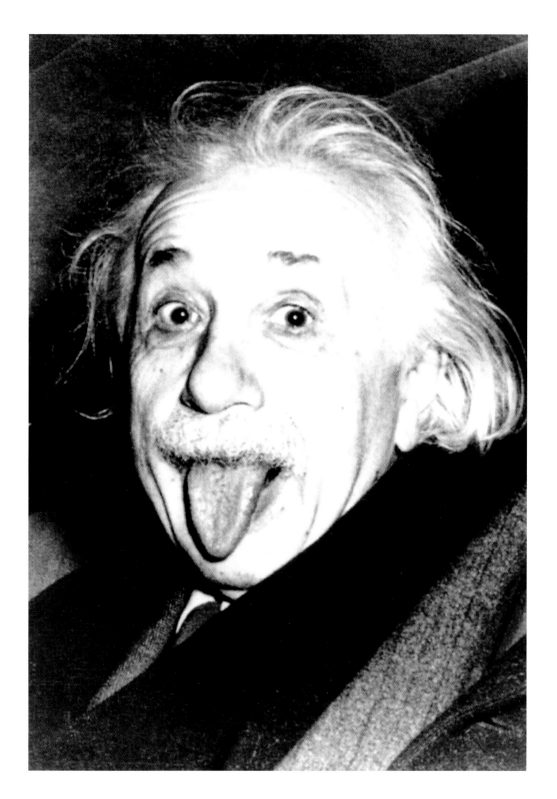

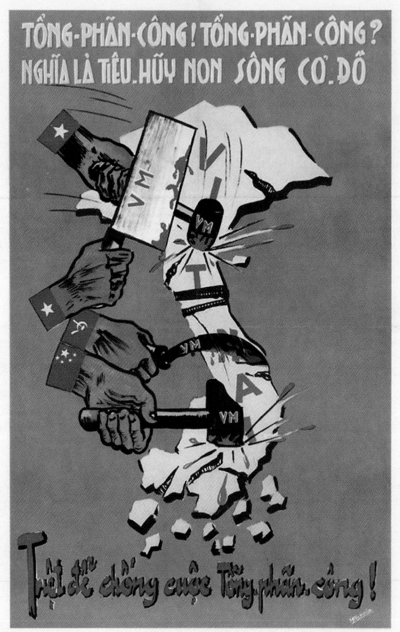

Vietnam Propaganda Posters
(1953–1963)

The Cold War was the biggest single factor shaping global politics after World War II. Foreign policy in the West was dictated by the Domino Theory, which held that if one country in a region turned Communist its neighbours would swiftly follow. This belief focused America's attention on South Vietnam.

The United States Information Agency was part of the American psychological warfare programme, founded in 1953 by President Eisenhower to promote the interests of the USA abroad and undermine the Soviet Union. Its aim was to present America in a positive light as a country that was working to bring about a better world, and it concentrated its operations on "wavering" countries that looked most likely to turn Communist and fall under the influence of the USSR or China.

The USIA operated in 150 countries. It was behind radio broadcasts, fake newsreels, documentaries, pamphlets, posters, periodicals and cultural exchanges. To lend it credibility, its output was intended not to be seen as American propaganda but as coming from independent sources, so the USIA sought out local media and influential opinion-formers to give the appearance that its products were created at home.

By 1959, with North Vietnam under Communist control, the USIA's South Vietnam office in Saigon was employing twenty-one Americans and 210 locals on an annual budget of $900,000. Always careful to cover their tracks, they planted stories in all the newspapers, commissioned pamphlets and posters and produced films, in which the USSR was portrayed as the real colonial power and the USA as the champion of freedom. The North Vietnamese were invariably depicted as pawns of the Communists, and their leader, Ho Chi Minh, a puppet of Mao and Stalin. The regime of the US-approved South Vietnamese leader, Diem, was shown in a glowing light.

An over-arching fear of communism blinded the USIA to Vietnamese character and sentiment. Its disdain for the majority of the country's people, culture and religion, evident in internal USIA documents, prevented them from bonding with the people they were trying to manipulate, and their efforts to win hearts and minds did not have the desired effect.

Diem's widely-reviled regime, so long supported by the United States, was brought down by a military coup in 1963 with CIA approval, and Diem himself assassinated. Despite all the money and resources poured into South Vietnam by USIA, pollsters found that only a small minority of Vietnamese believed that America and Vietnam had similar goals, most feeling that Nasser's socialist Egypt was a fairer society. Two years later, Cold War persuasion having failed, President Lyndon Johnson committed American forces to a "limited war" in Vietnam. They would be there until 1973.

OPPOSITE: *With the surrender of the Japanese occupiers in 1945, the stage was set for a battle of the hearts and minds of the Vietnamese people between the West and communism. France wanted to take back its former colony but after the 1949–1954 French Indochina War, they left the North to Ho Chi Minh and the Americans had to step in to prevent the dominoes from falling.*

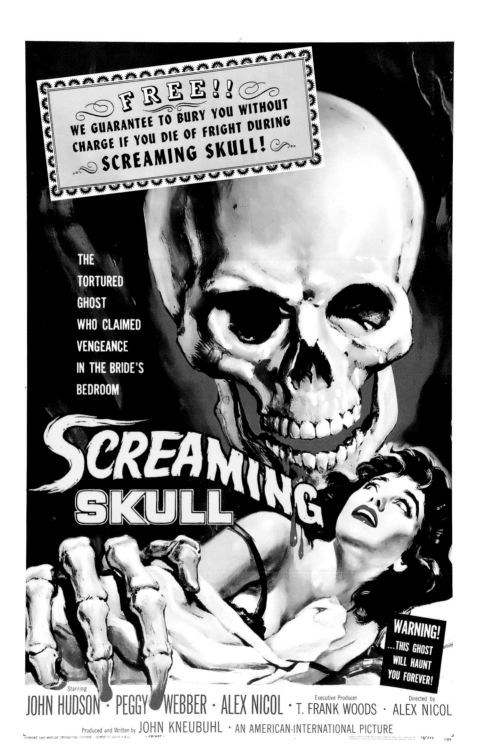

Film: B-Film Thrillers

(1957 & 1958)

It's a truism that in periods of international tension, Hollywood will make films about aliens. Over 500 sci-fi and horror features were released by Hollywood between 1948 and 1962, a time when American fear of Soviet communism was at its height.

These were emotionally turbulent times. Relief at the end of World War II was tempered by the horror of the atomic bomb which ended it. The science that created the bomb also ushered in the affluent modernity of the Atomic Age.

The liberal film industry was a primary target of Senator Joseph McCarthy's communist witch-hunt, and studios became cautious about making any picture which could be construed as culturally or politically subversive. Sci-fi and horror satisfied the dramatic requirements for tension and resolution. It was both more frightening and less expensive to hint at danger rather than show it. And in the hands of a skilful director and an intelligent audience they could be vehicles for metaphorical comment on American society and politics.

In the hands of journeymen directors, however, the deluge of 1950s films with titles like *Attack of the Crab Monsters* and *Screaming Skull* were pure entertainment with a visual style that was camp, titillating and, at least in retrospect, inadvertently hilarious. They coincided with the rise of the suburban drive-in theatre and the emergence of a new market, teenagers with new disposable income in the post-war boom. They were exercises in escapism, although they fed on the very existential terrors one went to the drive-in to escape.

Posters advertising these films owe everything to the covers of pulp fiction paperbacks – lurid, suggestive, titillating, violent. *Attack of the Crab Monsters* was released in 1957. The film's irradiated crustaceans were not only the product of nuclear blasts, like Godzilla or the giant ants of 1954's *Them!*, they were also, to judge from the poster, distinctly Asian in appearance. After wars with Japan and North Korea, and with Vietnam already on the horizon, the anonymous artist was playing on American fear of the "Yellow Peril" to drum up ticket sales. The racial stereotyping was far less apparent on the crabs in the film itself.

Screaming Skull was released a year later. One line of text was sufficient to convey the sort of entertainment young moviegoers could expect. "The tortured ghost who claimed vengeance in the bride's bedroom" covered all the bases: a supernatural terror, a scantily clad protagonist, and – in a time when television's most famous couple on *I Love Lucy* slept in separate beds to appease censors – the bedroom as a primary setting. It's no accident that *Screaming Skull* was remade in 1973, as the Vietnam War was drawing to a close and Nixon had warmed the Cold War with a 1972 visit to China.

Crucially, designs like these were drawn, not photographed. The only limit to what exaggerated claims they could make for the films were those of the artist's imagination. B-movies invented a cinematic language which is still used by directors today, either accidentally in bad movies or as a knowing tribute in good ones.

LEFT AND OPPOSITE: The most convincing representation of the B-movie monster was often on the poster not on celluloid.

TWA Jet-Age Posters

(1959–1965)

In the late 1950s and early 1960s commercial airlines phased out propeller-driven aircraft and entered the self-styled Jet Age. The art of the travel poster reflected this self-conscious modernity with a more abstract style, exemplified in the work of David Klein for TWA.

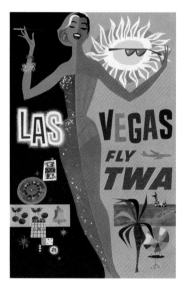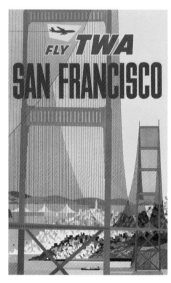

TWA was formed in 1930 by the merger of two airlines to become Transcontinental and Western Air. When tycoon Howard Hughes acquired a majority stake in the airline in 1939, he retained the initials but changed the name to the grander-sounding Trans-World Airline.

After World War II Hughes turned his attention to the expansion of TWA's network into Asia, Europe and the Middle East. TWA and Pan Am became the leading and competing global US carriers, and Hughes stole a march on his rivals when he ordered the first of thirty-three Boeing 707s on 2 March 1956. In fact the order, worth nearly $500 million, overstretched the airline's finances and forced Hughes to relinquish control in 1960; but the Jet Age had well and truly begun.

David Klein (1918–2005) was a West Coast watercolour artist who relocated to New York and became a highly regarded poster designer. He made his name through Broadway theatre ads with a bold, colourful, animated style which usually picked up on a single element of each production and abstracted it: a glass unicorn for Tennessee Williams' *The Glass Menagerie*, for example, or a kilted dancer for *Brigadoon*.

The same technique worked well for travel posters, and Klein worked for TWA for ten years from 1955 to 1965. His name became synonymous with TWA's advertising, for whom the consistent use of a single artist helped to define the company image.

One aspect of each poster's destination dominated it – the Golden Gate for San Francisco, the Eiffel Tower for Paris, a pair of sunglasses for Florida. They were obvious choices, but executed with cheerful flair which made your eyes want to linger on the advertisement. His early designs included the outline of a Lockheed Constellation, which in the early 1950s was TWA's newest addition to the fleet. But soon they were amended to show the now-classic TWA element of a small blue jet and its jetstream. TWA, the posters declared, was the Jet Age.

One of Klein's most famous posters was a completely abstract but instantly recognizable version of New York's Times Square, a multi-coloured perspective of the Square's neon billboards so precisely of its time and place.

In the 1960s graphic art in advertising fell out of fashion to be replaced by photography. But in 2001 the online travel agency Orbitz ran a retro campaign using several of David Klein's iconic TWA posters, sparking renewed interest in Klein's legacy in the last few years of his life. In 2012 a first printing of his Times Square poster sold at auction for $9,944, a record high price for a high-flying poster by a highly regarded artist.

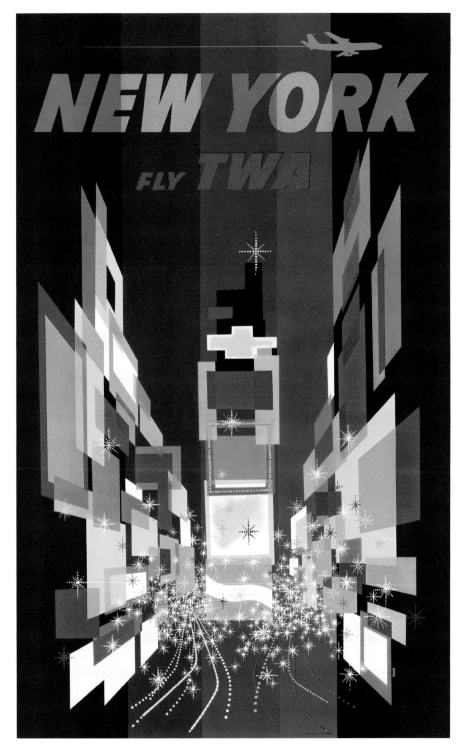

OPPOSITE AND RIGHT: David Klein produced many Broadway posters including The Music Man, Brigadoon *and* Cat on a Hot Tin Roof, *but it is his beautiful TWA posters that are the most celebrated and have become emblematic of the Jet Age. The Times Square poster is on display at the Museum of Modern Art (MoMA) in New York.*

Athena Posters

(1964–1995)

Launched in London in 1964 as a gallery selling fine art prints, Athena expanded with a chain of British high street stores whose posters decorated a million teenage bedrooms. Besides traditional reproductions, several of its original posters became iconic images in their own right.

As rock 'n' roll became rock during the 1960s, its posters developed from the unimaginative playbill templates of its early years to more creative psychedelic works of art. These were beautiful designs, too good to be abandoned once each concert or festival had taken place. They were retained or collected as home decoration by fans. Posters became the wall covering of choice for the young, and their tastes expanded beyond concert posters to images of actors, film posters, modern art and contemporary photography.

Athena's growth coincided with this trend. Its stores supplied the market with affordable art and in the 1970s it became a byword for poster art. It was accused by art critics of popularizing fine art for the masses, as if that were a bad thing. As well as supplying images of already popular works it created a few classics of its own.

Among its bestsellers in the 1970s was a design for J. R. R. Tolkien's then-popular fantasy trilogy *The Lord of the Rings*. The whimsical gothic drawing of Gandalf and Frodo surrounded by a sepia frame reminiscent of 1960s psychedelia was drawn by Jimmy Cauty, a British artist later to achieve fame as a member of subversive music groups The KLF and The Orb.

Its two most famous images, published ten years apart, can be seen as yardsticks of social change over the intervening decade. The first, widely known as *Tennis Girl*, depicts a young woman on a tennis court hitching up her tennis dress to reveal a glimpse of her naked behind. The slightly risqué, slightly sexist shot is a staged photograph taken by photographer Martin Elliott using his girlfriend Fiona Butler as the model. It originally appeared in a 1977 calendar and later sold over two million copies.

So universally known is the original that it has been widely parodied. Tennis player Pat Cash adopted the pose for a photograph, and *Star Wars* star Mark Hamill once posted a version on Twitter which showed Princess Leia, holding a blaster instead of a tennis racquet, with the architecture of Tatooine in the background. The dress which Ms Butler wore was bought at auction by the Wimbledon Club in 2014 and is now on display in the club's museum.

Ten years later Athena published *L'Enfant*, better known as *Man and Baby*. The black and white print shows a topless muscular male model cradling a new born baby in his arms. It appeared in 1987, two years after the era-defining Levi Jeans television commercial which showed model Nick Kamen stripping to his underwear in a laundrette. What seems commonplace now was radical then – men's bodies could be sexy, too. Society had at last begun to move on from a time when a glimpse of a young woman's bottom was the modern equivalent of a saucy British seaside postcard.

Athena's high street shops began to lose business in the early 1990s, and the group went into administration in 1995. Today, it is the IKEA framed print that dominates the market that Athena once ruled.

SPENCER ROWELL

ABOVE: *Fiona Butler was 18 years old when she was photographed in 1977. Athena licensed the photo a year later.*

LEFT: L'Enfant, *the work of photographer Spencer Rowell, sold over five million copies. With the inclusion of the small baby, the poster has been hailed as ushering in New Man: the strong but gentle, quiet but sexy role model for our post-feminist times.*

OPPOSITE: *Jimmy Cauty drew his* Lord of the Rings *poster before co-founding groups The KLF and The Orb. Today he produces agitprop artwork – his 1:87 riot diorama* Aftermath Dislocation Principle *went on display in Banksy's Dismaland in 2015.*

The Cult of Mao

(1966–1976)

The arts, Chairman Mao proclaimed, should serve politics first and art second, if at all. China's printing industry was nationalized in the early 1950s and the army placed in charge, establishing aesthetic principles and motifs which directly reflected Communist Party ideology.

Posters were a central weapon in the revolutionary arsenal of the People's Republic of China and never more so than during Mao Zedong's Cultural Revolution from 1966 to his death ten years later. In the early stages of that disastrous experiment, low literacy rates made visual propaganda the primary medium for ideological communication from the state to the people.

Posters were not only pasted in public places. They entered the home, once a private place and now overlooked by the Chinese leader. Portraits of him above ideological messages replaced the old family altars which were demolished by Mao's zealous Red Guard. In place of religious devotions, families were encouraged to ask Mao's image for guidance in the morning, thank him at noon, and report back on their revolutionary contributions at night.

It is often said that China's current industrial power was built on the intensive communal efforts of the Cultural Revolution. It may be true, but it was a social tragedy. Apart from the loss to China of its teachers, intellectuals and artists, it airbrushed history. There was no mention of the politically orchestrated famine of 1958 to 1961 in which forty million people died. Nor is there any trace of the former Party figures literally airbrushed out of reprints of old posters after being condemned and purged as counter-revolutionaries.

Red, the colour of Revolution, saturated every piece of Party propaganda. Mao, the Supreme Helmsman, was always the focal point, larger than life and often looming disembodied over groups of figures like a divine presence surveying the happiness which he had wrought for his worshippers. Secondary figures represented ideal versions of social groups, such as the armed forces and farm labourers. In no posters are there stereotypical bespectacled academics, whose knowledge and very existence was purged in the early stages of the Revolution. Free thinking was discouraged in favour of acceptance of the poster's party line, and only strong, ageless paragons of the proletariat were welcome in Mao's communist paradise.

Mao himself was depicted as a benevolent, patriarchal authority who directed rather than participated in worldly activities. China took inspiration from similar Soviet propaganda centred on Lenin and Stalin – a popular slogan during the Cultural Revolution was that "The Soviet Union's Today is Our Tomorrow." No matter which guise he appeared in, Mao was always styled as "hong, guang, liang" – red, bright, and shining, the source of a divine light illuminating those around him.

OPPOSITE: *Many of the early People's Republic of China posters followed artistic templates used by Joseph Stalin, where Stalin appeared as a benign fatherly figure. Mao even added himself to the classic Marx/Engels/Lenin/Stalin poster. In later years the posters developed a sophistication all of their own with prominent waving of the "Little Red Book" by fierce-looking Red Guards.*

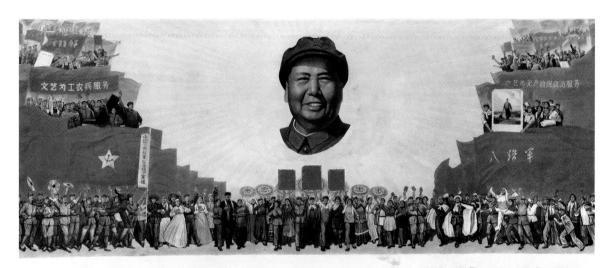

沿着毛主席的革命文艺路线胜利前进

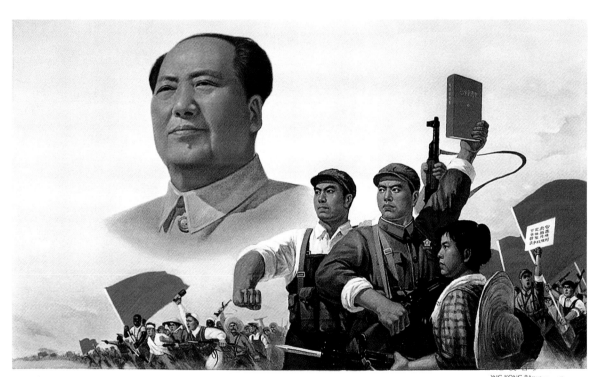

全世界人民团结起来,打倒美帝!打倒苏修!打倒各国反动派!

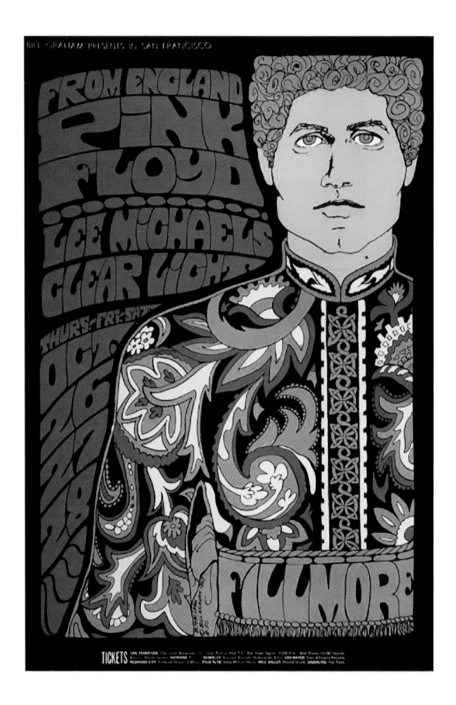

ABOVE: The Fillmore poster for Pink Floyd's visit to San Francisco in 1967 was more memorable than the gig, as it coincided with the start of charismatic founder Syd Barrett's erratic performances on stage.
OPPOSITE: Jefferson Airplane/Jimi Hendrix and The Doors headlining posters from 1967.

Fillmore Hall, San Francisco
(1966)

Seventy years after its first flourishing at the turn of the century, Art Nouveau had an unexpected revival. In the mid-60s, the sinuous curves of fin-de-siècle Paris resurfaced in the streets of San Francisco, tweaked and repurposed to evoke the altered perceptions of hallucinogenic drugs.

With the spread of Timothy Leary's "Turn on, tune in, drop out" drug-induced philosophy, live rock shows in the mid-60s attempted to recreate the LSD experience with strobe lights, liquid projections and long, free-form jams. The music and clothes were getting freakier, and so were the album sleeves. Some of the best, most enduring examples of 60s psychedelic art were rock posters.

These posters didn't like empty space and they hated straight lines. Swirling shapes, clashing colours and Op Art-influenced patterns swam and shimmered before the eyes. Some were well-nigh impossible to read, at least in a sober state of mind. *Time* magazine dubbed the style "Nouveau Frisco", and it became the definitive visual expression of psychedelic culture.

In 1966, 25-year-old Wes Wilson was working in a San Francisco print shop when he was approached by the promoter of San Francisco's Fillmore Auditorium, Bill Graham, to design posters advertising gigs at his venue. Wilson had no formal art training, but loved Art Nouveau and the block-lettering of the Vienna Secessionists, who saw text as part of the overall design rather than simply a means of conveying information.

He summed up his attitude towards his work as, "Use all the space and put as much colour in there as possible." The Fillmore posters pushed against the constraints of

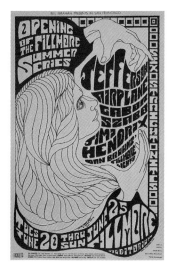

conventional advertising. Colour clashed with colour so that nothing stood out. Essential information was squeezed into odd spaces, each misshapen letter rubbing up against its neighbour, forcing you to study the advert closely in order to decipher it.

Wilson designed posters for the cream of West Coast psychedelia: Jefferson Airplane, Big Brother and the Holding Company, Quicksilver Messenger Service, Love, and The Grateful Dead. Even Fillmore shows by more traditional soul and blues artists like Martha and the Vandellas and Howlin' Wolf got the full psychedelic treatment, however incongruous it looked. Wilson was a fast worker, but the gigs kept coming and others picked up the style and ran with it, among them Rick Griffin, Victor Moscoso, Stanley Mouse and Alton Kelley. Some of the best were by Bonnie McLean, Bill Graham's wife, who got the gig after Wilson and Graham parted ways in a dispute over money.

The Nouveau Frisco era lasted from 1966 to 1972 and, like all successful underground styles, was co-opted by mainstream advertising agencies. But the Fillmore still takes pride in producing lavish one-off posters for gigs, which are handed out to concert-goers as they leave. Rarely but occasionally, the designs pay tribute to the Nouveau Frisco style in a fond recollection of the days when they really were in the vanguard of culture.

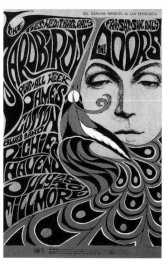

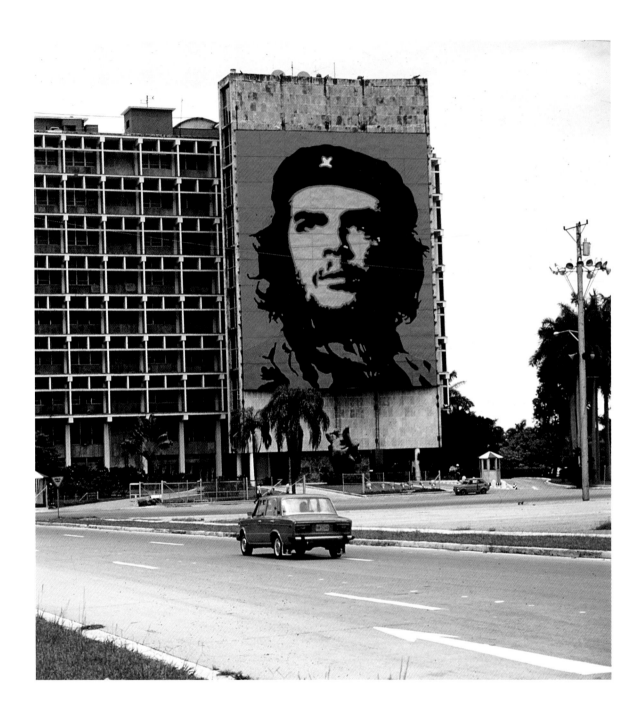

ABOVE: The description "iconic image" is greatly overused, but in the case of Jim Fitzpatrick's poster of Che Guevara, correctly applied. Here, Che looks out across the Plaza José Marti in Havana, Cuba.

Che Guevara

(1967)

There is one poster which more than any other transcends its origins, its context, its time and even the man whose portrait it is. Today more than fifty years after its creation you are as likely to see its image at an anti-corruption protest in Romania or a student conference in India as in a shop selling souvenirs in Havana.

The poster's official title is *Guerillero Heroico*, "The Heroic Guerilla Fighter". The original image was captured by Fidel Castro's official photographer Alberto Korda. It was taken in 1960 at a rally for the victims of a CIA bomb detonated in Havana Harbour. Jean-Paul Sartre and Simone de Beauvoir were among those present; and so too was Castro's new Minister for Industry, Che Guevara, the subject of the poster.

Korda knew as soon as he developed the negatives that the frame had potential as a portrait. There was something about Guevara's gaze, an unyielding anger and determination, which embodied the communist revolution for which they were all fighting. Korda cropped the image, which originally included another figure and the fronds of a palm tree; and he rotated it slightly clockwise to present Che's face perfectly vertically. Korda pinned a copy of the portrait on his wall.

Seven years later Guevara was fomenting revolution in Bolivia, and the CIA was closing in on him. His days were numbered and Giangiacomo Feltrinelli, an Italian publisher, acquired the rights to Guevara's Bolivian diaries. He was looking for a cover image of Che and Korda recommended his portrait. On his return to Italy Feltrinelli printed posters of the image to raise awareness of Guevara's plight, and to promote the imminent publication of the diaries. When news broke of Guevara's capture and execution in October 1967, there

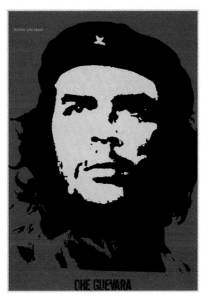

were spontaneous demonstrations in the streets of Milan, which used copies of the poster along with chants of "Che lives!"

In those moments Korda's image removed Guevara from his own context and made him a romantic icon of anti-establishment protest for everyone. The picture has been used and adapted in thousands of ways, often by people with no love of communism or knowledge of Cuba. One of the most famous is the stylized screen print by Irish graphic artist Jim Fitzpatrick, which introduced a red background to the image in 1967. Fitzpatrick had met Che in Ireland in 1963 and was impressed by him. Against accusations of plagiarism he insisted that he got his image of Che not from the Korda original but from a Dutch anarchist group which had in turn been given it by Jean-Paul Sartre.

Neither Fitzpatrick nor Korda received royalties for the use of the image. It was not through choice – Feltrinelli, for example, assigned the copyright of his posters to himself. In 2008 Fitzpatrick donated the copyright of his version to a hospital in Havana. But Korda, a lifelong committed Cuban communist, was simply delighted that his photograph was spreading the image and ideals of Che Guevara far and wide. The only time he put his foot down about its use was when it was co-opted by an advertising agency for a Smirnoff Vodka campaign. This, Korda felt, debased the memory of the man: not for Che or Korda the capitalist dollar.

Warhol: *Marilyn*
(1967)

In 1936, essayist Walter Benjamin famously wrote: "Even the most perfect reproduction of a work of art is lacking in one element: its presence in space and time, its unique existence at the place where it happens to be." Andy Warhol's entire career could have been a repudiation of Benjamin's words.

His argument, that an original painting had an "aura" that no reproduction could duplicate, came up against an artist formed and inspired by the era of mass production. The son of an Austro-Hungarian coal miner, Andrew Warhola (1928–1987) grew up in Pittsburgh before attending the Carnegie Institute of Technology. His first job was drawing shoes, and the discipline of commercial art provided a basis for everything that was to follow. Warhol embraced the idea of art as a commodity, and took the aura of the "original" out of the equation.

Moving to New York, he provocatively named his studio The Factory, putting a strong emphasis on productivity and a healthy work ethic. It was here that he surrounded himself with a retinue of drag queens, street hustlers and eccentric wannabes, and reputedly proclaimed that "in the future, everyone will be world-famous for 15 minutes".

But more importantly he found his true medium in the silkscreen print, producing multiple copies while reducing his own input to a minimum. By delegating the task to assistants, he didn't even have to be present for a work to be a genuine Warhol.

And if his art was all about becoming a commodity, so was his iconography. The subject matter of his most celebrated pictures were all the products of consumer capitalism.

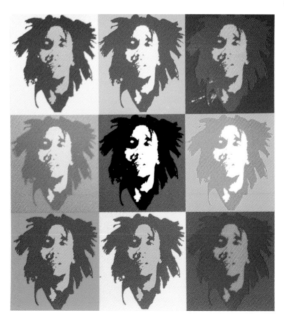

To Warhol, the branded packaging of Campbell's soup, Coca-Cola and Brillo Pads was all part of the same cultural process as Marilyn Monroe and Elvis Presley.

Warhol demonstrated that he was more attuned to mass media than any previous major artist. As the 1960s ticked over into the 1970s and then the 1980s, he closed the gap between art and business. With his trademark silver wig and black polo-neck making an iconic and instantly recognizable persona, he ultimately became a brand himself. But for all his efforts to deconstruct the romantic ideal of the Artist, he couldn't kill the aura. Warhol pictures are among the most expensive in the world: *Silver Car Crash (Double Disaster)* (1963) fetched $105 million at auction in 2013.

The artist who was transfixed by glamour, who repeatedly said that he was mainly interested in surfaces and who took great pains to make people believe he was "a deeply superficial person" was playing a far smarter game than he let on. His work was a challenge to every cherished notion of high art that still remained in the 1960s, raising questions that artists and critics still wrestle with today.

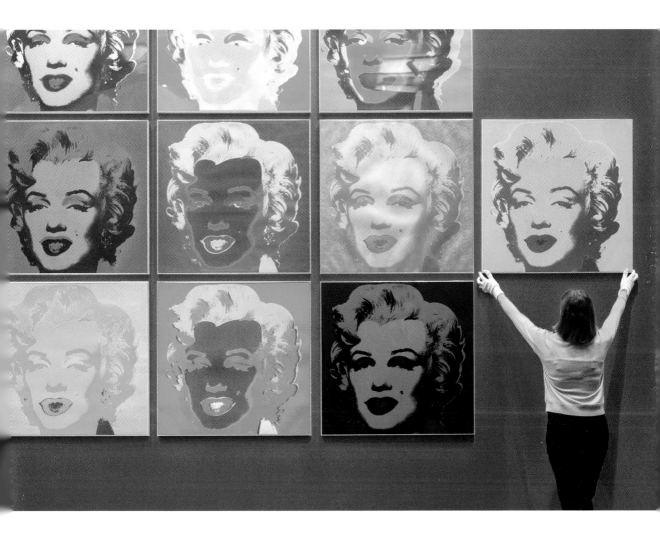

ABOVE: Ten screen prints of **Marilyn** *(1967) are displayed at the British Museum in March 2017 as part of their "American Dream: pop to the present" exhibition.*

OPPOSITE: Warhol's poster print style has been the inspiration for sixth form art projects the world over. This one, entitled **Marley** *(2009), is from Hampton School, Middlesex.*

Martin Luther King: I Am A Man

(1968)

One of the defining moments in the struggle for civil rights in America began as a sanitation workers' strike against appalling conditions in February 1968. Fighting the injustice of racial inequality and poor working conditions, strikers in Memphis, Tennessee created placards which demanded dignity based on nothing more – or less – than their humanity.

Two men, Echol Cole and Robert Walker, were crushed to death while sheltering from the rain in one of the Memphis Sanitation Division's garbage compactors. On 11 February 1968, 700 black workers seeking union recognition agreed to strike in a bid to get safer working conditions. The mayor, Henry Loeb, refused to negotiate and a local politician, E. H. Crump, raised a police force drawn heavily from the Ku Klux Klan. In late March Loeb declared martial law and a group of 200 strikers were confronted by over 4,000 National Guard troops with fixed bayonets and armoured vehicles.

The strikers marched silently past them in single file, each carrying a large placard with the words "I AM A MAN". In the 1780s, abolitionist movements in America and Britain adopted a slogan in response to the use of "boy" as a pejorative against black slaves: "Am I Not a Man and a Brother?" By changing the abolitionists' slogan from a question to a proclamation, the Memphis activists were demanding the dignity of recognition, not asking for it.

The strikers' slogan also invoked America's Declaration of Independence, specifically its second sentence: "We hold these truths to be self-evident, that all men are created equal." All men: to deny America's black population their "certain unalienable Rights," among them "Life, Liberty and the pursuit of Happiness," was to imply that they were less than men.

The posters were bold, not fancy. They were produced by Allied Printing within the Clayborn Temple, the strikers' organizing and housing hub. Around 400 were made, and they appear in nearly every image of the strike, on marches routinely met with police brutality. Files subsequently released show that the FBI was monitoring the situation. As the strike gathered national attention, civil rights leaders descended on Memphis to bolster the strikers' morale, trailing the press circus in their wake.

Among them were Jesse Jackson and Martin Luther King, Jr. who came to speak at the invitation of local preacher James Lawson, the chairman of the strike committee. "At the heart of racism," Lawson told the strikers, "is the idea that a man is not a man. You are human beings. You are men. You deserve dignity."

On 3 April, King delivered his inspiring and prescient "Mountaintop" speech in which he urged peaceful protest and an economic boycott. "I want you to know tonight, that we, as a people, will get to the Promised Land. So I'm happy, tonight. I'm not worried about anything. I'm not fearing any man." He was assassinated the next day by a white supremacist.

The strike was finally settled on April 16 when Mayor Loeb conceded, awarding the men union recognition and a pay rise. The men had to threaten to strike again to hold him to it.

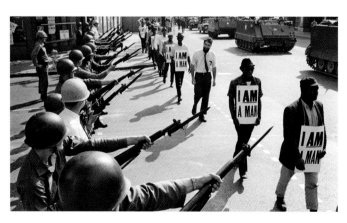

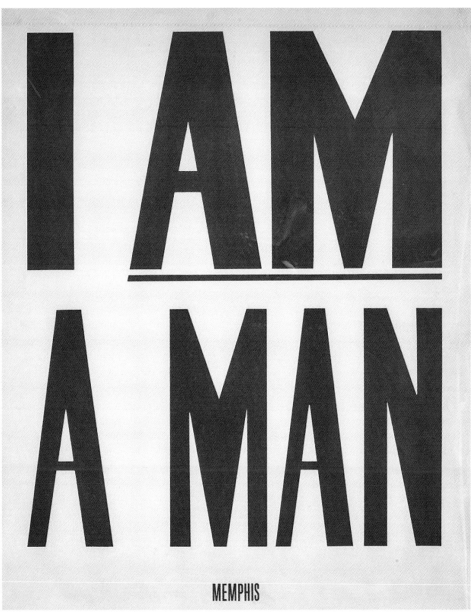

OPPOSITE: *National Guard troops block off Beale Street as Civil Rights marchers demonstrate peacefully in Memphis on 29 March 1968.*

100 Posters That Changed the World_____159

Mexico Olympics

(1968)

Since the first modern Olympiad in Athens in 1896, only two world wars and a global pandemic have prevented the Games being held every four years. The posters accompanying them provide a brief history of the graphic arts.

By 1912, when the Games came to Stockholm, the Olympic Games were already a sporting institution. These were the last Games to allow private entries as well as national teams, and they were the last to award solid gold medals to their winners. Swedish illustrator Olle Hjortzberg designed the poster for the Games, a triumph of curving geometric flags of the nations. The modesty of its classically naked athletes was preserved with artfully if uncomfortably placed finishing-line ribbons.

The Stockholm poster is notable to modern eyes for the absence of the Olympic Rings. The distinctive logo was only devised in 1913. It did not make its debut on a poster until 1928, when an Olympic flag can be seen in the background of the poster for the Amsterdam Olympics. Amsterdam introduced the element of an Olympic Flame to proceedings too.

In 1936 the Games came to Adolf Hitler's Berlin. Berlin was originally due to host them in 1916, when they were cancelled because of World War I. Under Hitler, the Olympic Rings became the Aryan victor's laurels on posters for the event; and on souvenir lapel pins the black middle ring sat below a black German eagle and swastika. Hitler's pride was dented when African American track athlete Jesse Owens won four golds, although Germany did come top of the medals table. The city has not hosted the Olympic Games since.

The 1968 Games in Mexico, were given a vibrant advertising image – part 1960s psychedelia, part Aztec tradition – while the rings were incorporated into the circles of the date, '68. As the Olympics moved into the 1970s the Munich Games of 1972 played a similar visual trick with its logo, a circular spiral of alternate black and white stripes designed by Otl Aicher, a German typographer who also introduced the now-familiar stick figures representing the various sports. The Olympic Rings were barely visible in the design, but their rainbow of colours was taken up by the central motif, a large cross suggesting a meeting place for all. Sadly the Cheerful Games, as they were styled, were overshadowed by the murder of several Israeli athletes by the Palestinian terrorist group Black September. Black was the one colour not featured on the Munich 1972 poster.

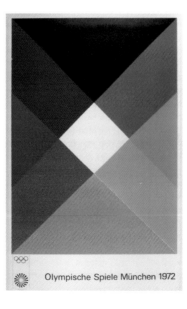

Olympische Spiele München 1972

OLYMPIC GAMES
STOCKHOLM 1912
JUNE 29th – JULY 22nd.

ABOVE: The official Mexico Olympic poster for 1968 was created by Lance Wyman, echoing the expanding-line patterns used by native Huichole Indians.
OPPOSITE: There were no Olympic rings, just carefully placed ribbons in the 1912 poster for the Stockholm games. By 1972 they had been demoted to a minor logo on the Munich poster.

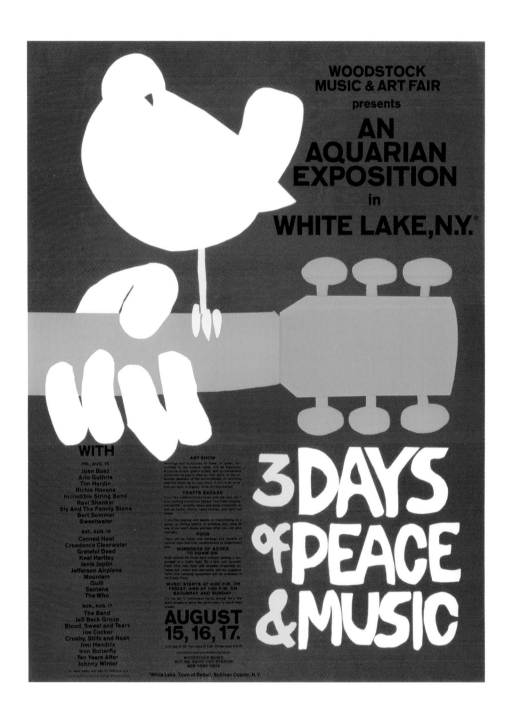

ABOVE: *It was put together quickly and not all the acts listed on the bill made it to upstate New York, but the poster for the event has become a classic, constantly reproduced over the last fifty years.*

Woodstock

(1969)

A dove and a guitar: the poster encapsulated the event, and the event encapsulated the counter-culture ethos of a generation. But the creation of the Woodstock poster was as casual and unplanned as the festival itself.

Almost as soon as the last note had been played on the Woodstock stage, the name became synonymous with a culture and a generation. The three-day rock festival now appears as a pinnacle of hippy hope, a brief candle of optimistic light in the dark closing years of the 1960s.

In the late 1960s America was a pressure cooker of tensions waiting to let off steam. The assassination of Martin Luther King Jr. in 1968 and the riots which followed it laid bare the institutional racism which existed in much of the country. The further deaths of 40,000 young American servicemen in Vietnam by the summer of 1969 were also raising questions about how the US functioned as a nation. Young people were ready to reject "business as usual".

They found their means of expression in music and communal living, an alternative vision of society based on equality, humanism, and pacifism: in two words very much open to interpretation, Peace and Love. When Woodstock was announced, with a poster which captured everything they believed in, it came along at just the right time. Half a million young people flocked to the event.

Logistically, Woodstock was a shambles. Woodstock the town banned the festival with just over a month to go, and the organizers were forced to make it a free event when it ran out of time to fence off the new arena, on the land of dairy farmer Max Yasgur. The unexpectedly vast audience overwhelmed the catering and toilet arrangements, and unscrupulous locals profiteered with sales of basics like food and water.

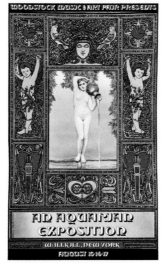

The poster which drew them to the place was similarly chaotic in conception. Underground artist David Byrd was originally commissioned to design it. He delivered a rich collage of cherubs and symbols of love surrounding a classical image of a water-bearing nymph, to reflect the Age of Aquarius which Woodstock was supposed to celebrate. The colours were rich ruby, turquoise and pink, very much in keeping with the luminous hippy music posters of the West Coast.

When the venue for Woodstock changed, Byrd could not be reached; and Arnold Skolnick was called on at short notice to come up with a new version in the course of a weekend. He had never designed a poster before, and created the Woodstock one by cutting out shapes from coloured paper and moving them around until he was satisfied with the result. "A poster is supposed to be so simple that if you're driving by slowly in a car, you can see it", he said later.

The festival's line-up was overprinted in alphabetical order with every name the same size, a decision meant to reflect Woodstock's egalitarian principles. For three days, perhaps even longer, Woodstock seemed to prove the central thesis of the counter-culture movement: that the human spirit could flourish outside the confines of hierarchies and formal institutions.

Perhaps it is just as well that the Woodstock poster no longer represents merely a chaotic music event, but an entire philosophy which has never really gone away. Its attractively simple message of Peace and Love through Music persists.

METROPOLITAN POLICE

HAVE YOU SEEN THIS WOMAN?

Missing from her home at Wimbledon since evening of 29th December, 1969.

Height 5ft. 9in., medium build, dark brown hair, brownish green eyes, dark complexion, Australian accent.

Wearing black cashmere reversible coat, fawn coloured wool on reverse side, no button. Green jersey suit. Cream patent shoes, square toes, 1½in. heel, yellow metal chain across instep.

IF YOU HAVE SEEN Mrs. McKay since 5 p.m. on 29th December, 1969, please inform Wimbledon Police Station at 01-946 1113, or your nearest Police Station.

Printed by the Receiver for the Metropolitan Police District, New Scotland Yard, S.W.1

ABOVE: The missing poster issued by London's Metropolitan Police might have helped find Muriel McKay, as she lived long enough to write five letters for her kidnappers.
OPPOSITE: Teresa Halbach wasn't reported missing until three days after her disappearance, by which time the worst was feared.

Missing Posters

(1969–2005)

The first 48 hours in any Missing Persons case are always the most critical – people go missing for a variety of reasons, but the first two days are when there is most likely to be a successful outcome. Which is why Missing posters have a more subtle purpose than is first apparent.

Disappearances can be for all sorts of reasons, whether it's a runaway, failure to return from a long-distance hike or an abduction. The time it takes to confirm that someone is genuinely missing combined with the time needed to produce a poster, print it and distribute it to key locations means that Missing posters are more likely to be an appeal for evidence rather than a safe return.

Muriel McKay was abducted in Wimbledon on 29 December 1969 and the Metropolitan Police subsequently issued a poster to jog the public's memory. She had been kidnapped for a million-pound ransom in the mistaken belief that the victim was Anna Murdoch, the wife of Rupert Murdoch, who had just bought the *News of the World* and *Sun* newspapers. Murdoch had lent his Rolls Royce to Alick McKay while he went back to Australia and the kidnappers had followed it to a house in Wimbledon assuming it belonged to the newspaper mogul.

Over the next forty days, the kidnappers made eighteen calls, and sent five letters written by Mrs McKay as "proof" that she was alive, and so the poster could possibly alert the attention of anyone who might know of her whereabouts.

After police failed to apprehend the kidnappers at a ransom pick-up – two members of the public spotted the suitcases loaded with money and informed local police who were unaware of the sting – they traced a Volvo saloon to a Hertfordshire farm where there was enough evidence to convict the two brothers guilty of the crime. However, no trace of Muriel McKay was ever found.

Manitowoc County in Wisconsin has become the global focus of cable television viewers after the disappearance of Teresa Halbach in 2005. Halbach worked for a car sales magazine and had been to Steven Avery's property to photograph a car just before she went missing. The subsequent Netflix documentary about the jailing of Avery (who had been wrongly imprisoned for another killing) for her murder has formed the basis for two separate documentary series.

The "Endangered Missing" poster issued by local police might have brought some attention to the case, but it is the involvement of Netflix that has brought analysis in forensic detail to every aspect of the investigation and some of its glaring flaws. In some regards a Netflix documentary is the new Missing poster, much longer in the production, but jogging the memories of viewers and drawing out further evidence to solve a crime.

 Endangered Missing

Teresa Halbach

Birth:	3/22/1980	Hair:	Lt Brown
Missing:	10/31/2005	Eyes:	Brown
Race:	White	Height:	5'6"
Sex:	Female	Weight:	135#

Missing From: Manitowoc/Two Rivers, WI
Age Missing: 25 Age Now 25

Teresa Halbach was last seen on Monday, October 31, 2005 in the Manitowoc/Two Rivers area, but may have traveled further to Green Bay or the Fox Cities. She was driving a 1999 dark green Toyota Rave 4, license plate number SWH582. She was wearing blue jeans, white button-down shirt, and a spring jacket.

IF YOU HAVE ANY INFORMATION PLEASE CONTACT
Calumet County Sheriff's Department, (920) 849-2335 or
Youth Educated in Safety, Inc. 1-800-272-7715

11/2/05 Sponsored by The Guardian Life Insurance Company of America

 GUARDIAN

Anti-Vietnam War Posters
(1970)

President Nixon took an increasingly tough line on protesters against the Vietnam War. Having suspended the draft at the end of 1969 he reintroduced it in January 1970. Things came to a head when US troops invaded Vietnam's neighbour Cambodia in April 1970.

As the Sixties became the Seventies, disillusioned youth – angry with itself and the Establishment – focused on the pointless war in Vietnam. As long ago as 1965, then-President Johnson had been urged to withdraw from a fight which the US could not hope to win. When Nixon announced the invasion of Cambodia on 30 April 1970, opposition – especially from those of draft age – intensified. America, they claimed, was simply slaughtering its own children.

Then, at Kent State University in Ohio on 4 May 1970, state troopers opened fire on a group of unarmed demonstrators. In a sustained salvo of live rounds some thirteen seconds long, four students were killed, one was paralysed for life by his injuries, and eight others were hit by flying bullets. America was indeed killing its young. The National Guard's weapons included rifles, a pistol and a 12-bore shotgun. The soldiers were the same age as their victims.

Less than three weeks after the killings at Kent State, Crosby, Stills, Nash & Young (who had performed at Woodstock the year before) recorded the song "Ohio", which Neil Young had written after seeing photographs of the event in a magazine. Its haunting refrain "Four dead in O-hi-o" punctuated by heartfelt cries of "Why?" and "How many more?" captured the shock of the Woodstock generation at what America had become.

If the authorities hoped that the Kent State Massacre would bring objectors to heel, they were disappointed.

Attempts were made to discredit the victims but anti-war sentiment was galvanized. Protests erupted on campuses all across America and, in the days before social media could spread news virally, posters were the principal medium of communication. All that summer, university art departments were pressed into service, often with the consent of staff. At UCLA Berkeley the art school lecturers even ran poster-making workshops and cancelled the graduation ceremony in protest at the shootings.

Many posters were little more than announcements of opposition. Others showed considerable design flair and some were almost professional in their production values. Most were anonymously created, and many subverted that most revered American icon, the Stars and Stripes flag. One replaced the stars with a white peace sign on the blue background. Another rotated the flag through ninety degrees so that the stripes became prison bars behind which the Statue of Liberty wept. One of the most memorable portrayed the flag upside down, and turned the stripes into red rifles and the stars into waves of USAF planes, a reference to the three million tons of bombs dropped on Indochina during the war.

These posters played a vital part in exposing the folly of the Vietnam War. Nixon finally ended conscription and withdrew American troops from Vietnam in 1973.

OPPOSITE TOP: Subverting the Stars and Stripes has become a regular form of protest since Vietnam.
OPPOSITE BOTTOM: A 1972 anti-Vietnam War poster with photography by Leonard Nones, better known in the US for his fashion photography in GQ.

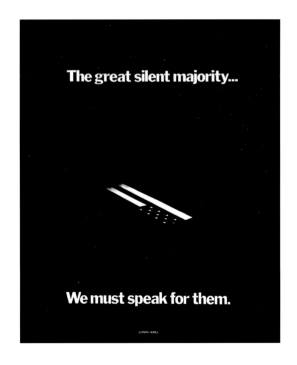

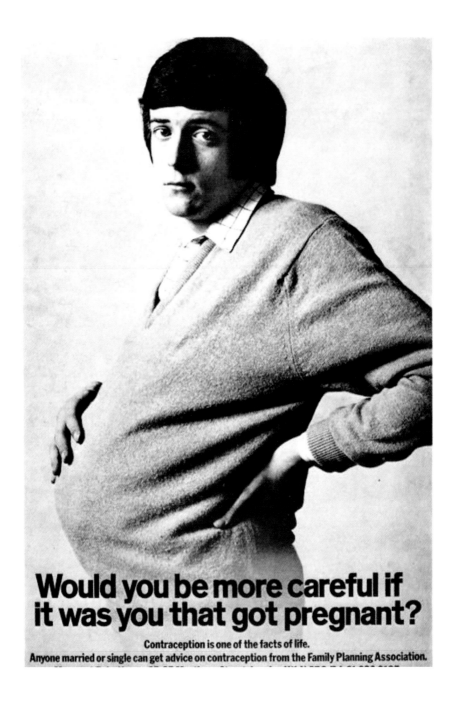

Would you be more careful if it was you that got pregnant?

Contraception is one of the facts of life.
Anyone married or single can get advice on contraception from the Family Planning Association.

ABOVE: Since its appearance on 12 March 1970, Pregnant Man has often been referenced in the media. At the time of release the British press were desperate to track down the model who wanted to remain anonymous. Today the poster is part of the V&A Museum's cultural collection.

Contraception Posters

(1970–1995)

In June 2008, Thomas Beatie, née Tracy LaGondino, gave birth. Since then the idea that men could become pregnant has, arguably, become marginally less unconventional than it had been for most of history. This was not the case in 1970 when The Pregnant Man poster made its first appearance in the United Kingdom.

Created by CramerSaatchi, later Saatchi & Saatchi, for the Health Education Council, it shows a young man with one protective hand on his swollen belly while his other hand supports his aching back. "Would you be more careful if it was you that got pregnant?" asks the strap line. "Yes, I would" is the answer, judging by the rueful expression sported by the laden gentleman.

One of the clichés of Sixties Britain is that the Pill, introduced in 1961, ushered in a new period of sexual freedom. Many women would argue that it freed many men from shouldering any responsibility for contraception. The Pregnant Man poster was designed to change that attitude.

Even in 1970 publicly displaying posters about contraception was ground-breaking. In a much less gender-fluid era, the way in which the poster forced viewers to think about sex and gender roles was genuinely shocking. In more conservative circles, the poster's subversion of traditional masculinity was seen as offensive.

All of which was as intended. The poster provoked questions in parliament and made the headlines. It also secured the reputation of the ad agency which created it.

Posters were an effective way of achieving the campaign's end. It certainly wouldn't have worked on the radio; and the subject was altogether too

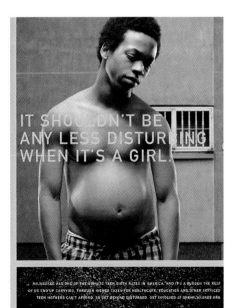

sensitive to have been raised during commercial breaks on TV at the time. A poster, on the other hand, could be placed where a target audience would see it, and – just as importantly – where those who might be shocked or embarrassed by it would not.

Over a quarter of a century later, the public health department in Milwaukee, Wisconsin, used similar tactics as part of a campaign to lower their teen pregnancy rates. A report showed that the city had the second highest teenage birth rate in the United States, twice that of the national average. This had adverse effects in terms of welfare costs, social deprivation and life outcomes.

As part of the efforts to reduce teen births, a series of public awareness posters showing pregnant teenage boys was put up near schools. With tousled hair, low rise trousers and props such as skateboards and baseball caps, the boys could have been in an advert for trainers or body spray – were it not for their bulging bellies. Again the posters were deliberately shocking. The text below the image acknowledges this telling the viewer that it is time to "get beyond disturbed".

According to one source, between the poster's deployment in 2007 and 2016, Milwaukee's teenage birth rate fell by 65%. Perhaps more tellingly, the campaign was so successful that Chicago ran their own version, including repurposed posters, in 2013.

Keep Britain Tidy

(1970s)

Keep Britain Tidy has been wagging its finger instructively at the British population for nearly 70 years. Its iconic green Tidyman logo is the original eco warrior.

The "Keep Britain Tidy" slogan has been part of British life since the 1960s. Initially adopted as a resolution by the tweed and jam brigade of the Women's Institute in the 1950s, it was established as an eponymous charity in the 1960s.

Keep Britain Tidy began campaigning to change public attitudes to littering in the 1970s, with a poster campaign using celebrities and the "Keep Britain tidy" slogan. In those innocent times the celebrities featuring on the campaigns were mainstream, family-friendly favourites: beloved comedy duo Morecambe and Wise; Dixon of Dock Green, the nation's favourite TV policeman played by Jack Warner; and Wilfred Brambell from the popular TV sitcom *Steptoe and Son* (the BBC original of NBC's *Sanford and Son*).

Even when trying to "get down with the kids" by featuring pop stars, the stars in question – Abba, David Cassidy and the Bee Gees – were wholesome: no Iggy Pop or Alice Cooper here. Celebrities sported clean, bright, yellow "Keep Britain Tidy" T-shirts, and in the case of global superstars Abba, conscientiously paraded with brooms and rubber gloves. The charity's best-remembered partnership was with the Wombles, the furry, pointy-nosed creatures from a popular 1970s children's TV series whose raison d'être was clearing their local park of litter.

The main contribution made to visual culture by the Keep Britain Tidy charity, was not its poster campaigns, but rather its logo, the Tidyman. This stylized green figure, dropping litter into a bin, alongside the slogan "Keep Britain Tidy", was commissioned by the charity in the late 1960s, and has adorned waste bins, packaging and the charity's communications ever since. The

Tidyman is one of the great graphic icons. Its message is immediately and unmistakably recognizable; and although the charity opted to drop the logo in a 2009 rebranding exercise, it was reinstated in slightly updated form in 2017.

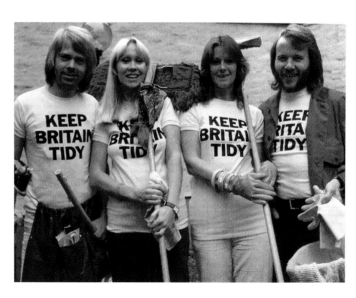

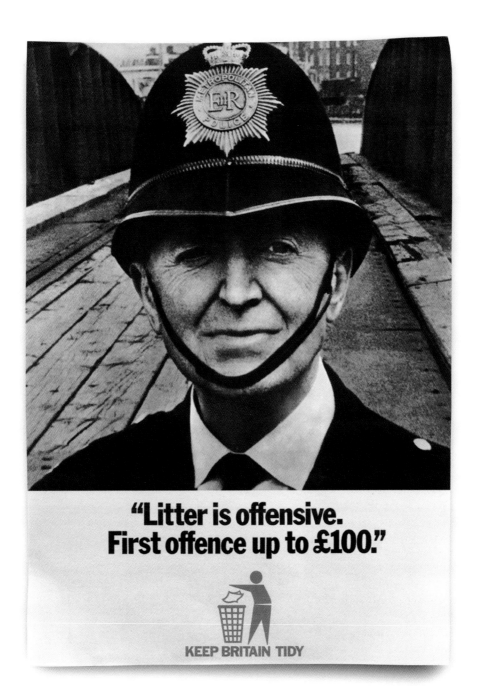

"**Litter is offensive.
First offence up to £100.**"

KEEP BRITAIN TIDY

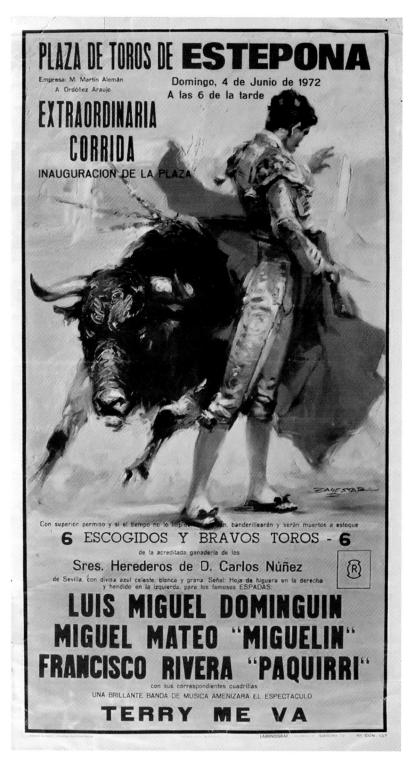

LEFT: A typical Spanish bullfighting poster, featuring the Plaza de Toros in Estepona, from 1972, the year its new elliptical-shaped bullring opened.

Bullfighting Posters

(1972)

It may have been Ernest Hemingway who introduced the international community to the spectacle of Spanish bullfighting, but it was the rise of the package holiday in the 1960s which encouraged everyone to bring a piece of it home in the form of a souvenir poster.

In 1932, Ernest Hemingway was riding high on the success of *A Farewell to Arms*. He chose to follow it up not with another novel but with a non-fiction book celebrating the spectacle and symbolism of the Spanish bullfight. To watch a bullfight, he wrote, is "like having a ringside seat at the war".

Spanish-style bullfighting, known as the *corrida*, has deeply embedded historical roots, believed to go back as far as the worship and sacrifice of bulls in Mesopotamia and the cult of Mithras in ancient Iran. Stylized images of bulls have been found in Palaeolithic cave systems. The Romans loved it, spreading the practice through their empire, but nowhere has it become more a part of the fabric of life than in Spain.

Francisco Romero, in the 1720s, is said to have been the first to ditch the horse and simply go head-to-head with a bull, driving the crowd wild and changing Spanish bullfighting forever. The modern style was established by Juan Belmonte, who insisted on staying within arm's reach of the bull at all times. He was gored repeatedly for his trouble, but the innovation stuck.

It's the final section of the bullfight that provides its definitive image. The matador, with his red cloth, or *muleta*, enacts a series of passes, like a dance, before despatching the bull with a sword. And, as in a dance, the seasoned observers who make up the crowd judge him on artistic expression.

In addition to the artistry of the matador, the *carteles* (posters) advertising the corrida developed a unique style of imagery and lettering,

based partly on circus and partly on cinema styles. The tall thin sheets of paper on which they were printed lent themselves to heroic images of the leading matadors of the day. Developments in lithography allowed for better and better colour reproduction, and the best bullfighting posters were created by specialist artists and printing presses.

The 1950s were dominated by the presses of Valencia on Spain's east coast and by one artist in particular, the Valencian Juan Reus (1912–2003) who often worked with the Ortega printing company in that city. His posters were printed up as blanks – without lettering – which could then be overprinted with the details of any corrida and its participants. He learned his craft from one of the greats, Roberto Domingo, a bullfight artist of the 1920s.

The dramatic imagery of the carteles is reminiscent of popular art in other genres. One of Reus's contemporaries, Vincente Ballestar, (1929–2014) made a greater name for himself as a designer of pulp fiction book covers, but also designed bullfight posters for the Laminograf company in Barcelona in the 1970s.

Times have moved on: as a souvenir the bullfighting poster is now as kitsch as a straw donkey. Few hang them without irony now. But in Spain the tradition has proved incredibly resistant to change. Animal cruelty concerns have had only minimal effect, ignored by the majority of Spaniards, who are as transfixed today as Hemingway was in the 1920s by the ritualized carnage of the corrida.

Anti-Smoking Posters

(1975–2017)

The detrimental effects of smoking on the health of smokers, non-smokers, society, the economy and the environment are now well established. They have prompted governments to campaign against it since the 1960s, in advertising campaigns on TV, in the press and on billboards.

Soon after he took over the throne of England, King James VI of Scotland issued one of the earliest statements opposing the new habit of smoking tobacco. His "Counterblaste to Tobacco" got it right when it characterized smoking as "a custome loathsome to the eye, hateful to the nose, harmful to the brain, dangerous to the lungs."

Despite sporadic local bans in Europe it caught on nevertheless. In the 1930s scientists in Germany first identified the link between smoking and lung cancer, and the Nazi government became the first to campaign against the habit. After World War II the popularity of smoking combined with the Nazis' opposition to it discouraged victorious governments from trying to ban it. It wasn't until damning reports by Britain's Royal College of Physicians and the US Surgeon General in the early 1960s that the truth became inescapable.

UK and US governments adopted a variety of strategies to inform the public about the dangers of smoking tobacco. Some emphasized the negative aspects of smoking, others the positive benefits of giving up. Over time the message about the negative impact on health has become increasingly explicit, from warnings about lung cancer to images of lung cancer victims, and eventually to pictures of their diseased lungs.

Despite strong opposition from so-called Big Tobacco, the tobacco producers' lobby, smoking has at last begun to decline in popularity and social acceptance. But young women in particular have proved persistent adopters of the habit, and several campaigns have been directed at them. Marc Bolan, a prominent teenage heart-throb of the 1970s, lent his face to a British campaign which announced that "Marc Bolan doesn't smoke and he doesn't like kissing girls who do." The poster also drew his screaming fans' attention to the impact of smoking on their pocket money, and how much more make-up and clothes they could buy if they gave up.

Many campaigns tried to put pressure on non-smokers by warning them of the risk of passive smoking. A poster from the American Cancer Society was one of many campaigns which targeted both young women and those most passive of non-smokers, their unborn babies.

Nobody thinks smoking is good for you any more. At best some smokers believe it's cool or rebellious to smoke. Gone are the days when cigarette manufacturers like Lucky Strike and Camels promoted the health benefits of smoking their brand.

Today there are strict controls on advertising and packaging cigarettes and many countries have curtailed smoking in public places. But the war on tobacco is by no means over. In 2012 the Australian government commissioned Sydney advertising agency Loud to produce a new series of posters emphasizing the upside of quitting. The result was the "Stop Smoking – Start Repairing" campaign. Ordinary Australians were encouraged to have their photographs taken in booths with a number of standard health statistics superimposed on them; for example, the benefit after one smoke-free week to your sense of smell, or after twelve weeks to your lungs' ability to cleanse themselves. The posters feature a range of ethnic origins of both sexes, and remain part of the Australian government's National Tobacco Campaign today.

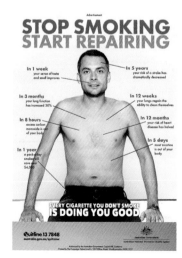

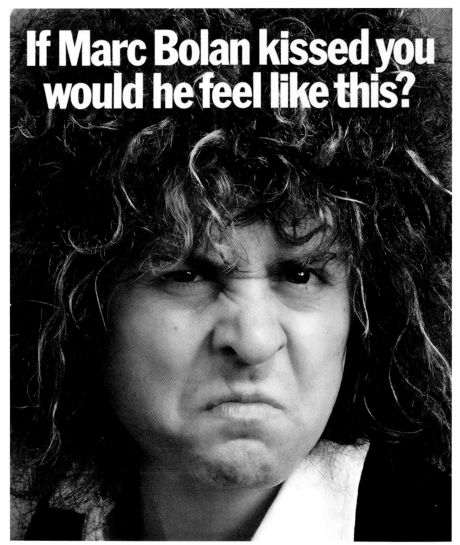

If Marc Bolan kissed you would he feel like this?

He would if you smoked.

Marc Bolan doesn't smoke and doesn't like kissing girls who do.

"Their breath smells of stale tobacco," he says, "and their mouths taste like an old dog end."

And Marc Bolan is only one of millions of young men who won't find you tasty if you smoke.

The silly thing is that if you smoke 20 cigarettes a day, it costs you about £150 a year to make yourself thoroughly unattractive.

Just think how many clothes and how much make-up you could buy instead.

AS 18P

🖐The Health Education Council

ABOVE: Teenage girls in Britain formed a resistant core of young smokers in the 1970s, and there was no greater pop star who might appeal to them than T-Rex's Marc Bolan.
OPPOSITE: One of four posters run by the Australian government in 2017 highlighting the ways smokers can reverse the damage done if they quit smoking.

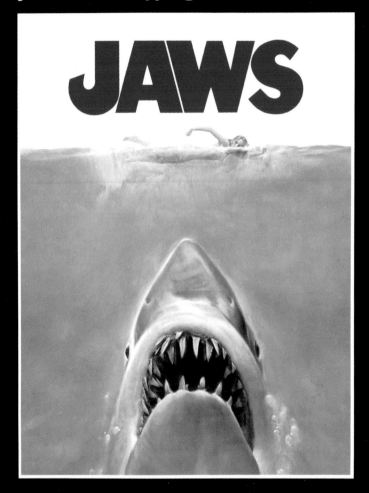

Film: *Jaws*

(1975)

Often referred to as the first summer blockbuster, the Spielberg-directed film *Jaws* is based on Peter Benchley's novel about a great white shark that terrorizes the fictional American seaside town of Amity. The simple, direct poster leaves its audience in no doubt about the horror which awaits them.

The cover of the novel's paperback edition was illustrated by an artist called Roger Kastel. He came up with the image of a shark lurking below a swimmer having read just the first few pages of the book, in which a young woman goes skinny-dipping and becomes the first victim of the monster. The same shocking sequence, accompanied by the approaching menace of John Williams' memorable score, opens the film. Though we don't see the shark, we can see the result as the swimmer is dragged underwater.

The poster for the Universal Studios film took Kastel's image and dramatized it. The paperback's shark is rounder-nosed, more distant, with barely visible teeth. The shark on the film poster quite clearly has one thing on its mind. It is brutally direct. The first thing you notice is the shark, then its teeth, then its victim; all of which draw your eye upwards to the title.

The massive size of the shark contrasts with the diminutive size of the swimmer – can the two, we ask ourselves, really be painted to the same scale? She seems mercifully unaware of the horror that is about to engulf her. Her innocent splashing and the murderous intent of the shark tap into our collective terror of the unknown. Jaws is the monster which we always feared was lurking in the depths of the oceans, or indeed around the corner of some dark alley, or in the unlit cupboard under the stairs.

While the poster is explicit, Spielberg kept the shark implicit for much of the film. The audience do not see all of it until two thirds of the way through the film. Spielberg knew that the shark in his audience's collective imagination would be much more vivid and scary than the animatronic versions produced by his prop department. Keeping it out of sight built suspense.

The film actually discouraged people from swimming in the sea for a long time after its original release. This phenomenon inspired the promotion of the film's sequel. The poster for *Jaws 2* showed the same image of the shark, now rearing above water behind a water-skier – a woman, of course – with the strap line "Just when you thought it was safe to go back in the water …"

OPPOSITE: Apart from attracting attention by showing the monster in terrifying detail, the film poster for Jaws *added to the sense of anticipation, as audiences knew what was coming, long before it appeared in close-up.*

Farrah: Red Swimsuit

(1976)

For a glamour poster that adorned the bedroom walls of so many adolescent boys, it's remarkably unsleazy. And as the biggest-selling poster of all time, shifting 20 million copies, it sealed Farrah Fawcett's status as an icon of the 1970s.

She was a teenage dream – her head tossed back, mouth beaming a wide, unaffected smile; the red of her one-piece swimsuit picked up by the horizontal stripes of the Mexican blanket behind; and that hair, the late-afternoon sun catching its highlights. It was the most famous hairstyle of its era, the Farrah.

The daughter of a Texas oil contractor, Farrah had been named "most beautiful girl on campus" at the University of Texas in the mid-1960s, and when Hollywood agent David Mirisch saw her he wasted no time in signing her up. She arrived in LA in 1968, aged 21, but her big break was slow in coming. By 1976, she was still better known as the wife of TV's Six Million Dollar Man, Lee Majors, than for her own achievements.

Then, Ted Trikilis of the poster company Pro Arts Inc heard from a neighbour's son that the men in his dorm were buying women's magazines specifically for the shampoo ads featuring Farrah Fawcett. Trikilis paired her with photographer Bruce McBroom for a picture session at her house in Mulholland Drive.

Farrah was no passive model; she had substantial input in the shoot, doing her own hair and make-up and selecting the final picture from 40 rolls of film. The red swimsuit was her own. Asked to don a bikini, she instead put on a one-piece by designer Norma Kamali to conceal a scar on her abdomen. Kamali later admitted to being puzzled by Farrah's choice, admitting that it wasn't a design she particularly liked.

Farrah couldn't have asked for a better boost to her career. That year, she appeared in her biggest movie yet, *Logan's Run*, followed up by her defining role in the TV show *Charlie's Angels*, alongside Jaclyn Smith and Kate Jackson. It was a huge success, but Farrah quit after the first season – ostensibly to broaden her acting range, but it couldn't have escaped her notice that she'd earned more from poster royalties than from an entire season of top-rated TV.

Farrah kept working, scoring Emmy and Golden Globe nominations and receiving critical acclaim for serious roles playing a battered wife and a real-life murderer, but her star never shone so brightly again. Diagnosed with cancer in 2006, she lived for three more years, her passing overshadowed by the death of Michael Jackson the same day.

But America didn't forget. In 2011, the famous poster image was recreated as a limited edition Barbie doll and her swimsuit added to the cultural treasures of the Smithsonian's National Museum of American History.

RIGHT: Farrah was in control of her image and made the creative calls on the photo shoot: "The reason I decided to do a poster was, well, if you don't sign a deal to do one, someone does one of you anyway and then you get nothing."

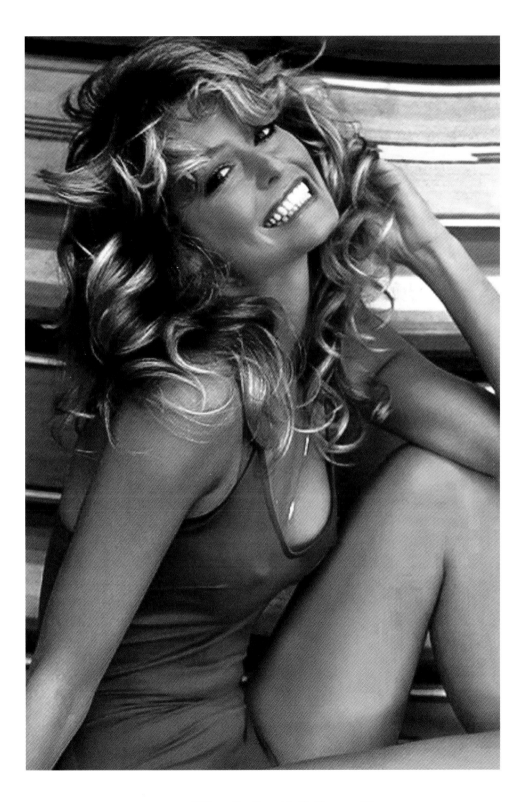

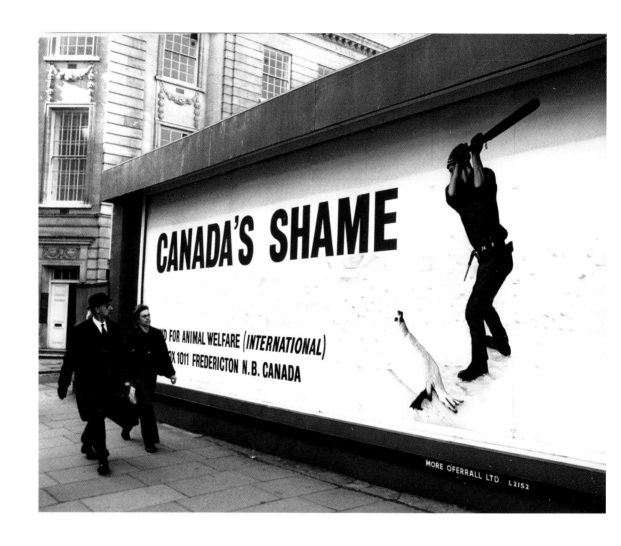

ABOVE: Focusing attention on the Canadian seal hunt brought about results. In 1983 the European Union banned the importation of seal pup products and in 1987 Canada banned the hunting of white-coated seals.

Seal Clubbing Protest

(1977)

Seals are killed for their fur, their meat and their blubber. They have been central to the Inuit diet and way of life for 4,000 years. In the modern era western sensibilities have been offended by the extent of the slaughter, prompting a number of poster campaigns.

Brian Davies was born in Wales and emigrated to Canada in the 1950s. In 1961 he became an office bearer in the New Brunswick branch of the Society for the Prevention of Cruelty to Animals (the NB SPCA) and under his influence the branch began to take an interest in wild animals as well as domesticated ones. In the course of that expansion he encountered the Canadian seal hunt for the first time.

Seal hunting is an emotive issue. Native Canadians depend on it for clothing, food, and a small amount of trade. But much of the killing is done by Newfoundland and Labrador fishermen, for whom it contributes only about 5% of their annual income. Seal pups may legally be slaughtered from the age of only twelve days, and at its height in the 1950s the trade saw the wild population decline by two thirds as a result.

The manner of their dispatch is violent and sometimes inhumane. Hunters point to the treatment of other young animals in the farming industry such as hens and pigs; but comparisons with other species hardly seem relevant. Davies began a Save the Seals campaign, and his adoption of a pair of seal pups drew attention to his cause.

When in 1969 the NB SPCA stopped backing the campaign, because they felt it was distracting from their

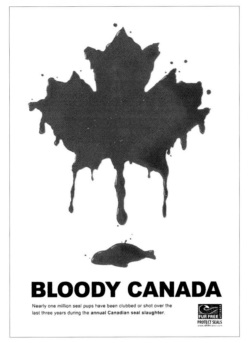

BLOODY CANADA

Nearly one million seal pups have been clubbed or shot over the last three years during the **annual Canadian seal slaughter.**

FUR FREE
PROTECT SEALS

core activities, Davies quit and formed the International Fund for Animal Welfare (IFAW). IFAW won an early victory when it forced the Canadian government to introduce annual quotas for the slaughter.

Celebrity endorsements from film star and animal rights campaigner Brigitte Bardot and others drew global attention to the hunt, putting Canada and its fishermen on the defensive. In 1977 Davies kept up the pressure with a huge billboard poster proclaiming "Canada's Shame" beside the image of a man clubbing a seal to death. The billboard was sited directly opposite Canada House in London's Trafalgar Square at a time before such sites were regularly used for campaigning.

The poster turned heads in London, and it made headlines in other media. It certainly goaded the Canadian government, which later that year prosecuted Davies for flying a helicopter over the seal territories and threatened to withdraw the charitable status of IFAW's finances. Faced with this hostility, IFAW relocated to the US and redirected its activities. In 1983 its campaigns convinced the European Union to ban all imports of young seal products and the market for them temporarily collapsed. It was a landmark in international attitudes to wild animals.

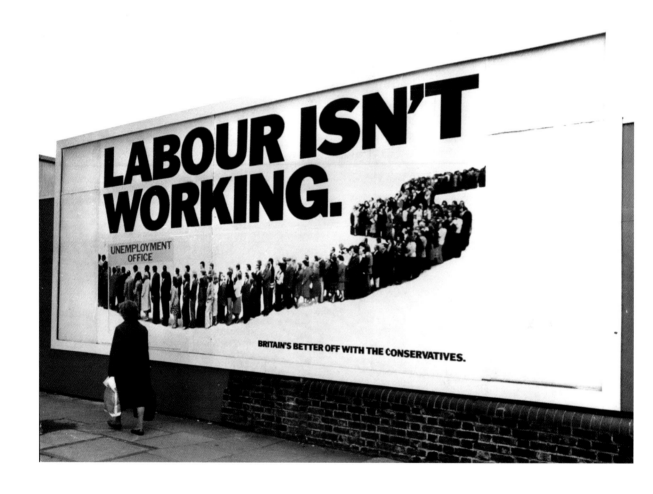

ABOVE: Art director for Labour Isn't Working, *Martyn Walsh, says that the premise for the poster was straightforward: "The brief for the advert was one that all political parties fall back on, don't make promises that you might not be able to keep. Instead, fall back on the government's poor track record."*

Labour Isn't Working

(1978)

British Prime Minister James Callaghan faced an uphill struggle in the late 1970s. Under his Labour government, by mid-1978, inflation was out of control and, most worryingly, unemployment was soaring towards 6%. High prices and unemployment were not vote-winners.

Worst of all, the Labour Party – traditionally the friend of the working classes – was fighting a losing battle in its efforts to regulate the strike actions and pay demands of the trade union movement. It all fed a public perception that Britain under Callaghan's Labour Party was in decline.

Anticipating that Callaghan would soon be forced to call a general election, the Conservative Party led by Margaret Thatcher hired the advertising agency Saatchi & Saatchi to persuade voters to turn Tory. The firm rose to the challenge with a poster that became the gold standard of political advertising, distilling the country's anger, frustration and anxiety into an image impossible to ignore.

Copywriter Andrew Rutherford thought up the slogan "Labour Isn't Working", prompting art director Martyn Walsh to suggest a picture of a vast crowd outside a Job Centre to accompany it. Their boss, Charles Saatchi, was underwhelmed, so they switched the crowd for a long, snaking queue and the words "Job Centre" for "Unemployment Office". With the added line "Britain's better off under the Conservatives", it was submitted to Mrs Thatcher, who disapproved because she thought that even mentioning one's opponents on a poster was giving them too much publicity.

She was talked round and the Hendon branch of the Conservative Party promised 150 people for a photo shoot. On the day, they could only supply twenty, so several images were spliced together to create the illusion of a queue of hundreds. Rutherford and Walsh felt that the last-minute changes actually improved the design, giving it greater impact.

In the end, the poster only appeared on twenty billboards, but its impact was seismic. Labour were furious; at a time when political advertisements were uncommon in Britain, Denis Healey denouncing it in the House of Commons as "soap powder advertising". Saatchi chairman Tim Bell later estimated that the furore was worth £5 million of advertising.

Resurrected with the revised slogan "Labour Still Isn't Working", it became the defining image of the 1979 General Election, which the Tories won easily with a 43-seat majority. The Conservative Party Treasurer Lord Thorneycroft went so far as to claim that the poster had won it for them. Saatchi & Saatchi were instrumental in two more Conservative victories and in 1999 *Campaign* magazine proclaimed it "the poster of the century". The fact that unemployment tripled within two years of Mrs Thatcher taking office was quietly swept under the carpet.

And there was still life in it. A poster for the 2015 General Election was headed "Labour Isn't Learning", an acknowledgement that the public still remembered the original, now nearly thirty-five years old. Memories were jogged again, and not pleasantly, when Nigel Farage reused the idea for his anti-immigrant "Breaking Point" poster in 2016. It even crossed the Atlantic: Mitt Romney used the original photograph in a poster attacking Barack Obama. Clearly, something was working.

Theatre: *Cats*

(1981)

Cats, the musical by Andrew Lloyd Webber based on T. S. Eliot's collection of feline poetry *Old Possum's Book of Practical Cats*, broke new ground in almost every aspect of its production. The instantly recognizable poster remains a model of simplicity.

Lloyd Webber's *Cats* was such an unlikely premise for a musical that many promoters would not touch it. The composer had to underwrite it himself, to the tune of nearly half a million pounds. It went on to break box office records previously held by another Lloyd Webber show, *Jesus Christ Superstar*.

Its stage design was intended to immerse the audience in the cats' world and in the spectacle of the production. The cast of cats entered the theatre through the audience and Director Trevor Nunn insisted on placing the orchestra backstage instead of in the orchestra pit at the front, in order to have nothing between the audience and the action. The show pioneered the use of radio microphones for every performer, and automated lighting, giving technicians greater control over their effects no matter which theatre they were in. Off-stage the show was one of the first to take full advantage of merchandising.

All these innovations and more are now standard for big-budget live theatre. *Cats* is credited with kick-starting the fashion for global mega-musicals – theatre where the spectacle was more important than the plot, and shows which could be seen in several productions running simultaneously around the world. It was stipulated that the staging of *Cats* everywhere must be to the same design and standard as the original London West End version, creating a sense that wherever you saw it you were seeing it at its original best.

Part of that drive for uniformity was reflected in the design of the poster, commissioned by producer Cameron Mackintosh. Traditional theatre posters carried quotes from positive reviews, names of the stars and images of the setting, costumes or actors. *Cats* did away with all that and treated the musical as if it were an all-singing, all-dancing brand of beans.

The poster was designed by Dewynters, an advertising agency based in London's West End – Theatreland. The minimalist approach consisted of one simple, immediately understandable image of two cats' eyes on a plain black background and the title of the show at the bottom. No stars, no reviews. Up until that point the musical had been known as *Practical Cats*, but "Practical" was too big to fit on the poster. The tagline "Now and Forever" was introduced chiefly to balance the two other design elements. The design is not *quite* as simple as it seems: if you look closely at the cat's eyes, the pupils are in fact blurred dancers moving in pools of yellow light. Still, with no other design elements to distract you, it is a striking poster which leads you inescapably to its message – "see *Cats*".

The image was applied to a diverse array of merchandise, almost none of it in any way feline. Cushions and coasters, mugs and glasses, pencils and baseball caps, lapel pins and fridge magnets, shopping bags and T-shirts: they all got the *Cats* eyes treatment. In the 1980s, when T-shirts became not just expressions of fandom but items of high street fashion, the *Cats* T-shirt – yellow eyes on black cotton – was the second bestselling T-shirt of the decade, outsold only by the Hard Rock Café. How's that for brand management?

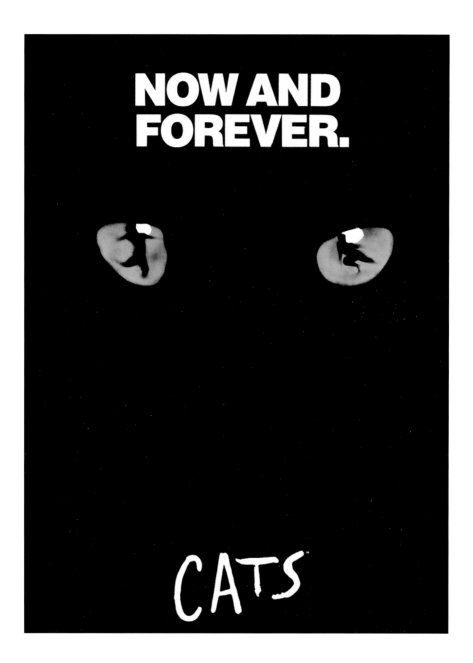

ABOVE: Andrew Lloyd Webber's groundbreaking musical could have ended up as Practical Cats *were it not for the poster.*

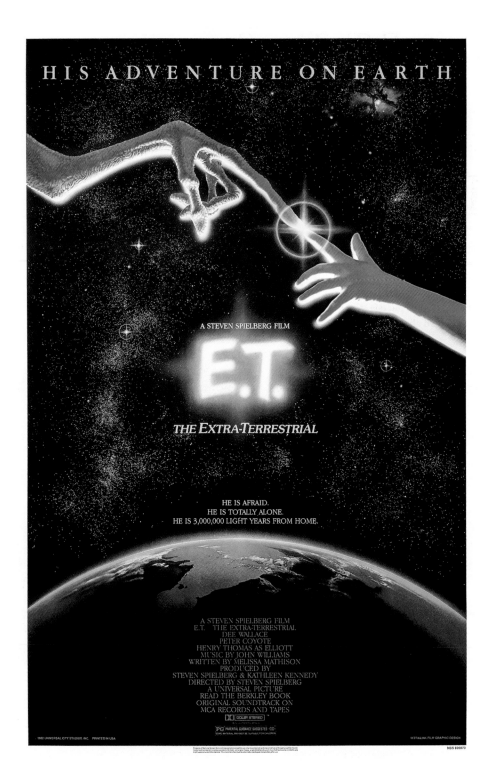

Film: *E.T. The Extra-Terrestrial*
(1982)

Some films have memorable posters, others are more formulaic – step forward *The Fast and the Furious* (four people and a car) – but *E.T.* is perhaps unique in that it had two wholly different yet equally memorable posters.

Most films portray alien visitors to Earth as hostile invaders. From the Daleks to Predator, they make contact with humans in order to eat us, hunt us for sport or use us as slave labour. *E.T. The Extra-Terrestrial* presented an alien that was lovable rather than lethal. Would the public buy it?

Directed by Steven Spielberg and released in 1982, *E.T.* defied convention, smashed box office records and won four Oscars. It tells the tale of Elliott, a boy who befriends a stranded alien and helps him return home despite sinister government forces.

Not unlike Michelangelo's painting *The Creation of Adam*, one version of the film's publicity posters shows the extra-terrestrial's divinely glowing digit tip-to-tip with one of Elliott's fingers. Spielberg is said to have suggested that John Alvin, the poster's creator, take inspiration from the Michelangelo fresco in the Sistine Chapel. However, Spielberg himself denies that the film has any Christian narrative. Rather more simply, he says it was inspired by an imaginary friend he invented after his parents divorced.

If the "touching fingers" poster points to the film's themes of communication, understanding and friendship then another publicity poster makes clear its magical appeal. Taken from the film's climactic chase scene, it shows Elliott and E.T. soaring above a forest into a night sky which is backdropped by a radiant full moon. The image embodies all the fantasy aspects of the film: Elliott's escape from 1980s suburbia; the ability to fly; and a special, secret friendship.

Their vehicle for this miraculous journey is a BMX bike. In the early eighties, BMX racing in the United States was a niche but growing interest. After the film's release in the UK, BMX sales boomed as every child yearned to emulate the stunts in the film. Flying above tree tops may not have been viable for all, but with some imagination, a plank and a couple of house bricks to make a ramp, every would-be Elliott could get airborne.

At the end of its first theatrical run the film had taken more than $600 million and surpassed *Star Wars* as the highest grossing film: good going for a project that cost a mere $10.5 million to make. In fact, *E.T.* remained the highest grossing film until 1993 when *Jurassic Park* was released. Spielberg was probably not too put out. He directed that as well.

OPPOSITE PAGE: Designer John Alvin used his daughter's hand to stand in for Elliott's in the original movie poster.

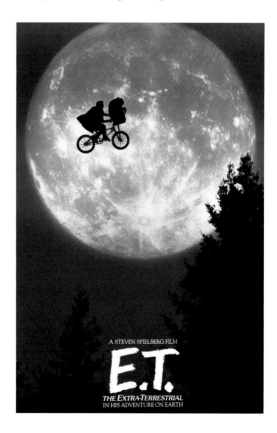

Nuclear Waste Trains

(1983)

When Ken Livingstone became the leader of the Greater London Council (GLC) in 1981, one of his first acts was to declare the capital to be a nuclear-free zone. He cancelled spending on the city's nuclear defence plans and campaigned against the passage through London of nuclear waste.

A radical left-wing thorn in the side of the right-wing Conservative government of Margaret Thatcher, the GLC flaunted its egalitarian socialist aims. Its financial support of many minority community groups – LGBT associations, feminist organizations and groups opposing racism – earned it the nickname of The Loony Left. The Conservatives exploited this perception and drove their opponents the Labour Party towards the centre of British politics, isolating Livingstone and his sympathizers.

Nevertheless, in 1983, the GLC declared a Year of Peace, a core plank of which was its anti-nuclear position. It was an issue high on the public's agenda at the time. Cruise missiles from the US had recently been stationed in the UK, and Britain had just adopted the US-made nuclear warhead Trident. In addition, a much-anticipated public enquiry was underway into the construction of a proposed second nuclear power station at Sizewell B in Suffolk, just to the north of London.

All of England's nuclear waste, the used plutonium from its nuclear power stations, had to be transported to the country's reprocessing plant in the North West. Three of the power stations were in the South East near London. The GLC commissioned a series of four posters depicting, with simple and recognizable photographs, trains carrying flasks of nuclear waste through residential districts of the city. The photographs were taken by Martin Bond, a town planner turned photographer with a special interest in the environment.

In one picture, identified as Hackney, pedestrians, shops and a double-decker bus full of commuters are visible beneath the slogan, "Spot the nuclear train". It takes you a moment to see the lethal cargo of a goods train passing overhead on a bridge. There are hundreds of such bridges in London and the message was clear: you could be standing next to dangerous material, a potential terrorist target, without even knowing it.

The posters did a good job of raising awareness, and disapproval, among the public. Anti-nuclear protesters sometimes tried to force trains to stop, drawing attention to their vulnerability. The campaign was less successful, however, at stopping the passage of plutonium through the capital. In 2002 a nuclear train crashed south of London after striking a road vehicle; and trains still travel across London from each generating station once or twice a week. Britain now has fifteen nuclear reactor sites of which four are near London and either operational or under construction.

Ken Livingstone continued to lead the GLC until 1986, when the government found a way to disarm him – by abolishing the GLC altogether. The Labour Party, which moved to the centre under Tony Blair, finally regained power in 1997, and in 2000 reintroduced the office of Mayor of London. It barred Livingstone from standing as a Labour candidate; but he stood as an independent and won. He served two terms, but when he stood for a third in 2008 he was defeated by Conservative rising star and future prime minister Boris Johnson.

OPPOSITE: *Two examples of the posters aimed squarely at the Thatcher government. On the left wing of the Labour Party, Greater London Council leader Ken Livingstone was keen to see more traditional forms of power generation.*

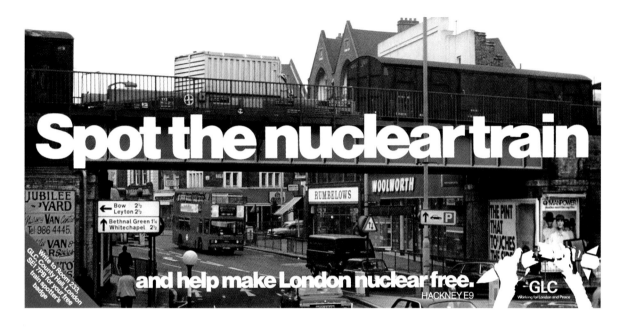

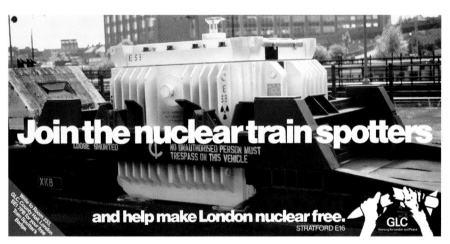

Drink-driving Posters

(1983–1996)

Road safety has often been a target of government initiatives. The use of seat belts, the roadworthiness of vehicles, awareness of the rules of the road – all have improved thanks to advertising campaigns. The public has at times seemed reluctant, however, to accept the dangers of driving while drunk.

In the early years after the invention of the motor car, when thrill seekers might hurtle along at up to 10mph, driving under the influence of alcohol was little more than an amusing challenge. But throughout the twentieth century the trend was for cars to get faster, and for wine and beer to get stronger. Fatalities of both the occupants of cars and of pedestrians rose steadily through the first half of the century. New safety features in cars focused more often on the driver and their passengers than on the unlucky pedestrians who got hit.

Over the years campaigns against drink-driving have taken a variety of approaches. Some focus on the victims outside the car, others on the consequences for the driver or passengers. A 1983 US poster addressed a third group, the *friends* of drunk drivers. The "Friends don't let friends drive drunk" has been so successful that 68% of Americans now say they have intervened to prevent someone from driving. By 1998 the US was recording its lowest number of road fatalities due to alcohol since records began.

In the UK the first drink-driving commercials were aired in 1964, at a time when there were still no laws in the country governing the consumption of alcohol by drivers. The year 1977 saw the first campaign specifically aimed at the Christmas season, which was usually a particularly black period for alcohol-related traffic accidents. The slogan was "Think before you drink before you drive", and the campaign was the first to make serious inroads into the number of

deaths caused by drunk drivers. In the decade following its introduction, drink-driving deaths fell by 46%.

The slogan was abbreviated until eventually it became THINK!, a logo in the form of the STOP sign painted on roads at junctions. The Think! posters became increasingly explicit about the consequences of drink. A series from the 1990s was particularly hard hitting. Knowing that people would look away, it adopted a split-screen approach, so that when they looked away their eyes would meet a second stark message.

The 1990 "Kathy can't sleep" poster reminded the public that it wasn't just the immediate victims of an accident who suffer. The 1992 contribution was a harrowing close-up of a young woman (played by future TV and musical star Denise van Outen) as medics try unsuccessfully to revive her.

In the world of advertising wordplay, it is convenient that think rhymes with drink. Backed up by newspaper and TV advertisements, the 1990s images continued the success of the Think! campaign in reducing road deaths. In 2000, Think! became the name of a newly created UK government department, responsible for all aspects of road safety, including the rising threat of drivers under the influence of illegal drugs. Thanks to the campaigns they run, the number of deaths on the road continues to fall.

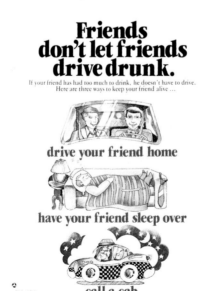

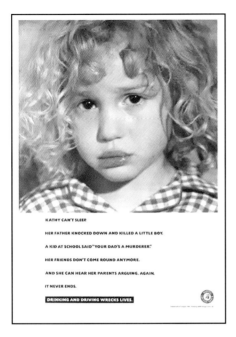

KATHY CAN'T SLEEP

HER FATHER KNOCKED DOWN AND KILLED A LITTLE BOY.

A KID AT SCHOOL SAID "YOUR DAD'S A MURDERER."

HER FRIENDS DON'T COME ROUND ANYMORE.

AND SHE CAN HEAR HER PARENTS ARGUING. AGAIN.

IT NEVER ENDS.

DRINKING AND DRIVING WRECKS LIVES.

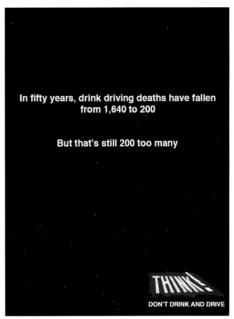

In fifty years, drink driving deaths have fallen
from 1,640 to 200

But that's still 200 too many

THINK!

DON'T DRINK AND DRIVE

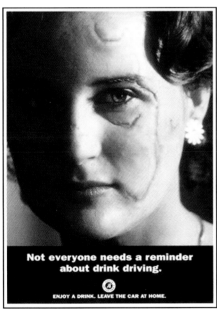

**Not everyone needs a reminder
about drink driving.**

ENJOY A DRINK. LEAVE THE CAR AT HOME.

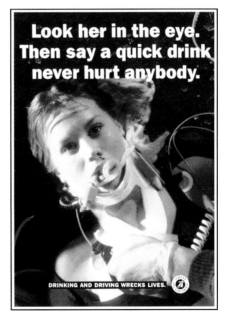

**Look her in the eye.
Then say a quick drink
never hurt anybody.**

DRINKING AND DRIVING WRECKS LIVES.

ABOVE TOP LEFT: *"Kathy Can't Sleep"* from 1990.

ABOVE LEFT: *"Mirror"* from 1996.

ABOVE RIGHT: *"Eyes"* from 1992.

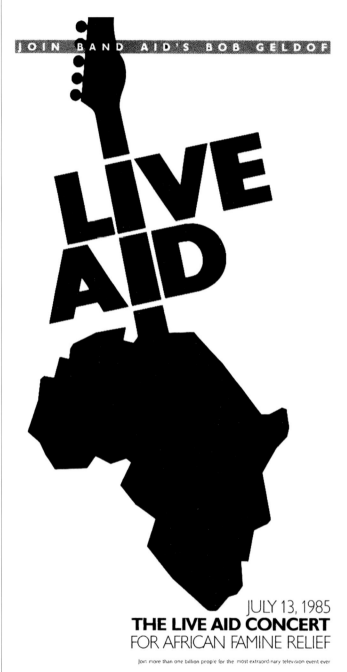

JOIN BAND AID'S BOB GELDOF

AT
**WEMBLEY STADIUM
LONDON**

BOOMTOWN RATS
DAVID BOWIE
PHIL COLLINS
ELVIS COSTELLO
DIRE STRAITS
BRYAN FERRY
ELTON JOHN
HOWARD JONES
NIK KERSHAW
PAUL McCARTNEY
ALISON MOYET
QUEEN
SADE
SPANDAU BALLET
STATUS QUO
STING
THE STYLE COUNCIL
THE WHO
U2
ULTRAVOX
WHAM!
PAUL YOUNG

**U.K. PRODUCER:
HARVEY GOLDSMITH**

AT
**JFK STADIUM
PHILADELPHIA**

BRYAN ADAMS
ASHFORD & SIMPSON
JOAN BAEZ
THE BEACH BOYS
THE CARS
ERIC CLAPTON
PHIL COLLINS
CROSBY, STILLS & NASH
DURAN DURAN
BOB DYLAN
THE FOUR TOPS
HALL & OATES WITH EDDIE KENDRICKS AND DAVID RUFFIN
THE HOOTERS
MICK JAGGER
KRIS KRISTOFFERSON
PATTI LaBELLE
HUEY LEWIS & THE NEWS
MADONNA
PAT METHENY
BILLY OCEAN
JIMMY PAGE
TEDDY PENDERGRASS
TOM PETTY & THE HEARTBREAKERS
ROBERT PLANT
POWER STATION
THE PRETENDERS
JUDAS PRIEST
SANTANA
SIMPLE MINDS
TEARS FOR FEARS
THOMPSON TWINS
TINA TURNER
NEIL YOUNG

**U.S.A. PRODUCER:
BILL GRAHAM**

PHILADELPHIA PROMOTER:
ELECTRIC FACTORY CONCERTS

JULY 13, 1985
THE LIVE AID CONCERT
FOR AFRICAN FAMINE RELIEF

Join more than one billion people for the most extraordinary television event ever

Live Aid

(1985)

Nearly half the population of Earth tuned in to the self-styled Global Jukebox of Live Aid. Its logo, a guitar shaped like Africa, captured the event's mission simply and clearly without the need for words, transcending language just as the music did.

Between 1983 and 1985 Ethiopia experienced a desperate failure of crops, a tragedy exacerbated by widespread human rights abuses which left 1.2 million people dead and a further 2.5 million internally displaced. BBC reporter Michael Buerk presented an unflinching report of the "biblical famine" which was seen worldwide by tens of millions of viewers in 1984.

One of those viewers was Bob Geldof, singer with new wave band the Boomtown Rats. Distressed by the scenes of devastation that he saw, Geldof and his friend Midge Ure of electropop group Ultravox recorded a fund-raising song with as many of their pop star friends as would fit in a recording studio. "Do They Know It's Christmas?", credited to Band Aid, went to #1 and stayed in the British charts for twenty weeks.

Geldof, having touched a charitable nerve in the British public, next sought to capitalize on it. Live Aid was the next step up, a benefit concert to raise further funds for famine relief. In a post-punk age of political cynicism it stood out as a curiously optimistic experiment. Could rock 'n' roll really save the world? Many clearly believed that it could.

The idea caught on, not only with the public but with rock musicians. What began as one concert became two day-long festivals, held consecutively at Wembley Stadium in London and John F. Kennedy Stadium in Philadelphia on 13 July 1985. Singer Phil Collins flew across the Atlantic in order to perform in both. Around 72,000 people attended in London and over 80,000 in Philadelphia, and the live television broadcasts were watched by 1.9 billion viewers in 150 nations including in the Soviet Union and China, something which had never occurred before for a Western broadcast. It is said that it was watched on over 500 million of the world's 600 million television sets. By any standards Live Aid was a singular cultural event, and it raised over $80 million for its cause.

Bob Geldof designed Live Aid's logo himself, with two functions in mind: simplicity and replicability. The simple fusion of a guitar and Africa captured the essence of the event for members of the public who might be moved by Ethiopia's plight but might equally not know anything else about Ethiopia including its location. The logo announced, "This is a pop music event; and it's about a place in Africa" – even if, as critics observed, it conflated Ethiopia's circumstances with the entire continent.

It was a distinctive shape, recognizable in any scale – on a tiny television set, or on the giant banners which framed the Live Aid stages. After the live shows it appeared on album covers, T-shirts and posters, instantly recognizable.

It worked. Band Aid worked, pulling together artists and fans from the cynical world of rock music in a common cause. Since then charity singles for other causes have become a regular feature in the charts, and Band Aid have reached #1 another four times with new versions of the original song. Live Aid worked, despite doubts about the effectiveness of the funds on the ground and accusations of mere virtue-signalling on the part of smug first-world pop stars. The event was a milestone in popular culture, a coming of age and a demonstration of power by the music industry.

OPPOSITE: *Many of the American acts approached to appear at Live Aid failed to realize the significance of the event, hence the inclusion of many British acts on the Philadelphia bill.*

AIDS DON'T DIE OF IGNORANCE

[GAY OR STRAIGHT, MALE OR FEMALE, ANYONE CAN GET AIDS FROM SEXUAL INTERCOURSE. SO THE MORE PARTNERS, THE GREATER THE RISK. PROTECT YOURSELF, USE A CONDOM.]

What Have You Got Against A Condom?

The simple act of putting on a condom can save your life, if they're used properly and every time you have sex. For more information about AIDS and condoms, call 1-800-342-AIDS.

AMERICA
RESPONDS
TO AIDS

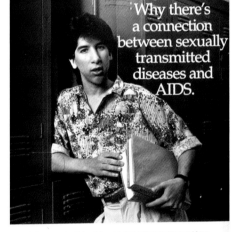

Why there's a connection between sexually transmitted diseases and AIDS.

Simple. The same type of sexual behavior that can infect you with gonorrhea, genital herpes, syphilis, and other sexually transmitted diseases (STDs) can also infect you with something else — the AIDS virus.

You get STDs by having sex with someone who is infected. That's bad enough.

But if you continue the same unprotected sexual behavior, you could get something you can't cure. AIDS.

If you'd like more information on the relationship

between AIDS and sexually transmitted diseases, call the National AIDS hotline: 1-800-342-AIDS. The hotline for the hearing impaired is 1-800-AIDS-TTY.

AMERICA
RESPONDS
TO AIDS

AIDS Posters

(1986–1987)

By 1986 the HIV/AIDS pandemic was out of control, a seemingly unstoppable disease for which there was no known treatment. In the absence of a cure, prevention was the only way to combat its spread. The UK and the US governments both launched multimedia awareness-raising campaigns.

AIDS (Acquired Immune Deficiency Syndrome) was first identified in the USA in 1981, and HIV (Human Immunodeficiency Virus) was recognized as the cause in the early years of the decade. Its origins have been traced to a chimpanzee virus from which a human form emerged in the Belgian Congo in the 1920s. Chimpanzees are the closest living relatives of humans in the animal kingdom.

Something approaching panic gripped the public as the advance of AIDS, "the gay plague", accelerated. There was considerable misunderstanding about the condition, its cause and the way in which it was transmitted from one person to the next. In 1986 Great Britain became the first country to try to demystify the subject and educate its population.

There was disagreement within the British government about how best to approach the issue. The disease was most prevalent among the young, because they were the most sexually active section of the population. Margaret Thatcher, the prime minister at the time, famously espoused "Victorian values" of morality, and in matters of promiscuity she favoured a message of abstinence.

Health minister Norman Fowler, however, took the advice of his Chief Medical Officer which was based on the experience of treating venereal disease among troops during World War I, that abstention was an unrealistic ambition. Furthermore any such approach would be fatally undermined by the emergence of any further ministerial sex scandals, of which there had recently been a few. Fowler, who had grown up in the permissive 1960s, wanted a campaign of explicit sexual health education which urged realistic precautions and an awareness of the risks.

In a deliberately frightening campaign the UK government's headline was "Don't Die of Ignorance". The campaign was devised by advertising executive Sammy Harari and consisted of leaflets delivered to every home on Britain, a series of billboard posters and hard-hitting TV advertisements featuring crumbling cliffs and icebergs; a doom-laden voiceover by actor John Hurt; and a bouquet of lilies and a copy of the leaflet laid against a monolithic tombstone chiselled with the stark single word "AIDS".

The US followed in 1987 with a campaign under the banner "America Responds to AIDS", which addressed not only sexual transmission but the dangers of sharing needles. Instead of the shock tactics of the British poster, the American series used simple portraits of young people to convey the message that everyone was at risk.

Critics of both campaigns included the Catholic Church, who opposed the advocacy of condoms even as a life-saving measure. Others argued that promoting safe sex merely encouraged promiscuity. The US series of posters was attacked by some community leaders for depicting only the low-risk middle classes and not those most vulnerable on the fringes of society – addicts and the homeless.

But both campaigns were vital in enabling a public conversation about AIDS to begin. Advances in medical understanding, and compassionate visits to the bedsides of patients with AIDS by prominent figures such as Princess Diana all helped to change attitudes to the disease. In the wake of the posters, the late 1980s saw a significant fall in new cases. These were successful campaigns.

OPPOSITE TOP: The UK response to the AIDS epidemic included posters, and a TV advert directed by Nic Roeg; the Royal Mail even marked mail with the slogan.
LEFT: The US campaign used a variety of models from different ethnic groups, along with a poster targeting heroin users who shared needles.

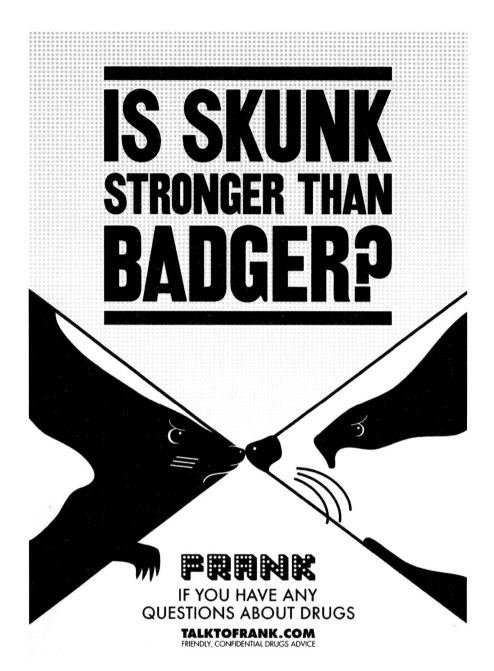

ABOVE: One of several posters produced for the ongoing and successful "Talk To Frank" drugs campaign. Another posed the question, "Does Meow Meow have whiskers?"

Drug Abuse Posters

(1987–)

The so-called War on Drugs often seems unwinnable, and the speed with which drug-taking subcultures invent new ways to get high can be bewildering. Most governments employ a dual strategy of law enforcement and anti-drug propaganda.

When Nancy Reagan urged America's youth to "Just Say No" in 1986, respectable America applauded her initiative. But for rebellious youth, the advice of a First Lady was automatically something to be ignored. Even for "nice" children, a 1987 poster of a cartoon bloodhound called McGruff (below) barking about the evils of crack carried little weight. Saying no to your peers could be difficult or impossible. Furthermore the zero-tolerance approach encouraged by Nancy Reagan made criminals of thousands of young Americans, especially from minority communities.

In Britain, in the same year that Nancy Reagan delivered her simple homely message, the government was trying a tougher approach. The striking image of a young heroin addict looking pale, listless and spotty – "you'll start looking ill, losing weight and feeling like death" – backfired when the romantic image of wasted youth became a teenage pin-up. It even inspired the fashion world which responded with a new look: "heroin chic".

The challenge of not making drug use attractive to the anti-establishment community continued to defeat successive governments for the rest of the century. Then in 2003 the UK government launched a radical new approach. Instead of demonizing drugs, it attempted to demystify them. Instead of making them taboo and exciting, it encouraged users and parents to discuss the pros and cons.

The programme was called "Talk to Frank". It acknowledged the world of the internet for the first time, with a website, email access and online chat available as well as traditional telephone hotlines. Frank

was conceived as some sort of older brother to whom one could turn for experienced, honest advice. He was never pictured, so he could never become either cool or uncool. He was not designed to appeal to hardened addicts, but he was someone whom parents could turn to for information about a drug culture which had radically changed since their own youth when all you had to know about was cannabis, LSD and heroin. What did parents know of skunk, wonk or meow meow? And what should they know?

Frank met stiff opposition from conservative voices both inside and outside government. Was it wise, critics asked, to be quite so honest about the highs as well as the lows? Frank acknowledged the pleasures of some drugs, notoriously admitting in an early advertisement that "cocaine makes you feel on top of the world". And, in the name of preventing contaminated supplies, Frank seemed sometimes to be giving instructions on how to acquire illegal substances safely.

Frank continues to offer his perspective on new developments, including the rise in so-called legal highs. It is hard to measure his real impact on drug use, however. It has declined by around 10% on his watch; but at least some of that fall is attributed to a general decline in cannabis consumption. Nevertheless Frank has won a degree of trust among his intended audience by having no visible connection to government, and by his apparent frankness about the subject at hand. Two-thirds of young people have said they would turn to him for information and advice. And sometimes having an older brother to confide in is just what you need.

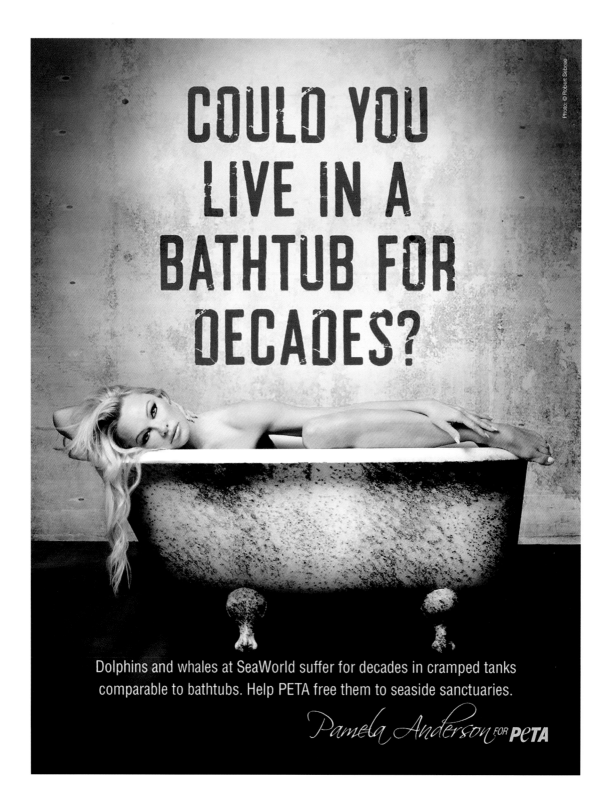

PETA Posters

(1990)

People for the Ethical Treatment of Animals (PETA) are renowned as much for their deliberately shocking poster campaigns as for their successful targeting of companies in the name of animal welfare.

In 1972 Ingrid Newkirk, living in Maryland and studying to be a stockbroker, found a family of abandoned kittens in a neighbouring house and took them to a local animal shelter. She was horrified to learn later that the kittens had immediately been killed. That discovery set her on a path. She is the co-founder and President of PETA, the largest animal rights charity in the world, with an annual turnover of more than $50 million and a global membership of 6.5 million people.

From the start, PETA used visual shock tactics to draw attention to their causes. For their first major campaign in 1980, they went undercover in a behavioural research laboratory, taking photos of the treatment of the macaque monkeys being used as experimental subjects. PETA's documentation resulted in a police raid. *The Washington Post* published PETA's graphic and disturbing photos of the monkeys, arousing a public outcry about the use of animals for scientific research.

As PETA has grown in size and wealth, it has become synonymous with high-profile advertising campaigns. "We are complete press sluts," Newkirk told the *New Yorker* in 2003. "It is our obligation. We would be worthless if we were just polite and didn't make any waves." Their 30-year "I'd rather go naked than wear fur" campaign and others often featured naked, female celebrities such as actress Pamela Anderson, pop star Pink and supermodel Christy Turlington. Appearing discreetly nude in a PETA advert has become as much a mark of A-list celebrity as appearing on a red carpet.

PETA took on the theme park SeaWorld in 2011, suing it under the Thirteenth Amendment for violating the rights of its orcas, which PETA claimed were being held in conditions of slavery. Five years later SeaWorld agreed to end its captive breeding programme and to phase out the use of its animals in degrading circus acts, including dolphin-surfing.

Not everyone admires PETA's shock tactics. They are often accused of promoting misogyny in their use of naked women. Women are frequently photographed in humiliating and shocking poses, such as being wrapped naked in cellophane and labelled "human meat" or hung – naked again – from a butcher's hook. Models are, critics claim, being objectified and exploited. PETA don't disagree, but counter that animals are objectified and exploited too. There has also been criticism of the ethos at its own animal shelter in Virginia where in 2019 – despite Newkirk's formative experience with kittens – 65% of the animals were put to sleep.

PETA has, however, achieved significant victories in animal welfare over its 50-year existence, profoundly changing attitudes to the way animals are treated and the acceptance of animal exploitation and cruelty.

OPPOSITE: The organization has focused critical attention on SeaWorld.
BELOW: PETA's "Go naked" campaign, which was retired in 2020.

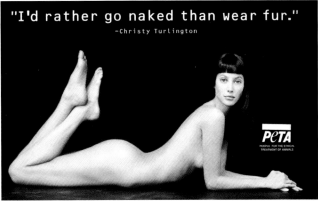

Banksy: *Girl With Balloon*
(2002)

A tender image in a medium more usually associated with political protest and bright aggressive letter forms, Banksy's *Girl With Balloon* has crossed many boundaries since it first appeared in 2002. In 2017 it was voted Britain's favourite work of art.

Is graffiti a form of art or of vandalism? Your answer is probably dictated by your age, whether you agree with the message of the graffiti, and whether it's on your building or someone else's. But international graffiti artist Banksy's admirers and critics are not so easily defined. For example much of his work has appeared on public buildings: in some cases it has been rapidly removed, yet in others it has been given protection against vandalism by other graffiti artists.

Banksy is a pseudonym. Although some think they have discovered his identity, it has never been conclusively admitted; and it is central to his activity that he escape identification. Graffiti is illegal, and it is a point of honour for graffiti artists to strike quickly and not get caught in the act. It was these requirements which drove Banksy to the technique by which he is recognized. While hiding from police under a refuse lorry, a stencilled serial number caught his eye. Far quicker, he realized, to spraypaint a stencilled design than to mark out his subversive groups of figures freehand. Furthermore, stencils could allow him a degree of accuracy and realism, and they made his designs repeatable.

Girl With Balloon first appeared on a stairway to Waterloo Bridge on London's South Bank in 2002. The lifesize figure of an unknown girl whose heart-shaped balloon is floating away on the wind was repeated at several locations around London. All of the original

locations had been painted over by 2007, although one version (on a shop wall) was carefully removed and preserved; that sold for half a million pounds in 2015.

The image has charmed its way into the public's hearts, no doubt assisted by the romantic image of the guerrilla artist whose works appear overnight. His critics are not charmed. Those on the right fear that acknowledging his work as art legitimizes the ugly vandalism of most graffiti artists. Those on the left consider his brand of anarchy too tame, too whimsical, and perhaps just too successful in the world of fine art capitalism.

Girl With Balloon has been widely reproduced in every format from greetings cards to posters, and Banksy himself has returned to it in several variations over the years. A version on the West Bank barrier between Israel and Palestine depicted the girl holding a bunch of red balloons and floating over the wall. Another showed the girl as a Syrian refugee. Yet another was painted onto the back of an IKEA picture frame.

A framed version of it was sold at Sotheby's in 2018 for over a million pounds; but Banksy had secretly installed a shredder in the frame, which sprang into operation immediately after the hammer went down. Banksy retitled the resulting half-shredded painting *Love in the Bin*, and it has been suggested that this will become even more valuable than the intact picture would have been.

RIGHT: The enigmatic Banksy is hard to pin down for interview, so it's difficult to know if the artist was influenced by Albert Lamorisse's 1956 short film, The Red Balloon, *which features a child pursuing a lost balloon across Paris.*

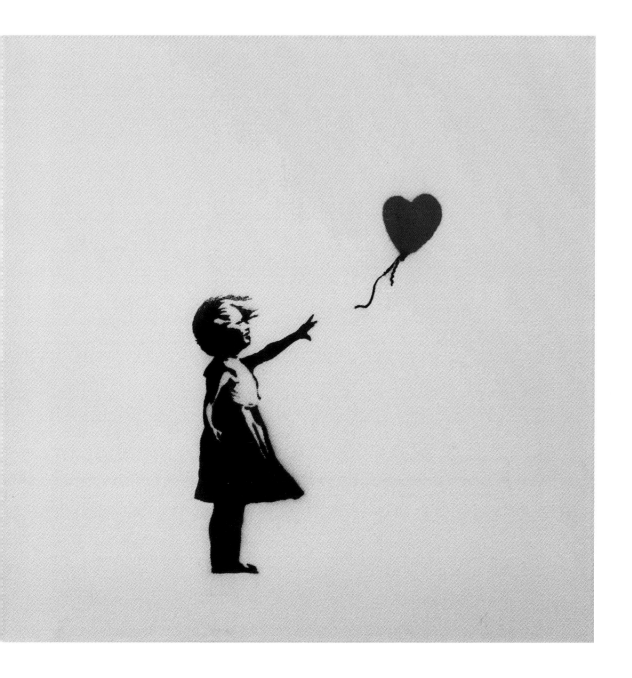

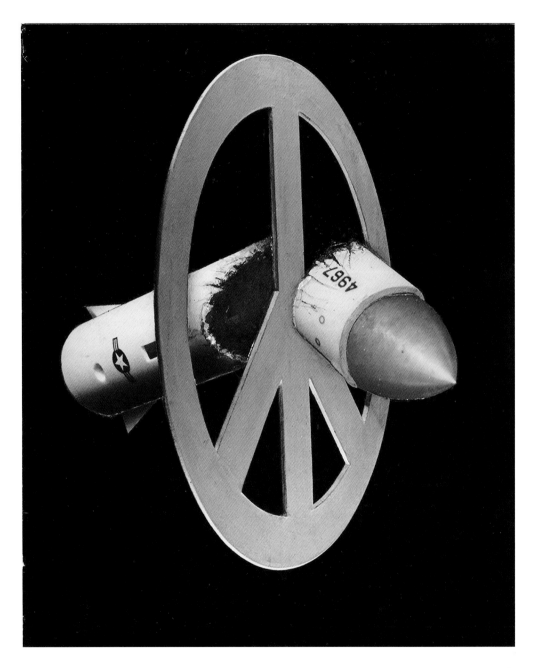

ABOVE: Peter Kennard's enduring anti-Trident photomontage. Kennard has been a Professor of Political Art at the Royal College of Art in London. In 2019 the book Visual Dissent *gathered together the best examples from his 50-year career.*

RIGHT: Demonstrators using Kennard's image protest in 2016 at the renewal of the Trident missile programme.

Anti-Trident Nuclear Missile

(2006–2016)

Protests against the introduction to Britain of the Trident nuclear missile system in 1980 were unsuccessful. But demonstrators protested again with renewed energy in 2006 to oppose the renewal of the Trident defence contract. A veteran anti-nuclear artist designed a new image for their campaign.

When Britain decided in 1980 to replace its own Polaris missile system with the US-made Trident nuclear deterrent, it aroused considerable opposition in the country. It wasn't just patriotism that riled the Brits; Britain's opposition to nuclear weapons stretches back to the founding of the Campaign for Nuclear Disarmament (CND) in 1958.

At that time artist Gerald Holtom designed an enduring symbol for the campaign. A stylized combination of the semaphore signals for N and D set in a circle, the symbol spread around the world and was adopted as the universal sign for Peace.

In 1980 the world was witnessing the beginning of the end of the Cold War and questioning the need for a nuclear deterrent at all. The CND symbol was much in evidence: London saw two massive protests, each attracting over a quarter of a million people, the largest ever seen in the country at the time. CND's membership rocketed from 3,000 in 1980 to 50,000 in 1981.

Despite these demonstrations the Conservative government of Margaret Thatcher gave the Trident programme the go-ahead. Then, as the first generation of Trident neared the end of its useful life, Britain decided in 2006 to renew its commitment to the system, sparking renewed protests. CND commissioned a strong new image to accompany them from one of its regular contributors.

Peter Kennard had been designing posters for CND since the 1970s. He had recently become famous for his photomontage of Tony Blair taking a selfie in front of a background of flames, regarded as one of the defining images of the unpopularity of the Iraq War. Now Kennard delivered another clear anti-war image: Gerald Holtom's CND symbol slicing through a Trident missile in flight, disarming it.

The image was carried on banners at demonstrations throughout 2006 and 2007. The protests served to raise awareness of the issues, but once again the protests had little impact on policy. Although many in British prime minister Tony Blair's own Labour Party opposed Trident, the decision to continue with the American system was ratified with the support of his Conservative opponents.

In 2016 a Conservative government led by David Cameron made the decision to renew the nuclear submarine fleet from which the Trident missiles were fired. Once again Peter Kennard's poster was paraded in protest. It was not the only government policy to come under fire that year. The Conservatives had been steadily privatizing parts of the nation's National Health Service (the NHS) and reducing the budget for the remaining public service. Campaigners argued that the money spent on an expensive weapons system would be better spent on the nation's health. "NHS, not Trident!" was the cry. Once again it fell on deaf ears and, only a few weeks after the nation voted to leave the European Union, the new system was given the go-ahead.

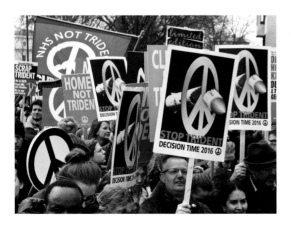

Stonewall Campaign

(2007)

Stonewall is a British LGBT rights organization founded in 1989. By lobbying the public and the British Parliament it has changed the law and people's hearts and minds, transforming the lives of the LGBT community in the UK.

The organization was named after the riots which followed a particularly violent police raid on a gay bar, the Stonewall Inn in Greenwich Village, New York, in June 1969, which galvanized the gay rights movement in the USA. In the UK, Stonewall emerged from the campaign to stop legislation (known as Section 28) introduced by the Conservative government in 1988, outlawing positive discussion of homosexuality in schools.

Although the campaign to stop the legislation failed, a group of active campaigners decided to form a campaign and lobbying group to fight to repeal the law and to ensure such examples of institutional discrimination didn't happen again. They included actors Sir Ian McKellen and Michael (now Lord) Cashman, journalist Duncan Campbell and senior civil servant Duncan Slater.

Stonewall lobbied governments and political parties to put gay and lesbian rights on the agenda and used legal action to challenge discrimination. It brought successful test cases to the European Court of Human Rights, which fuelled pressure to change UK laws on the right of LGB people to serve in the armed forces, the equalization of the age of consent and the acceptance of same-sex couples as adoptive parents.

As well as its successful legal challenges (Section 28 was repealed in 2003), Stonewall has campaigned to call out social discrimination and change attitudes to LGBT people. Stonewall's first and most memorable public campaign was initially aimed at combatting homophobic bullying in schools. Stonewall collaborated with 150 secondary school pupils and teachers to come up with a suitable slogan. In 2007, the "Get over it!" campaign was launched.

Posters on the Tube in London and UK wide on the side of buses proclaimed in black, red and white: "Some people are gay. Get over it!" Not everyone was impressed by the campaign. A Christian "gay cure" group, The Core Issues Trust, created posters parodying the Stonewall posters, but instead promoting being gay as something to overcome: "Not Gay! Ex-Gay, Post-Gay and Proud. Get over it!" Transport for London banned the opposing posters on the grounds that they were offensive, a decision supported by a judicial review and ultimately the High Court.

BELOW: The posters originally appeared on 3,500 bus panels, 600 billboards and on the display screens of twenty major railway stations.

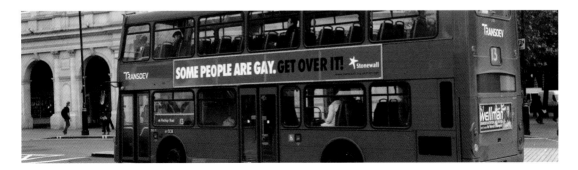

Obama: *Hope*

(2008)

Barack Obama's image as a political visionary was encapsulated in one poster which may well have won him the Democratic nomination in 2008. The poster spawned a thousand memes and became a part of popular culture. But its artist fell foul of the very administration he helped to elect.

In January 2008, Barack Obama, "The Senator from Illinois", was faltering in his attempt to be the democratic nominee for US President. His opponent Hilary Clinton was ahead in the polls and the Obama campaign team were open to ideas.

A radical artist, Shepard Fairey, was an Obama supporter and he wanted to design something for the campaign. Fairey, a skateboarder whose main claim to fame was a lamppost sticker called "Andre the Giant has a Posse", was concerned that his anti-establishment reputation might be damaging to Obama. But while they stopped short of employing him as a designer, they welcomed his support as a community activist and told him to go ahead.

Fairey created his poster design in one day. He produced a pop-art, stencilled image in red, white and blue, based on a striking photograph of Obama gazing upwards. It had echoes in its attitude of a previous young visionary US leader, JFK. And the styling was reminiscent of the classic poster of another challenger, Che Guevara. The colours not only invoked the US flag, but de-racialized the image of Obama. Here was an image of a leader: progressive, yet a patriot; dependable, yet visionary. A single word at the base of the image read PROGRESS.

The Obama team made only one change, replacing "progress" with "hope". Fairey produced an initial print run of 700 posters at his own expense. He distributed

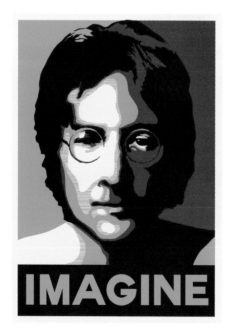

350 through his own activist networks and sold 350 to finance a further print run. By Super Tuesday, two weeks later, 4,000 had been produced. Obama won the Democratic nomination and the poster became a viral sensation, both reflecting and boosting his popularity with voters. By the time Obama was elected President, 350,000 posters and 500,000 stickers of the image had been produced.

Fairey's image has become a new cultural icon, part of the visual vocabulary of our time. Now innumerable versions exist, popular and political, from John Lennon to The Joker, from Arnie to Mr Bean. There are apps and online generators allowing everyone to create their own version of the Hope poster.

Fairey was invited to create a new poster to commemorate Obama's inauguration and was commissioned to design the cover art for *Time* magazine's Person of the Year in 2008. The original design for the Obama poster was acquired by the National Portrait Gallery in January 2009.

However, in a subsequent legal dispute over the copyright of the photo upon which Fairey based the design, Obama's Department of Justice argued that Fairey should receive a custodial sentence for tampering with evidence. In the end he got away with two years' probation and a $25,000 fine, which might be described as the triumph of Hope over (custodial) experience.

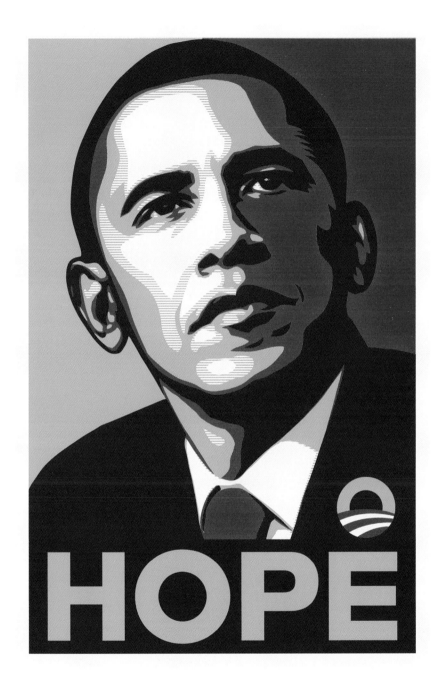

ABOVE AND OPPOSITE: Shepard Fairey's graphic approach to the Obama poster has been copied and applied to many portraits the world over. The Obama team's change of the word "progress" to "hope" played a critical part in its success.

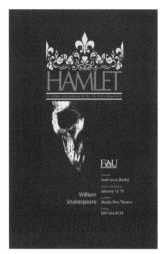

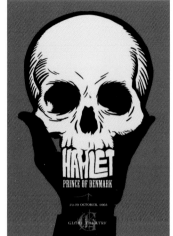

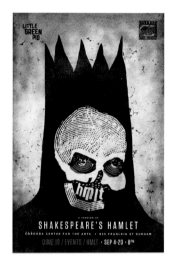

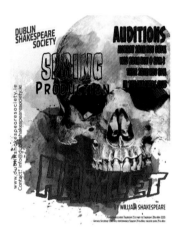

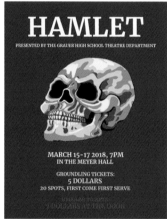

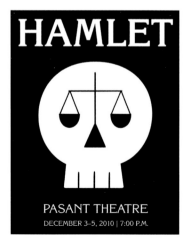

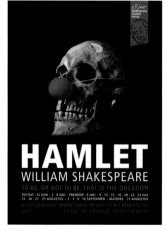

Theatre: *Hamlet*

(2010–2020)

There are two lines from Shakespeare's *Hamlet* that everyone knows: "To be or not to be", and "Alas, poor Yorick!" It is the skull of poor Yorick, the court jester of the Prince's childhood, which inspires most posters. Yorick's skull is a visual reminder that life is short but death is infinite.

Written between 1599 and 1601, the bloody tale of the dithering Dane examines common themes such as political skulduggery, madness and existential angst. Grief and death are the universal themes which power the plot. The narrative stems from the murder of Hamlet's father and ends with the deaths of almost all the main characters.

Hamlet's tally – nine fatalities by the time that curtain comes down – is only beaten by *King Lear* with ten and *Titus Andronicus* with an outstanding fourteen deaths. Yorick's skull is dug up by a gravedigger early in the play's final act and it provides the perfect visual trope for designers of *Hamlet* posters. Around this universal image of the play, however, each production and its accompanying poster tries to find a new angle on the timeless tragedy.

For example, Dutch theatre company Diever chose to promote their 2011 *Hamlet* with a skull wearing a red clown's nose. The unseemly comic conk serves to heighten the absurdity of life. In a tragedy, Death always has the last laugh.

The drama department of Florida Atlantic University adopted a more sombre tone in their *Hamlet*. Here a skull is half shrouded by shadow while the title is presented as part of a crown which weighs heavily on the heir to the throne. To wear the crown is to rule and to rule is to decide. Hamlet achieves neither.

The play is full of political intrigue and, through the years, several versions of *Hamlet* have reflected contemporaneous political machinations. The skull which illustrates the play's poster for Grauer High School in California echoes the colour palette of Shepard Fairey's poster for Barrack Obama's 2008 presidential campaign. The 2018 Grauer production colours a malevolent-looking skull with the same red, beige and blue tones. The suggestion here is betrayal and disappointment: Death, rot and stagnation dressed up in the colours of Hope.

The lurid colours employed by Dublin Shakespeare Society for their proposed 2020 *Hamlet* owe more to the tradition of B-movie posters. This is *Hamlet* as advertised by the Hammer House of Horrors. A more measured view was taken by the artist who designed the poster for a hypothetical production of *Hamlet* at the Pasant Theatre. Created by Bethany Ginther, a Michigan State University student, it uses simple shapes and lines to transform the skull's eyes and nose into weighing scales. It is a neat combination of Death and Justice, a double act which both drives and defeats the Prince of Denmark.

Although the skull represents death's inevitable victory, not all admirers of *Hamlet* see it that way. There is a long tradition of actors and patrons of the theatre seeking to cheat death by bequeathing their own skulls to be used as posthumous Yoricks. It is not a practice encouraged by all actors: apparently, real skulls chip far too easily.

Theatre: *Hamilton*

(2015)

When devising a smash-hit musical, it might be tempting to create new takes on previous successes. On the other hand, who could predict the success of a musical retelling of the life and times of America's first Treasury Secretary?

One of America's founders, Alexander Hamilton, was a lowly immigrant from the West Indies, the abandoned son of a Scottish nobleman, who worked his way up through American society to become George Washington's right-hand man. The significant role Hamilton played in American history had been sidelined until Lin-Manuel Miranda picked up Ron Chernow's inspiring biography of Hamilton. Miranda took the unconventional view that an eighteenth-century federalist would be the perfect subject for a piece of musical theatre.

Miranda wrote, scored and played the title role in *Hamilton*, which made its official Broadway debut in August 2015. Several hundred million box office dollars later, there is no denying that Miranda's hunch was correct: people do want to watch a modern musical that blends Revolutionary-period American politics with hip hop, R&B, jazz and show tunes.

The use of a young, racially diverse cast in a musical about old, white men helps bridge the historical gap between the period when the play is set and the time in which it is watched. As Miranda observed, *Hamilton* is a "story about America then, told by America now; and we want to eliminate any distance between a contemporary audience and this story."

The job of branding the show for promotion on posters and other merchandise fell to Spotco, an advertising firm which had worked on *Rent, Avenue Q, The Book of Mormon* and many other Broadway shows. In an interview with *Variety* magazine, Spotco founder Drew

Hodges said that a good Broadway poster didn't explain the show: it told people how it would feel to go. The *Hamilton* poster, then, tells people that seeing the show will feel heroic, like one man shooting for the stars. Forming the top point of a star, the upstretched hand of Hamilton in silhouette points to his true place in history.

Critics have complained that the triumphant, raised arm of Hamilton references John Travolta in *Saturday Night Fever*. More interesting is the likeness to the poster advertising the Royal Shakespeare Company's landmark production of *Nicholas Nickleby*, which transferred to Broadway in 1981. Roger Rees, who played Nicholas, stands centre of the poster, fist pointing defiantly upwards and his tailcoat flying. In fact, the image of an exultant Hamilton is a recurring pose struck every time he sings that he will not throw away his one shot to realize his ambitions.

Hodges wanted the logo to have as wide an appeal as possible, just like the show. The serif font used gives the show a classical air, but, as Hodges told *Variety*, the metallic gold of the background "is appropriate for both 1776 and Missy Elliott".

In its clarity it learned from the simple imagery of *Cats*; like that show's two eyes on a dark background, the *Hamilton* star can be applied to any number of merchandising items. It has helped to sell T-shirts, mugs, cast albums, an exhibition and will no doubt promote the proposed film of the show of the life of an unlikely musical hero. A golden star: it's the Broadway and Hollywood dream.

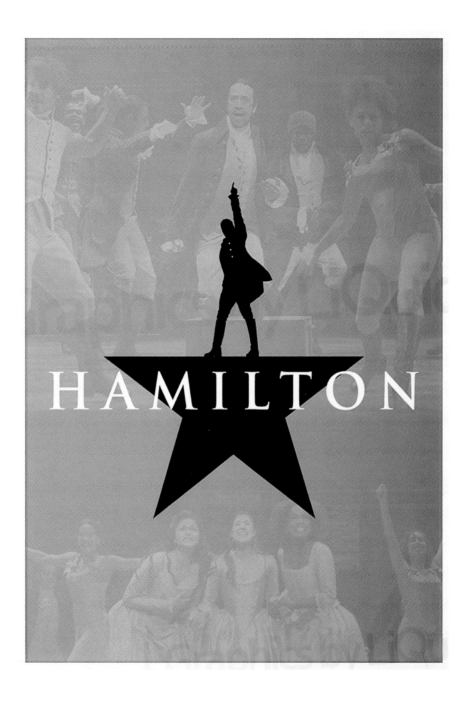

ABOVE: The theatre poster for Lin-Manuel Miranda's inspiring musical of Alexander Hamilton
OPPOSITE: With frock coat flying, Roger Rees punches the air in his role as Nicholas Nickleby, in
Trevor Nunn's Royal Shakespeare Company adaptation of the Charles Dickens novel.

100 Posters That Changed the World_____211

BEWARE OF THIEVES ON MOPEDS

www.met.police.uk/scootersecurity

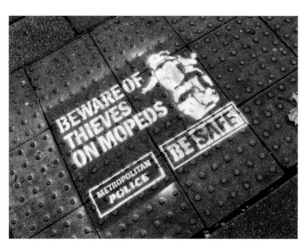

ABOVE AND LEFT: The Metropolitan Police turned to stencil art to get their message across in 2017. Given that many victims of mobile phone theft are robbed while looking down, it was an inspired idea to stencil on walkways.

Moped Thieves

(2017)

In 2016 a new crime wave hit London. One borough, Hackney, recorded 1,846 so-called snatch-and-grab thefts by two-wheeled thieves in its small area of the city alone. How could the Metropolitan Police get through to potential victims who only had eyes for their smartphones?

The crime was phone theft. Criminals on bicycles, scooters and mopeds were snatching the phones out of the hands of pedestrians while their victims were too engrossed in their screens to see the thieves coming. It was easy pickings in a crowded capital city. The bandits had become so bold that they even mounted the pavement to pull off their heists.

It wasn't a new modus operandi. In twentieth-century Italy, home of the Vespa scooter, young bucks on scooters would roar up behind tourists, deftly cut the straps of handbags and cameras with a sharp knife and race off with the spoils.

Towards the end of 2016 moped thieves became more brazen than ever when they rode up to a high-end jewellery store, smashed its windows with axes and sped away with a valuable haul. The jewellery robbery persuaded London's Metropolitan Police to confront the threat of moped bandits.

But how do you grab the attention of people in localized crime hotspots and convince them that this isn't another dreary government advisory notice? Perhaps drawing inspiration from acclaimed graffiti artist Banksy, the police turned to stencil art. The simple stencilled image of a pair of thieves on a scooter was combined with the few words that could be read by a pedestrian on the move: "Beware of thieves on mopeds." In 2018 the same basic image was used in leaflets and posters, notably on temporary pop-up banners. The police focused their attention on the entrances and exits of London Underground stations where commuters needed to concentrate to get on and off escalators.

Has the campaign been successful? By mid-2018 the number of thefts of mopeds had fallen by 22% and that of reported moped-mounted crimes was down by 55%. Whether it was the poster that was behind the success or the graphic police dashcam footage of patrol cars ramming moped thieves off their bikes, remains an open question, but it was interesting that in the digital age, it was old-fashioned media that was used to help solve the problem.

BELOW: The posters were placed at the top of escalators in all the nearby Underground stations.

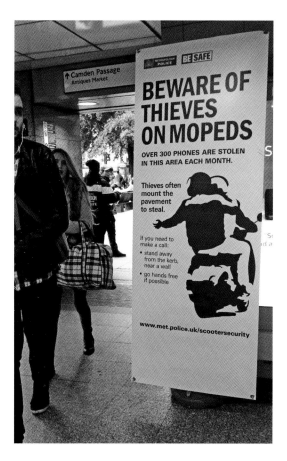

Extinction Rebellion

(2019)

For an organization that was only formed in October 2018, Extinction Rebellion (XR) have been very successful at raising their profile and making their aims known. Their influence outside the UK has spread quickly: more than seventy autonomous XR groups have sprung up, from Spain to South Africa.

Avowedly non-violent and decentralized, in April 2019, the climate change pressure group nevertheless managed to organize a very effective, protest-led shutdown of central London that lasted for several days. Extinction Rebellion's need and ability to mobilize and act quickly is emphasized by their logo which shows an hourglass inside a circle. It is easy to reproduce on posters, flyers and flags and, like all good logos, deceptively simple.

The circle represents Earth and the hourglass symbolizes how little time there is to save it from what XR claims is an irreversible tipping point in terms of climate change and species extinction.

Designed as an illustration of the threat of holocene extinction (the sixth mass extinction), the logo is the work of the anonymous East London street artist ESP. It is reminiscent of other protest group symbols such as the CND and Anarchist logos – two movements whose anti-capitalist sentiment and taste for civil disobedience is shared by many XR adherents.

XR has three central demands of governments. They must, XR insists, tell the truth by declaring a climate and ecological emergency and communicate the urgency for change. They must act now to halt biodiversity loss and reduce greenhouse gas emissions to net zero by 2025. And they must create and be led by the decisions of Citizens' Assemblies on climate and ecological justice.

In the UK, XR's aims have, in a general sense, been applauded by a wide cross-section of society. The Swedish environmental activist Greta Thunberg has lent her voice to XR protests and encouraged the support of young people indignant at the damage caused by older generations. More venerable supporters have enlivened news reports of XR protests by demonstrating a plucky willingness to be arrested for the cause.

The measures taken to combat the 2020 coronavirus outbreak began to achieve at least one of the objectives which Extinction Rebellion argues for. Greenhouse gas emissions fell dramatically as the world's transport systems shut down, factories closed up and the wider economy slumped. Given a taste of what a no-growth economy might look like, the public must decide whether it is a worthwhile trade-off for reduced gas emissions. Extinction Rebellion would argue that the alternative would be even worse.

OPPOSITE PAGE AND ABOVE: The Extinction Rebellion logo is a clever amalgam of the letter X for Extinction and a stylized hourglass representing the diminishing time we have to save the planet.

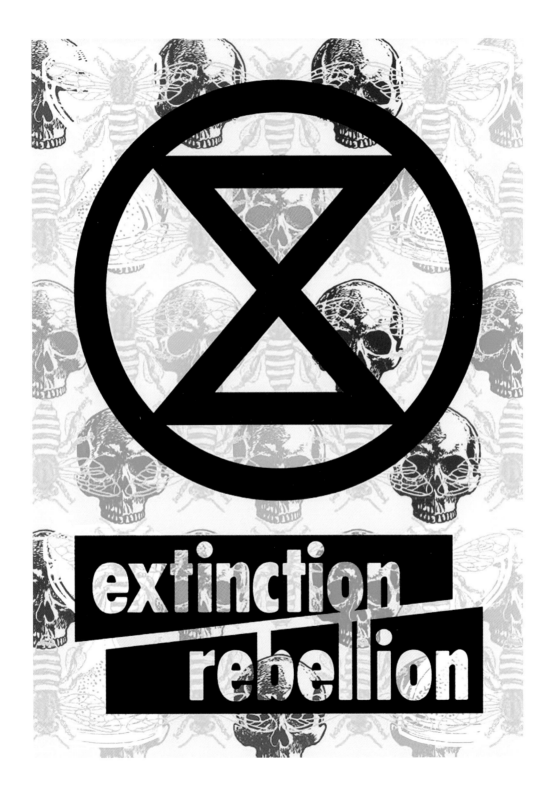

Index

ABOVE: *In 1916, the French Ministry of Beaux-Arts and the Ministry of War promised artists serving in the war, that their work would be shown in official war exhibitions. The government sponsored the Salon des Armées to show the work of the frontline artists and this exhibition raised 60,000 francs for soldiers. This painting by Henri Dangon won first prize.*

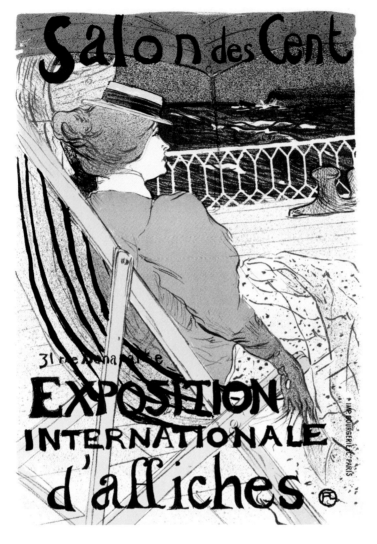

ABOVE: *Henri de Toulouse-Lautrec's 1895 poster for an exhibition of* affiches *(posters) at the Salon des Cent in Paris.*

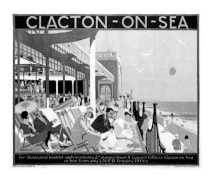

ABOVE: Henry Gawthorn's railway poster for holiday resort Clacton-on-Sea in Essex.

ABOVE: Shepard Fairey's landmark Hope poster has become a familiar canvas for mocking politicians.

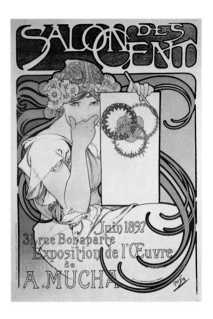

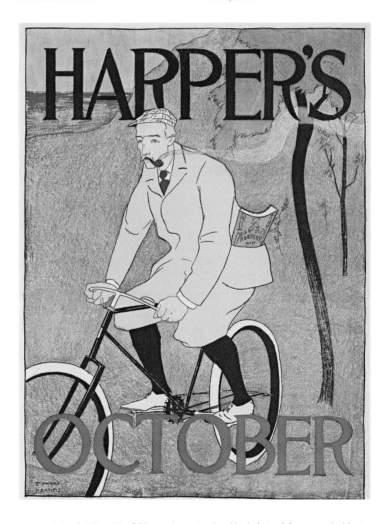

ABOVE: An early Edward Penfield magazine poster, signed in the bottom left corner and without his trademark "bull's horns" logo that he adopted later in his career. Penfield's work heralded the "Golden Age of American Illustration".

ABOVE: Mucha's poster for the St. Louis World Fair of 1904 was a startling contrast of European woman and Native American chief.

ABOVE: One of the thousands of WPA Federal Arts Project posters produced in the 1930s and 1940s, this one by Roger Floethe from 1937.

Acknowledgements

Thanks to Jonathan Trew, Alastair Mabbott, David Weinczok, Vin Arthey and Rosie Doyle for extra research; and to the latter for patience under fire. Picture credits: All photos in the book are from Alamy with the following exceptions: page 10, Coca-Cola; page 11 (top left), 12 (top), 14, 33, 42, 43, 44, 45, 46, 47, 51, 58, 59, 60, 61, 80, 81, 82, 83, 86, 87, 88, 89, 93 (main image), 101, 108, 109, 110, 111, 112, 113, 123, 125 (bottom right), 128, 129, 133, 137, 146, 147, 217, 221, 222, 223, Library of Congress; page 13 (top), 156, Theo Hopkinson; page 26 (top), People's Palace Museum, Glasgow; page 29, ABC Television; pages 30, 175, 194 (top) Health Education Council; pages 148, 149, Athena Posters; page 151, Stefan R. Landsberger Collection of the International Institute of Social Studies; page 164, Getty Images; pages 170, 171, Keep Britain Tidy; page 196, TalktoFrank.com; pages 198, 199, PETA; pages 204, 205, Stonewall; page 208, Diever Theater Company, Florida Atlantic University, Dublin Shakespeare Society, Grauer High School, Bethany Ginther/Michigan State University, Globe Theatre, Little Green Pig; page 210, Royal Shakespeare Company.

Also in this series:

Maps That Changed the World ISBN 978-1-84994-297-3
John O. E. Clark (2015)

100 Diagrams That Changed the World ISBN: 978-1-84994-076-4
Scott Christianson (2014)

100 Documents That Changed the World ISBN: 978-1-84994-300-0
Scott Christianson (2015)

100 Books That Changed the World ISBN: 978-1-84994-451-9
Scott Christianson and Colin Salter (2018)

100 Speeches That Roused the World ISBN: 978-1-84994-492-2
Colin Salter (2019)

100 Letters That Changed the World ISBN: 978-1-911641-09-4
Colin Salter (2019)

100 Children's Books That Inspire Our World ISBN: 978-1-911641-08-7
Colin Salter (2020)

About the Author

Colin Salter is a history writer with degrees from Manchester Metropolitan University, England and Queen Margaret University in Edinburgh, Scotland. His most recent publications are *Remarkable Road Trips, 100 Books That Changed the World, 100 Speeches That Roused the World, 100 Letters That Changed the World and 100 Children's Books That Inspire Our World*. He is currently working on a memoir based in part on letters written to and by his ancestors over a period of two hundred years.